THE
GREAT
WORKSHOP

BOSTON'S VICTORIAN AGE

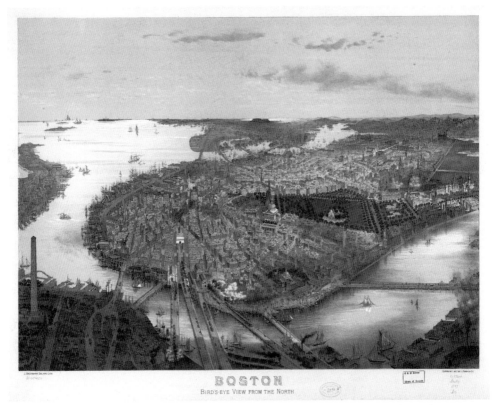

BOSTON
BIRD'S-EYE VIEW FROM THE NORTH

This bird's-eye view of Boston from the north dates from 1877. Numerous wharves are visible around the harbor, along with many railroad bridges crossing the Charles River. The Bunker Hill monument in Charlestown can be seen in the lower left. (Courtesy Library of Congress.)

Opposite: *A page from the 1897 Boston Rubber Shoe Company calendar featuring the State House.*

THE MAKING OF AMERICA

THE
GREAT
WORKSHOP

BOSTON'S VICTORIAN AGE

Chaim M. Rosenberg

ARCADIA

For Dawn

Published by Arcadia Publishing,
Charleston SC, Chicago IL, Portsmouth NH, San Francisco CA

Printed in Great Britain.

Library of Congress Catalog Card Number: 2004107923

For all general information contact Arcadia Publishing at:
Telephone 843-853-2070
Fax 843-853-0044
E-Mail sales@arcadiapublishing.com
For customer service and orders:
Toll-Free 1-888-313-2665

Visit us on the Internet at http://www.arcadiapublishing.com

CONTENTS

ACKNOWLEDGMENTS

This book is mainly for Dawn, who has shown patience, understanding, and love over the two years it has taken for the research and writing.

Also, for my grandchildren Daniel, Naomi, Natan, Hadas, Rebecca, Colin, and Amber.

I am happy to have spent most of my life in the Boston area. I have much enjoyed its history and its rich cultural life. This book is my effort to give something back to a place that has been so good to my family and myself.

I am grateful to the Boston Public Library for access to their vast collection on the history of this great city and the towns that surround her. The Library of Congress permitted me to reproduce some of its ancient and rare maps of Massachusetts.

Jim Kempert at Arcadia Publishing has put up with my nagging over many months. Jim has guided this work almost from the beginning and has brought it to life.

INTRODUCTION

The Shawmut Peninsula was occupied in 1630 by English settlers, who were sponsored by the Massachusetts Bay Company. The small settlement was named Boston and has grown into a major city, soon to celebrate its 400th birthday. The peninsula was almost completely surrounded by water and connected to the mainland only by a narrow spit of land called the Boston Neck. The settlement faced the Atlantic Ocean and a series of islands to the east. To the north was the Mystic River. The Charles River and the Muddy River to the west entered the ocean through sluggish marshlands. To the south was the small Neponset River.

Boston became the most successful of the early efforts to settle the Massachusetts Bay Colony. The first settlers built their houses close to the dock, facing the ocean. The town suffered during the American Revolution when it was occupied by British troops. Boston recovered with the peace settlement and, by 1810, the town had grown to nearly 60,000 people. The living space needed to be increased. The Mill Road was constructed and bridges were built to connect the peninsula with the farmlands of Cambridge.

During much of the nineteenth century, the city fathers were occupied with two enormous public works projects: the first was to demolish the hills on Beacon Hill and use the gravel to fill the Mill Dam; the second was to haul gravel from Needham and to widen the sides of the Boston Neck to form the Back Bay and the South End. These projects doubled the land available for housing and for commerce.

Early Boston focused toward the ocean and trade with England, and later with the West Indies and the China Trade. This trade created Boston's early fortunes and provided the capital needed to fuel the beginnings of the Industrial Revolution in America.

Boston lacked the waterpower to build factories close to home. Instead, the textile and shoe factories and the machine shops sprung up in the smaller Massachusetts towns close to rivers. The waterpower of the Charles River upstream, the Merrimack at Pawtucket Falls, the Blackstone, and the Quequechan Rivers spurred the growth of Lowell, Lawrence, Fall River, and the other great industrial towns of nineteenth-century Massachusetts. The Massachusetts towns around Boston were in the grip of "mill fever." The pattern of industrial development close to—but outside of—Boston

continued with the coming of steam and electrical power. Soon, the shoe towns of Brockton and Lynn, the old whaling town of New Bedford, and Fitchburg, Taunton, Haverhill, and Salem became major industrial towns. Many of the towns in Massachusetts developed factories and made all kinds of goods from shovels to sewing machines, and from locomotives to cooking-ranges. However, textiles and footwear dominated. The towns benefited mightily from their factories. The townsfolk lived close to them and spent their weekly wages in the local stores.

During the course of the nineteenth century, Massachusetts changed from an agricultural to a highly industrial, urban state. The capital city, Boston, followed a much broader road than its hinterland. Major industrialization did not take place in Boston until the coming of steam power. Located toward the eastern end of Massachusetts, Boston grew as the dominant port and service center. From 1841 to the end of that century, some 450,000 immigrants arrived by ship into Boston. The flood of immigrants provided the labor for industrial growth.

Boston was the transfer station for people and goods. The city was filled with brokerage companies and huge warehouses bringing in raw wool from Australia and Europe, cotton from the south, and leather. These goods were then sent on to the mills. Timber, dried fish, textiles in all colors and patterns, work boots, and fancy ladies' shoes were exported from Boston Harbor to markets all over the world. Boston was "The Hub." The early dirt roads in Massachusetts radiated out from Boston to Maine in the north, to Providence to the south, and toward New York to the west. The Middlesex Canal, built in 1803, brought the timber and farm goods of northern Massachusetts into Boston Harbor. Starting in 1835, the railroads similarly radiated toward Boston.

Boston became a magnet for ambitious young men who journeyed from their small towns to seek their fortune in New England's largest city. Numerous enterprises were started in Boston, but the lack of space for growth encouraged many of these businesses to build their factories across the river and harbor in the adjacent towns of Cambridge, Somerville, Chelsea, and Malden. The excellent transport links, cheaper land, and the availability of steam and electric power helped combine Boston and these towns into a single industrial entity. The head offices were in Boston and the factories were in the nearby towns. In due course, many of the leading industrialists entered politics and a number became governors of Massachusetts.

The newly-industrial cities—both close and further afield—were linked by rail to Boston, which at one time had seven different railway terminals. The banks, universities, headquarters of companies, and the intellectual and cultural life of the state all had their centers in Boston. The city became the focal center of an elaborate horse-driven trolley system with connections to

nearby villages and towns. These connections were expanded when the lines were electrified after 1890. Before the automobile age, Boston was already a city of 670,000 people with each of the industrialized towns of Cambridge, Somerville, Lowell, Lawrence, Lynn, New Bedford, and Fall River at 90,000 or more. The great workshop of eastern Massachusetts produced everything needed for daily living and for industrial development. These goods were consumed both locally and by markets throughout the world.

The coming of the gasoline-powered automobile led to a highway system gravitating toward Boston much as the railroads and the trolley lines decades before. The nineteenth-century downtown has been replaced by shopping malls and office buildings built near the highways. The open areas that previously separated the towns have gradually filled in to form a continuous metropolitan region with over five million people. In our times, the same Boston-bound traffic patterns have continued with the "Big Dig." This hugely expensive project brings traffic from the west, south, and north into the heart of Boston (albeit underground). The port may no longer have its busy sea lanes, but Logan Airport—lying in East Boston a few miles to the east of the once-mighty harbor—is now the transportation link between Boston and the outside world.

The industrial development of central and western Massachusetts, including the cities of Worcester and Springfield, continued apace with the happenings in the region now known as Greater Boston. These regions well deserve their own history, but are not covered in this book.

This is a story of Yankee ingenuity. Most of these entrepreneurs could trace their ancestry back to the beginnings of the settlement of Massachusetts Bay. At their start, few of them were any richer than their imaginations, abilities, and drives. They built Massachusetts into a great industrial state. At first, they were paternalistic and caring toward their workers. The next generations of company owners were faced with stiff competition and showed much less regard for their workers. Overproduction, aging plants, friction between management and workers, and the Great Depression led to the decline of the mills and their moves to the south. The factories in Cambridge, Somerville, Lowell, Lawrence, Fall River, New Bedford, Brockton, Lynn, and many other towns closed down. The company towns of Whitinsville and Hopedale no longer build machinery. The warehouses in Boston—once filled with raw wool, cotton, leather, textiles, ready-to-wear clothes, and shoes—were left empty.

Massachusetts is no longer a major industrial state. Some Massachusetts towns have not recovered from the loss of their great industries. The remains of the industrial period are still to be seen in the deserted mills and the abandoned downtown. The cities and towns that were most heavily industrialized had the steepest economic and social declines. These largely blue-collar towns have had great difficulty finding uses for the abandoned

mills. Many of the towns that missed the nineteenth-century industrial boom have managed to keep their New England charm and have settled into desirable bedroom communities. Boston has seen the decline of its seaport. It has seen the fall of its industrial hinterland, the decline of horse and water power, and the near-collapse of the electric trolley system and the railroads. Boston is no longer a headquarters for major corporations and banks. In 1850, Massachusetts had nineteen of the largest one hundred cities in the United States. By 1910, the number had slipped to twelve. Today, only Boston itself ranks among the country's largest cities. Instead of busy factories and decent wages, the cities were left with large pockets of under-employment and have been kept afloat by heavy injections of state and federal aid. Government-provided housing subsidies, welfare, disability and social security payments, and other entitlements have lessened the impact of economic decline.

The health of a nation can be judged by the strength of its economy and the ways in which it enhances the well-being of its people. By these measures, nineteenth-century America, and Massachusetts in particular, was a harsh place. Workers labored long hours for little pay and with very little security. Relatively few lived beyond seventy years of age. The growth of the central government during the twentieth century and the implementation of numerous social-welfare programs, as well as improvements in the contract for work, have all improved the lot of the ordinary citizen and have brought about stability. People are now living longer and require many services as they age. The increasing demands on Social Security, Medicare, and other governmental programs are producing huge and unsustainable federal deficits that will have to be addressed by a combination of increased taxation and reduced benefits.

Metropolitan Boston can no longer measure itself by the size of its industries and the power of its economy. The factories and jobs in the great workshop that was Massachusetts have long since gone to other states and are now fast moving to other countries. A computer-based, service-oriented economy has replaced shoes and textiles. The massive mills that once employed thousands of workers have gradually been transformed into living quarters and the offices of many small businesses. In nearly 400 years of history, Boston and its hinterland have adjusted to many changes. It is now a mid-sized city, with a fascinating past, abundant Victorian-era architecture, a vibrant cultural life, and world-class universities. The state of its economy will determine its continuing prosperity. Boston will need to embrace its intellectual and entrepreneurial capital to develop the new industries necessary to provide the good jobs to sustain its population into the future. This book offers a nostalgic look back at metropolitan Boston at the height of its industrial age. My hope is that it will be a guide to Boston's development into the twenty-first century.

Chapter One

BOSTON

In 1620, a small party arriving on the *Mayflower* settled in Plymouth. In 1623 another group, sponsored by the Dorchester Company in England, attempted to settle on Cape Ann. They found the area inhospitable and, in 1626, some of them moved down the coast to start a new settlement, which they called Salem. Back in England, the Dorchester Company sold its assets to the Massachusetts Bay Company and in April 1630, eleven ships led by the *Arabella* sailed from England, mainly carrying Puritans, members of an English Protestant sect. The ships and settlers on board were sponsored by the Massachusetts Bay Company, which planned to settle the new territories and reap profits for itself and for the crown.

The Puritans had their own motives for leaving England. They were escaping the economic difficulties at home and the religious restrictions imposed upon them by King Charles I. In the New World, the Puritans, under the leadership of John Winthrop, aimed to establish their own society and practice their religion without hindrance.

In June 1630 the small fleet sighted land. Some time was spent moving along the coast looking for a good place to establish a community, and the fleet eventually anchored near Salem where some of the settlers disembarked. Others sailed a few miles south to Charlestown but the lack of ample fresh water there forced the settlers to look elsewhere for a permanent site. John Winthrop met a reclusive Anglican clergyman, the Rev. William Blackstone, who had settled on the Shawmut Peninsula several years before. The reverend told Winthrop about a fine stream on his side of the Charles River that could provide abundant water. Blackstone sold the peninsula to the settlers for £30 and moved to the wilderness and in September 1630, Winthrop and 150 other settlers crossed the Charles River from Charlestown and set foot on the Shawmut Peninsula. They named their settlement "Boston" after the town in Lincolnshire, England, from which many had come. By the end of that summer 1,000 people had arrived from England, settling in Boston and in the small communities along the Massachusetts coast.

The most striking feature of the Shawmut Peninsula was three hills known as Trimountain, and later as Tremont. The peninsula was connected to the mainland on the southwest by a narrow neck. It was a little over three miles

long and one mile wide. Most of the early settlers congregated on the eastern coast of the peninsula, known as the Town Dock, which was close to the supply of fresh water. They built rudimentary cottages for themselves and set aside an area of common land—known as the Boston Common—where they kept their animals. The American town of Boston was laid out in the manner of the English market towns the Puritans had left behind.

Boston grew slowly. In the year 1631 it had 300 people and, by 1634, had only increased by one hundred. In the course of time other settlements sprung up along the coast to the north and south of Boston. The English capitalists who financed the settlement of Massachusetts Bay well understood the need for the settlers to quickly become self-sufficient in food and shelter before they would be able to create surpluses for export and profit. Many of the settlers came from the farms of England and were seasoned in agriculture as well as in the making of shoes and cloth. Livestock, including cattle, horses, and pigs, were brought by ship to establish herds in the New World. In order to feed these animals, the English colonists spread beyond Boston to find natural marshes to provide feed for their livestock. They settled and built their family farms up and down the coast and along the banks of the rivers (Russell, 1982).

The richness of the land and the oceans soon provided the colonists with surplus to be sold both in the local Boston markets and abroad. As early as 1669, Boston was established as the chief horse market. Horses were shipped from the settlement to the West Indies where they were put to work powering the treadmills used to crush sugarcane. Other livestock was brought to the slaughterhouses in Boston, where much of the beef and pork was salted and exported to markets elsewhere in British North America or sent by ship to the West Indies. The hides were sent to tanneries and soon a homespun shoe industry developed. The surpluses of corn, grain, potatoes, lumber, and fruit, as well as livestock, from all over New England increasingly gravitated toward Boston to establish the economic pathways that were to endure and expand over the years.

The settlers soon grew less and less dependent on agriculture and took advantage of their proximity to the ocean and rivers. By the end of the seventeenth century, Boston had developed into a major maritime town with several shipyards and many wharves. Its fleet of seafaring ships was one of the largest in the British-dominated world, exceeded only by London and Bristol. Boston traders sent salted fish, wool, hemp, lumber, and furs to Europe and on their return, the ships carried finished goods from England as well as sugar, coffee, and molasses from the West Indies. Soon, Boston's sailing ships were trading in India, China, and South America. From its beginning until 1750, Boston remained the largest settlement in British North America. The town had over 3,000 houses, one-third of which were brick and the rest built of

wood. Churches, burial grounds, and meetinghouses were built along established streets and lanes and by 1743, Boston had 16,000 inhabitants. By comparison, Philadelphia had 13,000 and the port town of New York had about 11,000.

The French and Indian Wars (1754–1763) for control of the vast territories of North America seriously restricted Boston's economic growth. French ships captured or sank many merchant ships using the harbor and crippled Boston's maritime trade. Even after the end of the war the town's economy failed to pick up, but the British government was determined to force its colonies in North America to pay for the cost of government and its defense. New taxes were imposed on commercial and legal documents, as well as on sugar, glass, paper, and other necessities. The Tea Act of 1773 infuriated the people of Boston. Three ships, the *Dartmouth*, the *Eleanor*, and the *Beagle*, arrived in Boston Harbor carrying imported tea. At meetings held at the Old South Meeting House, residents demanded that the tea be returned to London. After the governor refused, a party of some fifty Bostonians boarded the three vessels, smashed open the chests, and threw the tea into Boston Harbor. The British were not long in reacting to what is now known as the Boston Tea Party. They occupied Boston and cut off the harbor to the outside world.

Two months later, the British suffered heavy losses at the Battle of Bunker Hill. In March 1776, General George Washington took Dorchester Heights and forced the British to leave Boston and its harbor. The liberated town was left a mess. The population had declined from 20,000 before the siege to less than 6,000 and those who had remained could barely support themselves.

Boston recovered after the War of Independence. Its trade with Britain and the West Indies was restored and new markets were found in South America, India, and China. The population of Boston started to grow again and, by 1790, it had risen to 18,000. In 1800, 25,000 people were living in Boston and, twenty-five years later, the population had reached 60,000. The increasing population created difficulties with town services. The outdoor marketplace was becoming overcrowded, the streets congested, and the sewage system grossly inadequate. Peter Faneuil's Hall, opened in 1743 near the wharves, greatly improved the distribution and sale of foodstuffs for the growing town. The town expanded, and the West, South, and North Ends were settled. The gold-domed State House was completed in 1798, and in 1822 Boston was incorporated as a city.

Faneuil Hall soon proved too small. There was a need for a larger place to accommodate the needs of the farmers and the townsfolk. Under the leadership of Mayor Josiah Quincy, a far larger marketplace was built around the original Faneuil Hall; it consisted of the North and South buildings and the Market House (called the Quincy Market) between them. The design of the

Market Place resembled the markets found in English towns. All stalls were leased by the time the market opened in 1826. Only foodstuffs were offered for sale in the market house, but all sorts of goods were sold in the South and North market buildings (Quincy, 2003). There were sail makers, tobacco dealers, imports from Europe and the West Indies, clothing stores, agricultural suppliers, and even stalls selling snuff.

The Shawmut Peninsula was too small to accommodate this growth. The city fathers decided to widen the area on either side of the Boston Neck that joined the peninsula to Roxbury and the mainland. Two of the three hills that dominated the horizon were demolished with picks and shovels over a twelve-year period. The gravel was moved by horse cart and used as landfill. In 1814, an earthen dike was constructed from Beacon Hill westward toward the village of Brookline. This dike—called the Mill Dam and later Beacon Street—separated the marshy tidal basin from the Charles River.[1]

As new areas became available for housing the city began to spread beyond its old boundaries. The landfill areas of the South End and South Boston were opened up for settlement and soon, narrow townhouses faced the streets and the squares. When Charles Dickens visited Boston in 1842, he described the city as "a beautiful one, and cannot fail, I should imagine, to impress all strangers very favorably."

During the second half of the nineteenth century, even more ambitious plans were drawn up to expand the land in Boston available for housing. The most important was the filling of the marshlands to the west of Beacon Hill. This area, known as the Back Bay, would add some 450 acres to the original 800 acres of the peninsula. New roads were to be built parallel to the Mill Dam, the most imposing of which would be Commonwealth Avenue, modeled after the boulevards of Paris. Beacon, Marlborough, Newbury, and Boylston Streets would run parallel to Commonwealth Avenue.

By 1858 shovels and horse carts were no longer needed. Now the digging was done by huge steamshovels built in Boston and working nine miles away in Needham. The gravel was loaded on open railway cars and hauled by steam-driven locomotives into Boston. The filling of the Back Bay took thirty years. This vast project made a veritable dustbowl of eastern Needham, but Boston had an elegant new residential area. The incorporation (between 1866 and 1873) of the nearby towns of Roxbury, Roslindale, Charlestown, Brighton, Dorchester, and West Roxbury greatly increased the size and population of the city of Boston.

[1]In 1814, Uriah Cotting and his group formed the Boston and Roxbury Mill Corporation with the plan to build several dams connecting Boston with Roxbury and to use the tidal flow for waterpower to drive mills. This area was called the Back Bay to distinguish it from the harbor, the Front Bay. The waterpower from these dams was too weak and Cotting joined his business partner, Francis Cabot Lowell, in the development of textile mills at Waltham where the flow of the Charles River was stronger.

Some of the merchants and ship owners had grown wealthy, but life was a daily struggle for most people. The strict Puritan standards had begun to weaken and other forms of worship and behavior were accepted. Still, Boston remained a Protestant town, tethered to its Anglo-Saxon roots. In 1850, with 136,881 people, it was one of the largest cities in the United States. The newly incorporated suburbs added another 50,000 people.

The tremendous growth of Boston during the second half of the nineteenth century was the result of large-scale immigration from Europe and increasing trade through the port. The large shoe and textiles mills, the machine shops, and countless other industries that sprung up in the towns outside of Boston created an army of brokers dealing in wool, raw cotton, and leather, as well as in manufactured products for export. The building boom created by the filling of Back Bay and the growing suburbs also created many jobs. By 1880, the population of Boston had risen to 362,839, making it the fifth largest city in the United States. By 1910, the population had almost doubled again to 670,585.

The Boston of 1850 was a walking city with most inhabitants living within a few miles of the town center. The relatively slow horse carts allowed people to live as many as five miles from the center of Boston and still travel to work and to the market. After 1890, the faster and more reliable electric streetcars extended the living space to ten miles from the center of the city. Land for housing was sold along the trolley routes and when the houses were built, people were within walking distance of the streetcar lines. The small towns within a twelve-mile radius of Boston began to grow, eating into farming land. The streetcar network was enlarged—both to create and to meet the demand for housing—further from the center of the city. Roads were laid down. Sewerage, gas, and electric lines were installed, and armies of carpenters, plumbers, and masons were constructing more houses. Schools, churches, and shops were built along the main streets and clustered near the railway stations.

A new downtown Boston developed. This relatively small area consisted mainly of Washington, Beacon, and Tremont Streets and Scollay, Haymarket, and Adams Squares. Here the large department stores, banks, insurance companies, hotels, theaters, clubs, and organizations were established. The streetcars from the suburbs passed through downtown. South Station train terminal and the ferryboat terminals were within walking distance of downtown. Tremont Street was known as Piano Row and had a number of upscale shops, several theaters, and the first Horticultural Hall. Tremont started at Scollay Square and ran west into Roxbury. The imposing Chickering Piano Factory was built at 791 Tremont Street. In 1898, a tunnel was completed under Tremont Street to relieve the severe traffic congestion caused by the numerous streetcars that previously clogged the street.

Washington Street, which was the city's major throughway, became its main shopping outlet. Instead of the stores congregating in a central market, customers could now walk up and down the long street where the new stores were being built. The big department stores, including Gilcrest's, Raymond's, Filene's, R.H. White & Company, Magrane-Huston Company, and W&A Bacon Company, were on Washington Street. William Filene opened stores in Lynn and Salem before opening a dress store on Winter Street in Boston. This was the beginning of the great retailing chain of department stores.

In 1836 the fatherless and penniless fourteen-year-old Eben D. Jordan left his home in Danville, Maine to seek success. He caught the steamer at Portland and arrived at the port of Boston. Within a few years, he set himself up in business on Hanover Street. In 1851 he formed a partnership with Benjamin L. Marsh. The Jordan Marsh Company on the corner of Washington and Avon Streets was the biggest department store in Boston. Jordan also owned a large share of the Globe Publishing Company, publisher of the *Boston Globe* newspaper, and was a major shareholder of both the West End and the Boston Elevated Railway Companies.

Summer Street had wholesale establishments and warehouses. Boston's great wool market was centered on Summer Street. Winter Street was known for retail shops specializing in dry goods and millinery. The Music Hall was at 15 Winter Street and was the early home for the Handel & Haydn Society and the Boston Symphony Orchestra. State and Devonshire Streets housed the Custom House, the Boston Stock Exchange, several major banks, and many of the head offices of the out-of-town industries.

Boston had become a stratified society. The wealthy ship owners, mill owners, bankers, and brokers built their houses on Beacon Hill or along the elegant streets of the new Back Bay. On the weekends and during the summers, they departed to their homes in the country. Theater and music had become a part of their lives, as Boston had many theaters, mostly along Tremont and Washington Streets. The wealthy Bostonians were the major benefactors of Boston's cultural institutions. The Museum of Fine Arts moved in 1909 to its new buildings along Huntington Avenue. Colonel Bigelow Lawrence bequeathed his collection of armor and his wife gave the money to build a wing of the museum. Members of the Appleton family were major contributors to the museum fund and the Lowells donated the first Egyptian antiquities (Williams, 1970).

Isabella Stewart Gardner moved from Beacon Street to her new home at Fenway Court, built in the style of a fifteenth-century Italian villa. In 1903, the building, with its collection of Dutch and Renaissance masterpieces, was opened to the public. Eben Jordan Jr. gave the money to build the New England Conservatory of Music. The elegant Jordan Hall is named in his

honor. Across the street, also on Huntington Avenue, Jordan built the Boston Opera House.

Hotels were constructed near the railway terminals to accommodate the many salespeople coming to town. Fancy hotels such as the Parker House, the Creighton House, Young's, and the Adams House were built downtown. In the Back Bay were the Brunswick, the Hotel Vendome, and the Victoria Hotel. Many business deals were made over lunch in the restaurants of these fashionable hotels. Boston became a place where men gathered in their private clubs. There were dining clubs, literary clubs, sports clubs, and especially clubs for men of business. Some of these met in hotels while others had their own premises, complete with dining rooms and libraries. The Union Club came to occupy the former homes on Beacon Hill of Abbott Lawrence and his neighbor John Amory Lowell. The St. Botolph Club, founded in 1880, attracted men like Henry Lee Higginson, Leverett Saltonstall, Henry Houghton, and George Mifflin, as well as the architect H.H. Richardson, the artist John Singer Sargent, and the sculptor Daniel Chester French.

Status as measured by birth, wealth, and education became important in the lives of the proper Bostonians. The Lowells, Jacksons, Lawrences, and Appletons had left their small hometowns for Boston at the beginning of the nineteenth century and by the end of that century, these families were part of the social elite that formed the Boston Brahmins. Many of the leaders of industry sent their sons to be educated at Harvard University, which has played so important a role in defining the special quality of the city. The Massachusetts Institute of Technology was also the training ground for many a budding industrialist. Boston University began as a Methodist theological school on Beacon Hill, and Boston College had its start in the South End as a Catholic liberal arts college. Tufts University started in Medford with a donation to the Universalist Church and in 1880, Emerson College began in Boston as a school for oratory.

Most of those living in Boston could ill afford these luxuries. The city was full of overcrowded tenements housing workers and their families and the homes of the once-elegant South End became boardinghouses. The families living in these places could afford an occasional burlesque show or a day trip to Revere Beach. It is fortunate that Boston's park system, designed by Frederick Law Olmsted, afforded open space in an otherwise congested city.

There were opportunities for working folks to get a good education and to advance themselves, however. The Young Men's Christian Association (YMCA) opened its first American branch in Boston. The Boston YMCA sponsored courses in art, mathematics, architecture, and law and the response from working people was so great that the YMCA moved to larger quarters along Huntington Avenue. These informal courses grew more academic and the system grew to become Northeastern University.

Population of Selected Eastern Massachusetts Towns and Cities

(U.S. Bureau of Census)

Town (Year Settled)	1850	1900	1910
Boston (1630)	180,475*	560,957	670,585
Brockton (1649)	3,959	40,063	56,876
Cambridge (1630)	15,215	91,886	104,839
Fall River (1686)	11,254	104,863	119,295
Lowell (1821)	33,383	94,696	106,294
Lynn (1629)	14,257	68,513	89,336
New Bedford (1652)	16,443	62,442	96,652

*Includes Charlestown, Roxbury, and Dorchester

In 1800, Boston, with 24,937, was the only Massachusetts town with more than 10,000 people.

Chapter Two

TRANSPORTATION

The transportation system in the Massachusetts Bay Colony reflected the movement of people and commerce from one community to another. The early ascendancy of Boston as the first town and principal port of Massachusetts established a transportation pattern that has continued from the early ferry boats across the Charles River and the dirt paths between the villages to the mass transit systems of our times. The people who settled the Shawmut Peninsula in 1630 maintained contact with their fellow Englishmen, the 1620 settlers of the Plymouth Colony to the south and the 1623 settlers around Salem to the north. As new settlers came from England, the population of Boston grew and new settlements were established up and down the coast and along the banks of the rivers.

FOOTPATHS AND ROADS

The early residents of the Shawmut Peninsula kept close to home and could readily get about their town on foot. Soon, however, a ferry service was started from Boston to Charlestown and Chelsea across the harbor. Another ferry carried people across the Charles River to Cambridge. Oxen and horses were brought over from England and gave the settlers additional methods of transport. Water-powered and tidal mills were established in Roxbury, Dorchester, and Chelsea. Farms were established in Cambridge and the produce was conveyed by wagon to the market in Boston.

At first though, people walked, using paths already established by the Wampanoag Indians. Gradually roads were established between Boston and the other communities. These dirt roads were rutted and travel was slow and difficult, especially in the winter months and after the rains. Travel became a business with the establishment of toll roads, known as turnpikes, where the traveler had to pay a fee to use the road. Magistrates traveled to outlying towns. With the establishment of a national postal service in 1776, riders carrying the mail traveled regularly to the various communities. The towns of the Massachusetts Bay Colony remained largely isolated from each other until after the American Revolution

A map of Massachusetts Bay published in 1780 shows how few roads had been developed during the first 150 years of the colony. The northern road from Boston started with a boat connection over the Charles River to

Charlestown. From there the road led to Chelsea and on to Lynn, Salem, and Beverly before traveling north into New Hampshire. The western road traveled to Cambridge, home to farms and Harvard College, and on to Springfield before heading south along the western bank of the Connecticut River on its way to New York City. The third major road from Boston went west through the Boston Neck and then south to Dorchester, Milton, and Braintree before reaching the old colony town of Plymouth.

The growth in Boston's population after the American Revolution caused people to build their homes further and further away from the town center and for many it was now too far to walk to the market situated near Boston Harbor. In 1793 the first stagecoach ran from Boston over the New West Bridge into Cambridge and soon, stagecoach service was offered to the outlying towns. Roads were improved and turnpikes extended to link Boston to Providence and on to New York. The Massachusetts General Act of 1805 set out a fee schedule for use of the turnpikes. A man and his horse paid 4¢ and a coach drawn by two horses cost 25¢, but it cost only 3¢ to bring a dozen sheep or pigs across the turnpike.

During the 1820s, horse- or mule-driven omnibuses came into use between Boston and the surrounding towns. The Industrial Revolution had arrived and small factories were being built in many of these towns. The omnibus was larger than the stagecoach, carried more passengers, and made several stops along a route rather than traveling non-stop from one town to another as did the stagecoach. By 1856 the omnibus was replaced by the horse-drawn streetcar, which traveled on rails imbedded in the roads. The "horsecar," as it was called, was more efficient than the omnibus as it provided passengers with a more comfortable ride and was less of a strain on the animals.

The first horsecar in Boston started at Bowdoin Square and ran over the New West Bridge into Cambridge, following the route of the former stagecoach. During the next thirty years, horsecar service greatly increased, with some twenty companies competing in Boston and the surrounding towns. In 1887 all these companies were consolidated into the West End Street Railway led by Henry H. Whitney, a real estate speculator. Each horsecar had a driver and a conductor and was pulled by one or two horses, which could work for a couple of hours before needing to rest. Eight to ten horses were used each day for each streetcar, which necessitated a large staff to tend to the animals. The animals often became ill; they needed to be stabled, fed, and groomed. At its peak, the West End Street Railway in Boston had 8,000 horses and mules in service.

By the late 1880s horsecars traversed Boston in all directions with Tremont Street, Bowdoin Square, and Scollay Square as the main junctions. The usual fare was 6¢. From Temple Place, horsecars left every few minutes to connect with the Chelsea ferry and to the towns of Roxbury, Dorchester,

Brookline, and Jamaica Plain. From Bowdoin Square horsecars traveled to Cambridge, Newton Corner, Watertown, and Arlington. From Scollay Square the cars ran to Charlestown, Malden, Medford, Lynn, and Swampscott. Horsecars also linked the center of Boston with the harbor and the steamboats. Horse-pulled streetcars were traveling ten or more miles from the town center—well beyond regular walking distance. Whitney and the West End Street Railway Company developed land for housing along the routes of the horsecars, thus encouraging the expansion of the city well beyond its original peninsula setting.

Since Boston was a compact city, hackneys and horse cabs did not play as large a role as they did in European cities such as London and Paris. Still, cabs were available at the train terminals and ferries and outside the larger hotels. Boston was divided into districts and the fare for a cab or hack varied with the distance traveled. In 1907, hacks charged 50¢ per person within a given district. The price for a cab was only 25¢.

ELECTRIC STREETCARS

In 1889 the directors of Boston's West End Railway went down to Richmond, Virginia, to see the electrified system recently installed in that town. So impressed were they by its efficiency that they decided to convert Boston's horse-drawn system to electrification. Powered by electricity, a trolley could run at twice the speed of a horsecar. Trolleys were also larger and carried more passengers. The first electric streetcar began service on January 1, 1889 and ran from Park Station to Coolidge Corner in Brookline, then up Harvard Street to end at the Allston Depot. As electrification of the transit system expanded, the horsecar era came to its end. By the beginning of 1900 the horses, the stables, the blacksmiths, and the manure were gone. The electric trolleys, running along regular streets and stopping at every corner, offered great convenience and soon became the preferred way to travel. Each streetcar had a driver in front and a conductor who collected the fares. Open cars were used during the warmer months and were replaced by closed cars during the colder weather.

The burgeoning shopping and commercial growth of Boston required a rapid and reasonably priced transit system to bring people from their homes and factories into the city center. Tremont, Washington, and Boylston Streets together with Scollay, Adams, and Haymarket Squares became the downtown. Here were the hotels, shops, banks, and commercial buildings. An estimated half-million people poured each day into the downtown area to shop, work, or transact business. Tremont Street in particular became the focal point for the trolley lines. By 1895, over 180 streetcars per hour were passing the corner of Tremont and Park Streets. Three sets of trolley tracks were imbedded into the street to deal with the huge traffic volume. Tremont became clogged with

trolleys, horsecarts, and pedestrians. Many theaters and other forms of entertainment further increased the magnetic attraction of the city center.

The Boston Elevated Railroad Company built and ran electric streetcars to South Boston, Roxbury, Mattapan, Roslindale, and Dorchester to the south. West of the city streetcars ran to Newton Corner, Watertown, Cambridge, Somerville, and Arlington. To the north the city was connected to Charlestown, Everett, and Medford. Beyond a radius of five miles, the Boston Elevated connected with other electric trolley lines that had spread throughout the metropolitan area and beyond. It was now possible to travel by streetcar from Boston to Worcester and to points further down the line. The northern towns of Salem, Lynn, and Medford and the western towns of Watertown, Newton, Natick, Framingham, and Dedham developed into secondary hubs from which trolley lines spread out to other communities.

In 1894 the Massachusetts State Legislature created the Boston Transit Commission to design and build:

(a) a tunnel starting at Shawmut Avenue, traveling under Tremont Street, through Scollay and Haymarket Squares, and emerging near North Station on Causeway Street. A short branch line would be built under Boylston Street to the Public Garden near Arlington Street. These tunnels were completed in September 1898 at a cost of $4 million. The main tunnel ran 2.25 miles and had five underground stations, with Park Station in the middle.

(b) a tunnel under Boston Harbor from Scollay Square to Maverick Square in East Boston. This tunnel would make it possible for streetcars from the northern suburbs to come directly into the center of Boston. Previously the streetcars stopped near the wharves in East Boston where passengers transferred to ferries to cross the harbor to the city. This under-harbor tunnel was opened for traffic in December 1904. It cost over $3 million to build.

(c) a drawbridge over the Charles River connecting Boston's Causeway Street with City Square in Charlestown. This drawbridge was open for traffic in November 1899. It carried two streetcar tracks, two elevated railway tracks, and space for general traffic. The drawbridge allowed traffic to come directly from Charlestown, Everett, and Malden and cost $1.5 million to build.

The Commission was also to create the Boston Elevated Railway Company with a mandate to build and operate elevated railways in the city of Boston (Cheney and Sammarco, 1997 and 2000).

In September 1896, the West End Street Railway Company signed a twenty-year lease with the transit commission for the use of the subway. Within a year, the West End Railway was in financial difficulties and the transit commission approved the transfer of the lease to the new Boston Elevated Railway Company. With this decision, all streetcars in Boston came under a single management.

Boston's rapid transit subway, which opened in September 1897, was the first in the United States. New York followed in 1904 and Philadelphia came soon after in 1907. The Boston street transit system, with its new subway, tunnel, and bridges, was an early success. Congestion on Tremont Street and at Scollay and Adams Squares was much reduced. Some twenty-seven routes converged on Boston like so many spokes of a wheel. By 1901, 210 streetcars *per hour* were stopping at Park Street Station without serious backups. Passengers riding from ten miles away could now reach the center of Boston's business district in less than one hour. Also, the streetcar lines ran close to North and South Stations, thereby serving riders from all over New England and beyond. With the opening of the Maverick Square tunnel (1904) under the harbor, streetcars could now travel directly from the northern towns into the center of Boston.

THE BOSTON ELEVATED RAILWAY SYSTEM

In June 1901 the Boston Elevated Railway Company opened its rapid, state-of-the-art transit system. The elevated lines ran south of the city center from Dudley Street in Roxbury and ended at Sullivan Station in Charlestown, to the north. The larger cars of the elevated system could carry many more passengers than the single street trolley cars. The street trolleys conveyed passengers from the burgeoning suburbs who then entered the elevated trains to travel into Boston, or bypassed the city center. The Dudley Street Station became the destination point of trolleys coming from Hyde Park, Dorchester, Roslindale, Roxbury, and Dedham. The Sullivan Square Station had direct trolley connections with communities to the north of Boston such as Cambridge, Somerville, Medford, Malden, Arlington, and even Lowell. At Sullivan Square Station, a passenger could leave the elevated train and walk along the same level of the station to connect with a trolley car.

The "Boston El," as it was affectionately called, was the largest construction project in the history of the city. Construction began in January 1899 and the huge project was completed two and a half years later. Seven miles of elevated railway with ten stations were built. The terminals at Dudley Street and Sullivan Square were completed, as were the electricity-generating plant to run the system and two large repair shops. One hundred and fifty cars were purchased. Along some routes, the tracks of the regular trolley system ran on street level between the metal supports of the elevated railway.

From the Dudley Street Station, the El ran in a northeasterly direction above Washington Street. The El ran alongside the new South Station and continued along Atlantic Avenue, offering a fine view of Boston Harbor with its wharves, ferries, and ships. The elevated station at Rowe's Wharf linked the rail system with the steamers sailing from Nantasket, Plymouth, and Provincetown, as well as the ferries from East Boston. The El then followed

the curve of Commercial Street before turning north to cross the new bridge over the Charles River. Here it connected with North Station. The El then traveled toward Charlestown and on to Sullivan Square.

The Washington Street Elevated Railroad was connected to the Tremont Street subway. Modifications were made to the rail bed and the subway stations to accommodate the larger elevated trains. This system did not quite work out and, in 1902, the Boston Transit Commission decided to build a new subway for cars of the elevated system, under Washington Street from Broadway to Haymarket Square. This second tunnel permitted the Tremont Street subway to revert back to trolley use only. By the beginning of the 1900s, Washington Street had become the center of Boston's shopping and entertainment. The Washington Street tunnel ran parallel to the Tremont Street tunnel and was opened to traffic in November 1908.

INTEGRATED RAPID TRANSIT SYSTEM

The combination of streetcars and elevated trains coming from the suburbs into Boston created a highly developed rapid transit system. The whole system was under the authority of the Boston Elevated Railway Company and was interconnected and interchangeable. A single fare of 5¢ carried a passenger from any one point to another within an area of one hundred square miles. The company owned nine miles of elevated track, five miles of subway, and 215 miles of surface lines. It operated 450 cars and employed 8,000 men. In 1908 it carried 398 million passengers. The major stations were at Adams and Scollay Squares, Park Street, Copley Square, North and South Station, Dudley Street, and Sullivan Square. The major suburban terminals included Arlington, Brookline, Cambridge, Roxbury, Chelsea, Dorchester, East Boston, South Boston, Jamaica Plain, Malden, Medford, and Newton. To this elaborate city and suburban transit system was added the steam railway traffic in and out of North and South Stations, as well as the extensive ocean-borne traffic from Boston Harbor.

Over time, Atlantic Avenue Elevated use declined. This was partly due to traffic being diverted along the Washington Street Tunnel, but was also the result of the decline of Boston as a port. Without doubt, the automobile played a part as well. The Atlantic Avenue Elevated was closed in 1938 and demolished in 1942. The suburban electric streetcars suffered a similar fate under the onslaught of trackless trolleys and private automobiles. The small trolley car companies could not run independently, so companies such as the Boston & Newton and the Lynn & Boston folded into larger systems. To the northeast and south of the city the various trolley car companies merged into the Bay State Railway Company, while to the northwest and west the smaller companies coalesced into the Middlesex & Boston Railway. By the 1920s even these larger companies declined under the onslaught of the automobile. However, much of the streetcar system—including the subways under

Tremont Street and the tunnel under the harbor—is still in use today and is incorporated into the system of the Massachusetts Bay Transit Authority.

FERRIES, BARGES, SAIL, AND STEAMERS

A 1775 map of Boston Harbor shows the Shawmut Peninsula with its narrow neck leading to the village of Roxbury. Across the Charles River the towns of Charlestown and Cambridge already had sizeable populations, and there was a small settlement at Winisimmit (now Chelsea). These communities were linked to Boston by a regular ferry service. The sparsely-populated harbor islands— Governor's, Castle, Deer, Noddle's, Hog, Thompson's, and Long Island— were accessible by boat. The map shows the route from the harbor to the open sea. Vessels of up to sixty tons navigated the Mystic and Charles Rivers to serve the communities upstream.

In 1793 John Hancock, as the governor of Massachusetts, approved a plan to build a canal connecting Boston with the Merrimack River to the north. The twenty-seven-mile-long Middlesex Canal was regarded in its time as an engineering wonder. When completed in 1803, the canal had twenty locks, forty-eight bridges, and eight aqueducts. It was key to the development of East Chelmsford on the Merrimack River, which later developed into the mighty textile city of Lowell. People in Boston who wished to travel up the canal would first cross over into Charlestown to meet the canal boats at the passenger terminal. Freight boats carrying farm products, raw cotton, wood, coal, and salt as well as manufactured goods plied the canal. The boats were attached to ropes and pulled by horses walking on the path alongside the canal. One man would guide the horse and the second would steer the boat. The boats traveled within a limit of four miles per hour.

The canal ride was a source of delight for these early travelers, especially when the boats entered the locks or traveled over the viaducts. The aqueduct over the Shawsheen River was a special treat, rising some thirty-five feet to cross over the river. During the summer months families would travel the canal, stopping along the way to stroll or to spend a few days at one of the taverns. The Middlesex Canal was later extended to link Boston with the rivers of New Hampshire and brought timber and farm produce from the north to Boston. The canal remained a financial success until the opening of the Boston & Lowell Railroad in 1835, when its use declined until it was finally closed in 1853.

From its early days, Boston maintained contact with the outside world by sea. Trade was developed with Asia, the West Indies, and South America. Before the American Revolution, Boston was the largest port in the American colonies. Ships carried lumber, rum, tobacco, paper products, and salted fish to England and returned with English finished goods. From the West Indies sugar and molasses were shipped to Boston, where the sugar was refined and rum was made for export.

THE GREAT WORKSHOP

Boston and Salem became the major ports for the China trade. Looking for a commodity to sell, the Boston merchants decided to carry furs and otter skins to China. This involved a very long sailing journey south along the North American and South American coasts, around Cape Horn, and then up the western coasts to the northwest of North America. Here they bargained with Indian tribes to buy the fur skins, which they carried to Canton. In Canton, they sold the skins and returned to Massachusetts with tea, textiles, dinner and tea sets, and porcelain, as well as cases of silks. On their journey, these small ships would stop for supplies in the Falkland Islands, Galapagos, and Hawaii. The risky and arduous journey from Boston to China and back could take two to four years to complete.

In 1806, 1,083 sailing ships arrived in Boston Harbor from foreign ports (Morison, 1961). The pace of trade increased in the years to come. By 1844 an average of fifteen vessels entered or left Boston Harbor each day. The harbor became the dominant port in Massachusetts and its rise led to the decline of the ports of Salem and Newburyport. Central Wharf and India Wharf were lined with warehouses and the offices of the many mercantile firms coping with the flow of merchandise in and out of the harbor.

The railroads, which later connected Boston with the rest of the country, increased the importance of the harbor. Despite the shift of money into manufacturing, the established merchants and ship-owners held sway over Boston life well into the nineteenth century. Cotton and woolen textiles from the mills in Lowell and Lawrence, as well as footwear from Brockton and Lynn, were shipped from Boston Harbor to markets all over the world.

Boston is some 200 miles closer to European ports than is New York. In the era of sailing ships this was helpful to the city, but as the ships grew bigger and faster, this small advantage became less important. After 1820 the enormous growth of the textile business in Massachusetts greatly increased the flow of raw cotton and wool through Boston Harbor. Numerous brokerage firms set up shop near the Custom House and, after the fire of 1872, along Summer Street. By the first decade of the twentieth century, Boston Harbor handled half of the total wool imports to the United States and Boston became, after London, the world's largest wool market. Boston was also a world center for the importation of leather and the marketing of shoe and leather products. It was the largest center in the United States for the paper trade and one of the world's largest fishing ports. The building of a huge fish processing plant, with its up-to-date refrigeration, further enhanced the importance of Boston Harbor. Pianos, organs, clocks, silverware, ventilating equipment, locomotives, rum, biscuits, and numerous other products manufactured in factories in and around Boston were sent through Boston Harbor to markets in America and throughout the world. But after the American Revolution, the port of New York began to eclipse Boston in

international trade. In the nineteenth century the ports of Philadelphia and Baltimore also began to compete, but as late as 1900 Boston still remained the second largest port, with one-fifth of the nation's total export tonnage.

Befitting a major city, passenger travel grew apace with commercial shipping. On June 2, 1840 Samuel Cunard's ship, the 700-ton *Unicorn*, entered Boston Harbor to begin a regular transatlantic service. Soon afterwards the *Britannica* entered the harbor with Cunard on board. A "Cunarder" left every other Tuesday from Boston to Liverpool. In 1908, a first-class cabin cost from $75 to $175 for a one-way trip. The second-class fare was from $42 to $57. Having Cunarders arrive in town every two weeks was a thrill to the locals and a rare comeuppance to New York.

By the early years of the twentieth century the White Star and Leyland shipping lines were also making regular stops in Boston. Steamships of the White Star Line sailed from Liverpool to Boston once or twice a month (first-class cabin from $72 and second-class from $40) and the Leyland line sailed every Saturday from Liverpool to Boston (cabins from $67). The ocean passage took from five to nine days. The Cunard and Leyland steamers docked in East Boston while the White Star steamers docked in Charlestown.

There was also traffic from European ports such as Hamburg and Genoa. The ships of the Hamburg-America line berthed at the Commonwealth Pier in South Boston. The North German Lloyd line and the Italian Line tied up at the B&A pier in East Boston. The Red Star Line came from Antwerp and docked in Charlestown, as did the Sweden-Norway line. Steamers regularly plied between Boston, New York, Philadelphia, Providence, and Baltimore to Portland, Halifax, Yarmouth, and St. John. Boats carried passengers to and from the Massachusetts towns of Provincetown, Plymouth, Nahant, and Revere. From Rowe's Wharf ferries ran to Nantasket Beach, Hull, and Hingham. Other ferries crossed Boston Harbor from East Boston and Chelsea. (The fare was 3¢.)

The Fall River Line built a thriving overnight service from Boston to New York City via Fall River. Its fleet of steamships included the *Priscilla*, *Puritan*, *Providence*, *Pilgrim*, and the *Commonwealth*. These steamships offered luxury accommodations for the overnight trip to Pier 28 in New York. Passengers could enjoy a good meal in the restaurant before dancing to the music of the ships' orchestras. The cabins offered a good night's sleep before arrival the next morning in New York. The line ran from 1847 until 1937.

In 1907, 2,808 vessels (not including coastal vessels), carrying goods weighing over five million tons, entered or cleared Boston Harbor. Goods entering the port that year were worth $123 million and as much as $105 million worth of goods left the port. Wool, cotton, hides, and sugar were the main imports, and machinery, textiles, ready-to-wear clothing, and shoes were the main exports.

The proximity to Europe and the presence of a number of shipping lines coming to Boston made the city a port of entry for many thousands of immigrants. From 1821 to 1840, some 30,000 people from foreign lands arrived at the port of Boston. The number of immigrants arriving greatly increased during the twenty-year period from 1840 to 1860. In fact, over 300,000 immigrants arrived; 163,000 came from Ireland and 45,000 were from England, Scotland, and Wales. The Irish immigrants to Boston were but a stream in the flood that saw over two million Irish leave their homeland during that period. Immigration from Ireland began to decline after 1860, but it was soon followed by people arriving from eastern and southern Europe (Handlin, 1972). Between 1850 and 1910, over thirty million immigrants arrived in the United States. The port of Boston began to decline as a center of immigration when the federal government decided in 1890 to center immigration procedures at Ellis Island in the port of New York.

RAILROADS

In 1825 a steam-driven engine designed by George Stephenson pulled the first public passenger train along a rail bed from Darlington to Stockton in England. The great era of mechanized rail travel was beginning. Within five years railway networks were being developed all over the United States. By 1907 the United States had 286,000 miles of railway, more than half the total mileage of the whole world.

In June 1830 the Boston & Lowell Railroad was incorporated. This line would link Boston to the major textile manufacturing center thirty miles north on the Merrimack River. The following year the Boston & Worcester Railroad and the Boston & Providence Railroad were also incorporated. It took until 1835 before these three railway systems were completed. In 1839 the Eastern Railroad from Boston to Salem was opened, and in 1845 the Boston & Maine Railroad, the Boston & Fitchburg Railroad, and the Old Colony line from Boston to Plymouth were operative.

By 1845 Boston was the terminus of seven separate railroad systems. These railroads linked Boston with the major cities and the new centers of industrial development. These lines were soon extended, linking the city to the whole of New England, New York, and farther afield. By the end of 1840 the Commonwealth of Massachusetts had almost 300 miles of railroad with Boston as the hub. Twenty years later 1,220 miles of rail were in use in the state. One after another the newly-industrial towns of Beverly, Lynn, Waltham, Brockton, Fall River, and Taunton joined the rail network. Industrial goods could readily be carried from the factories to locations all over New England. They were also being shipped abroad through Boston Harbor. Cotton, wool, leather, and other raw materials made their way by rail from Boston Harbor to the factories.

Transportation

The railroads shaped the development of Boston. Grand stations were built by the railroad companies, and bridges were constructed over the Charles River to carry the trains. The terminals for the northbound trains were sited at the causeway near the present site of North Station and the trains from the south and west ended at terminals near the present South Station. Hotels and shops were soon to follow. The Boston & Worcester Railroad ran its trains on top of the Mill Dam. When the Back Bay was developed during the second half of the nineteenth century, its major roads, including Commonwealth Avenue, would run parallel to the tracks of the Boston & Worcester Railroad.

NORTHBOUND RAILROADS

The Eastern Railroad linked Boston with the growing communities to the north. It connected the city to Somerville, Chelsea, the shoe town of Lynn, and the towns of Salem and Newburyport. This line was later extended to Portland, Maine and to the rail network throughout the state of Maine. The Boston & Maine Railroad linked Boston to the textile town of Lawrence and the shoe town of Haverhill before crossing the state border into New Hampshire and on to Maine. The Boston & Lowell Railroad took forty-five minutes to travel the thirty miles between Boston and the textile-manufacturing city of Lowell. The Boston & Fitchburg Railroad had its terminal on Causeway Street in Boston. From there it crossed the Charles River to Cambridge and the early textile town of Waltham before reaching the paper mill town of Fitchburg. The railway line was later extended west of Fitchburg to connect with Troy and on to Albany, New York. Along its route, near the town of North Adams, the railroad entered the Hoosac Tunnel. This tunnel runs through the Hoosac Mountain for almost five miles. It was completed in 1875, after twenty years' effort and at a cost of $16 million. In its time, the Hoosac Tunnel was the longest rock tunnel in the country.

SOUTHBOUND RAILROADS

The Boston & Providence Railroad was incorporated in 1831 and was open for traffic four years later. Its Boston terminal was at Park Square. South of Mansfield a branch of the Boston & Providence traveled to the whaling town of New Bedford and from Providence the main line connected with New York. By 1890 four trains a day in each direction ran between Boston and New York. The *Daily Express* left Boston at 10:00 a.m. and arrived in New York at 4:30 p.m. The *Afternoon Service* left Boston at 1:00 p.m. and arrived in New York six-and-a-half hours later. This train had a dining car. The *Gilt Edge Limited* left Boston at 5:00 p.m. and arrived in New York only six hours later. The *Midnight Express* left Boston at midnight and took a leisurely seven hours to reach New York, but offered sleeping cars.

The Old Colony Railroad opened in 1845 with a Boston terminal on Kneeland Street. This railroad ran to the east of the Boston & Providence and served the many communities to the south, including the growing textile town of Fall River. From Fall River, trains traveled south to Newport, Rhode Island where passengers could board the ferry to New York City. The Old Colony Railroad also served Cape Cod.

WESTBOUND RAILROADS

The Boston & Worcester Railroad was incorporated in 1831 and opened for traffic in 1834. Its Boston terminal was at the junction of Lincoln and Beach Streets. The line traveled due west on the Mill Dam well before the Back Bay was filled. As a result, the plans for this new residential area were designed to accommodate the existing rail tracks. This line served the towns of Newton, Wellesley, and Framingham before reaching Worcester. As the state's second city, the industrial city of Worcester became a secondary hub, with connections to Providence and Springfield.

A second westbound rail system traveled from Boston to the cotton mills along the banks of the Blackstone River. It was known as the Boston & Woonsocket Railroad. By 1845 the town of Woonsocket, Rhode Island had over twenty cotton-spinning mills and a population of over 13,000. Near Woonsocket were the Massachusetts mill towns of Uxbridge, Bellingham, and Medway, and the cotton-machinery factory at Whitinsville. When the railroad was completed in 1851 it ran from Boston to Newton, crossing the Charles River at Newton Upper Falls and making three stops in Needham before heading southwest to reach Woonsocket. The cotton industry in Woonsocket lay within the economic orbit of Providence and the owners of the Boston & Woonsocket line hoped to attract some of this business to Boston. The railroad also linked Boston to the gristmills, sawmills, paper mills, and cotton mills as well as the ironworks at Newton Upper Falls. The railroad stopped at Charles River Village where there was a large paper mill. New industries and villages sprung up near the railway stations to be close to the transportation network.

These privately-held railroad companies could not succeed long as separate systems, so over time the Boston & Maine came to dominate rail traffic to northern New England. In 1884 the Eastern Railroad became part of the Boston & Maine. Three years later the Boston & Lowell joined and, in 1900, the Boston & Fitchburg system was included. Over one hundred separate railroad companies were absorbed into the Boston & Maine. The railroads coming into Boston from the west and the south also went through dizzying amalgamations and name changes. By the beginning of the twentieth century only the New York, New Haven & Hartford Railroad and the Boston & Albany Railroad had survived.

RAILWAY TERMINALS

With the merger of the railway companies, the need for seven separate terminals declined. Eventually two large terminals served Boston. The South Union Station at the corner of Atlantic Avenue and Summer Street was completed in 1898 at a cost of $14 million and was one of the largest railway stations in the world. The terminal served communities to the west and south of the city and was 810 feet long and 700 feet wide, covering an area of eleven-and-a-half acres. The station contained twenty-eight tracks used by the New York, New Haven & Hartford and the Boston & Albany Railroads. Over 400 trains entered and left each day. The station was connected both with the Boston Elevated and the streetcar lines, and served as the southern and western gateway to the city. By 1910 an average of 120,000 people a day passed through the station. This terminal was located near the numerous warehouses and brokerage companies huddled along Summer Street and was close both to the downtown and to the port of Boston.

The North Union Station on Causeway Street had a smaller but still impressive façade, with a frontage 370 feet wide. It was the terminal for the trains of the Boston & Maine and connected Boston with northern New England. It contained twenty-two tracks. In 1910, about 95,000 people each day passed through North Station. The streetcars stopped across the street from the station allowing passengers easy access to the center of the city and points beyond.

INDUSTRY IN BOSTON

O.L. Stone's 1930 book *The History of Massachusetts Industries: Their Inception, Growth and Success* is a major resource on the history of industry in Boston and the rest of Massachusetts, and is the source of much of the following information.

The original town of Boston had relatively little industry before the Civil War, as the lower reaches of the Charles River were too sluggish to offer the power to drive mills. The incorporation of the towns of Roxbury, Roslindale, Charlestown, West Roxbury, and Dorchester between 1866 and 1873 brought a good deal of established industry within the boundaries of The Hub, since small factories were built in these towns to take advantage of the local streams. Yet in 1630 John Harrison had no sooner arrived in the New World than he started making ropes. Gristmills and sawmills were established in Roxbury as early as 1633, and Daniel Henchman, a bookseller and publisher, erected a paper mill in Dorchester in 1730. In 1728 the king of England gave a charter, which included "a monopoly on the business of paper manufacturing in the Colonies forever," to the Tileston-Hollingsworth Mill along the Neponset River. This mill in Hyde Park is the oldest continuously operating paper mill in the country.

From its beginning, Boston, perched on the narrow Shawmut Peninsula, looked to the sea for its sustenance. In December 1783, the sloop *Harriet* left Boston Harbor with cargo for China. Soon Boston merchants were fitting out their ships for the long journey south around the Americas and on to the northwest coast in search of furs, which were then sold in Canton. On their return, these little ships brought back tea, crockery, and exquisite textiles that were sought after by Bostonians.

In the eighteenth century shipbuilding in Boston grew very rapidly and trade routes were established with England and the British West Indies. The ships took dried fish and lumber to markets abroad and returned with finished goods from England and sugar from Jamaica. Later, the port handled shipments of raw wool, cotton, and leather, which were sent to the mills and factories in Lowell, Lawrence, and other industrial towns. The ships carried the goods manufactured in the industrial towns of Massachusetts such as machinery, textiles, shoes, and ready-to-wear clothing. Many a Boston fortune and many beautiful homes on Beacon Hill were built on the trade with the West Indies and China (Morison, 1961).

The industries in Boston grew out of humble beginnings and made adjustments to changes in fashion and technology over time. A small gristmill was the forerunner of a major chocolate manufacturer. A small shoe shop grew to become a large factory. Jenny Manufacturing Company began in 1818 as a dealer in whale oil and an importer of goods from the West Indies. In 1856, Isaac and Stephen Jenner built a small factory in South Boston to refine camphene mixed with alcohol to make a "burning fuel," which could be used to light lamps. Jenner later became a major gasoline company.

Many other companies were not as economically swift and were either bought up by stronger competitors or fell into bankruptcy. Most of the companies described in this section were physically located in 1880s Boston (including the incorporated towns of Roxbury, Roslindale, Brighton, West Roxbury, Charlestown, and Dorchester). Several other major industries were started in Boston but moved across the Charles River to Cambridge, Somerville, and Malden. Some relocated across the harbor to Chelsea and Everett.

PIANO FACTORIES

Piano playing at home was a major source of entertainment before the coming of the phonograph and many piano companies sprung up throughout the United States to meet the demand. The piano makers in and around Boston were among the first to use factory methods to manufacture a large amount of instruments.

Jonas Chickering was born in 1798 in Mason Village, New Hampshire. He came to Boston at age twenty and worked as a cabinetmaker before joining John Osborne to make pianos. Later Chickering went into a partnership with John Mackay, a wealthy businessman and sea captain. The partnership lasted until 1841 when Mackay was lost at sea on a voyage to South America with a cargo of Chickering pianos. The success of the Chickering piano was assured after winning a medal at the Great Exhibition of London in 1851. To cope with the increased demand, Chickering built a piano factory at Washington Street, where most of the theatres and concert halls were located. This building was destroyed by fire, and an even larger factory was completed at 791 Tremont Street in the South End in 1854. It was said to be the second largest building in the United States. (The Capital Building in Washington, D.C. was the largest.) When Chickering's sons took over the piano business, it became known as Chickering & Sons. After the Civil War, the Chickering factory was producing nearly 2,000 pianos a year and had developed a serious rivalry with the Steinway Company. Chickering perfected the quarter grand piano, which was suitable for smaller rooms. The Chickering Concert Hall, near Symphony Hall, was built by the company to showcase its pianos.

Henry Mason was the son of composer Lowell Mason, who was the head of the Boston Academy of Music. Henry was an accomplished musician and

formed a partnership with Emmons Hamlin, who was more concerned with the mechanics of sound. In 1854 their company, Mason & Hamlin, started to build organs in factories in Boston and Cambridge. The factories were building 200 organs a week for sale all over the world. When the reed organ became less popular, the company switched in 1882 to the production of pianos.

Woodward & Brown, founded in 1845, assembled pianos in its factory at 387 Washington Street but used other companies to build some of the components. The legs of the pianos were made in a factory in Rutland, Vermont. The keys were built in Canton, Massachusetts. The "actions" were made in Winchester and the cases were made in the company's own mill.

The George Steck Piano Company, founded in 1857, operated out of a plant on the Neponset River. Its pianos received first prize at the Vienna Exposition of 1873. Both Richard Wagner and Franz Liszt played on Steck pianos and are said to have been very pleased by the sound.

Yet another Boston-based piano manufacturer was the Henry Miller & Sons Company. Miller started building pianos in 1863 in his factory at 611 Washington Street and his sons Henry Jr., Walter, and William eventually entered the business. All three sons were graduates of the Massachusetts Institute of Technology. The company was famous for its innovations and designs, developing a small grand piano and a portable player-pianola.

Hallet & Davis Piano Company was one of Boston's oldest piano companies, dating back to 1839. Its pianos were built in a six-story factory and sold out of its showrooms on Tremont Street. The Smith American Organ and Piano Company was located at 531 Tremont Street.

In their time these high-quality piano companies offered employment to hundreds of skilled workers in large factories, but the coming of music-making devices and other forms of entertainment eroded interest in learning and playing the piano. Early in the twentieth century both the Mason & Hamlin and the Chickering companies were absorbed into the American Piano Company. In 1929 production moved to Rochester, New York and the Boston factories were closed.

Other types of musical instruments were manufactured in Boston. William Cundy came to Boston from England in 1855 and started a business selling imported clarinets. Soon afterwards, the Cundy-Bettoney Company started to manufacture clarinets, piccolas, and flutes out of its store on Hanover Street. The company later moved to Hyde Park and added the production of brass instruments. It folded during the Great Depression.

Music-Making

In Boston the manufacture of musical instruments went hand in hand with the development of the arts. Music and theater from England and the Continent found a receptive ear in early nineteenth-century Boston. The Boston Theatre

at 100 Washington Street opened on September 11, 1854 with a performance of *The Rivals*. The building seated 3,100 people and was, for the next half-century, Boston's main stage for drama and opera. Some forty other theatres were built in Boston during the second half of the nineteenth century, offering the burgeoning population a wide range of theatrical performances from burlesque to Shakespeare.

Boston Symphony Orchestra, playing in its grand Symphony Hall, became the center of the city's cultural life. Chickering Hall (1901), owned by the piano company, was on Huntington Avenue next to Horticultural Hall and across the street from Symphony Hall. In 1912 Chickering Hall was renamed the St. James Theatre. The New England Conservatory of Music moved in 1902 into its new buildings at the corner of Huntington Avenue and Gainsborough Street, only a block from Symphony Hall.

PUBLISHING

Boston's first newspaper—the *Boston News-Letter*—appeared in 1704. The paper was published by John Campbell. A rival paper, the *Boston Gazette*, was launched by William Booker in 1719. Booker hired printer James Franklin to produce the paper for him but Franklin lost the contract two years later and decided to bring out a paper of his own. He was a pretty independent sort and published an anti-establishment weekly, the *New England Courant*.

James Franklin happened to be the older brother of Benjamin Franklin, who was born in Boston on January 17, 1706 and grew up along the Charles River. At age twelve Benjamin started working as an apprentice printer in James's shop. Despite his limited education, young Ben Franklin had literary ambitions. Starting in April 1722, he began submitting pieces for publication in the *New England Courant* under the name of "Silence Dogood." These witty, homespun articles appealed to James, who thought them to be written by an elderly but wise widow, little imagining that they were written by his teenage brother. Ben found his brother to be "harsh and tyrannical," and decided to run away to Philadelphia where he began his illustrious career as a printer.

Little, Brown & Company, Houghton & Mifflin, and Ginn & Company had their head offices in Boston, but their factories were in Cambridge. William David Ticknor started his publishing business in 1832 in the Old Corner Bookstore at the corner of Washington and School Streets in Boston. He formed a partnership with James T. Fields. Ticknor & Fields published the works of Dickens, Longfellow, and Emerson. The firm published Henry Thoreau's *Walden*, *Cape Cod*, and *The Maine Woods*, and did much to enrich American cultural life in the nineteenth century. In 1867 the publishing house moved a few blocks away to 124 Tremont Street. In addition to books, Ticknor & Fields published magazines. In the 1850s George Tickor was head of a committee to raise funds to build the Boston Public Library.

In the publication of sheet music and musical magazines, the Oliver Ditson (1836) and the White-Smith (1867) publishing companies stand out. Ditson was the organist and choirmaster at the Bullfinch Street Church. His publishing house was in a five-story building on Washington Street with branches in Chicago and New York City. Charles White and his partner W.F. Smith published popular songs and issued catalogs. The business started on Washington Street and later moved to Stanhope Street.

The W.S. Best Printing Company moved to 530 Atlantic Avenue and printed magazines, books, and maps as well as railway timetables and Boston hotel menus. A major literary magazine was launched at a dinner meeting of the Saturday Club at the Parker House on May 5, 1857. Present were some of Boston's literary giants, including Ralph Waldo Emerson, Henry Wadsworth Longfellow, and Oliver Wendell Holmes, who agreed to start a literary and political magazine to be called *The Atlantic Monthly*. The magazine had its offices at 8 Arlington Street and James Russell Lowell was its first editor.

LOCOMOTIVES AND OTHER MACHINES

In 1826 Holmes Hinkley rented an old building on Camden Street, located at Boston Neck. In this former horse stable, he set about making machines. Locomotives were soon all the rage and, in 1840, Hinkley began to build steam locomotives. His first locomotive was bought by the Eastern Railroad and traveled for many years between Boston and Newburyport. The Hinkley Locomotive Company—later known as the Boston Locomotive Works—was located at 439 Albany Street and later moved to 552 Harrison Avenue in the South End. It was established in 1841. It employed up to 500 workers and built over 600 engines before it closed.

John Souther worked for six years at the Boston Locomotive Works before starting his own ironworks. This developed into the Globe Locomotive Works at the corner of A and First Streets in South Boston. This company employed up to 600 men and built twenty to thirty locomotives a year. The steam shovels, used to load gravel from Needham onto the railroad cars to fill the Back Bay, were built at John Souther's factory.

Benjamin Franklin Sturtevant (1833–1890) was the son of a Maine farmer who left home in his teen years to become a shoemaker. While still a young man he began inventing machinery for the manufacture of shoes. He set up a factory in New Hampshire and made wooden shoe pegs, but the workers complained that the dust created by his machinery was affecting their health. So Sturtevant set about to design a method to remove this dust and in 1864, after many experiments, he developed a rotating exhaust fan to remove factory dust. Some ten years later he built two large factories, one in Jamaica Plain and the other in Hyde Park. In short order, the B.F Sturtevant Company became the world's largest manufacturer of industrial exhaust fans. The Boston factory

employed over 2,800 workers with branches in New York, Philadelphia, Chicago, and London.

In 1882 Sturtevant hired Eugene Noble Foss as director of manufacturing. Foss (born in 1858), who came from Vermont, was soon promoted to the position of general manager of the Sturtevant Company. In 1884 he married Benjamin Sturtevant's younger daughter Lilla. After Sturtevant's death Foss was elected president of the company and under his leadership it produced the American Napier automobile from 1904 to 1909. The company moved beyond exhaust fans to include vacuum cleaning, air-conditioning, and water-cooling systems. Sturtevant provided the air conditioning and blowers for New York's Holland Tunnel. During World War I Sturtevant built military aircraft for the U.S. navy and army. Additional factories were built in Framingham, Massachusetts, and in Wisconsin. The company was sold in 1945 to the Westinghouse Electric Company and the manufacturing of Sturtevant fans was shifted out of Boston to other cities. Sturtevant closed in 1989, bringing 130 years of business to an end (Tocco, 2003).

Eugene Foss resigned from the Sturtevant Company to devote himself to politics. He served as the governor of Massachusetts from 1910 to 1913 and was governor when the textile workers of Lawrence went out on the Bread and Roses Strike of 1912. Foss dispatched twelve companies of Massachusetts militia to Lawrence to control the crisis. He threatened to pull the troops out unless the mill owners agreed to improve the workers' conditions. After he failed in his bid for reelection, Foss returned to private life. He died in 1939 and was buried in Forest Hills Cemetery in Jamaica Plain near the Sturtevant family plot.

The Hawes and Hersey Company, making general machinery and specializing in the manufacture of rotary pumps, was founded in South Boston in 1859. Its equipment was used in sugar and soap processing and the company built the first steam-driven fire engine for the city of Boston. The Hersey water meter was first sold in 1885 and was still produced in Boston for the next one hundred years. (Hersey water meters are still sold throughout the United States under the banner of the Mueller Group.)

The Bay State Iron Company, also sited in South Boston, manufactured rails for railroads. In 1862 a shipment of iron rails from the company left Boston for a journey around the horn of South America to be laid by the Central Pacific Railroad from Sacramento City and to the goldrush town of Colfax, California. In 1866 another order of rail was sent on the clipper ship *California*. It traveled the same sea route and was laid between Colfax and Donner Summit.

The shovels to lay the rail bed and to dig the gold were manufactured by the Ames Shovel Company of Easton, some twenty miles south of Boston. This company was founded by Oliver Ames. His oldest son Oakes expanded the business and played a major role in the building of the Union Pacific Railroad,

which featured prominently in the California Gold Rush. Ames shovels were made from the metals produced by the Bay State Iron Company.

Yet another South Boston machine shop was the City Point Works, which was owned by Harrison Loring (1822–1907). Loring was born in Duxbury, Massachusetts. He built machines and boilers and started one of the first shipyards devoted to the construction of iron steamships in the United States. The merchant ships built at the Loring Yard included the *Massachusetts*, the *South Carolina*, the *Merrimac*, and the *Mississippi*. During the Civil War the yard built several ships for the navy and in the early 1890s the Loring yard built the cruiser U.S.S. *Marblehead*. Loring got into financial difficulties and the shipyard was closed in 1894. The remaining assets were sold at auction.

The Hunt-Speller Company on Dorchester Avenue made cast shot and cannons that were used in the War of 1812. Later the company made the rails for the Boston & Albany Railroad.

The Walworth Manufacturing Company was founded in 1842 by James John Walworth and his brother-in-law Joseph Nason. The two men started out in New York but moved to Boston to manufacture iron tubing to be used in the heating industry. The company had a ready market installing boilers and steam-heating systems in the large mills, as well as in hotels, large buildings, and ships. The science of central heating was still in its infancy and the conventional stoves and hot-air furnaces were insufficient to heat large spaces. The Walworth Company built coiled piping into a small space, which was the prototype of the radiator. The company also developed central ventilation systems using steam power. These innovations were welcomed in hotels, theaters, churches, and private homes. Its equipment was used to heat Boston City Hospital and the White House. The Walworth Company found markets for its products throughout the United States, as well as in Europe and South America. A large manufacturing plant was built in Cambridgeport across the Charles River from Boston. The company was highly innovative and expanded into equipment for electric streetcars, steam boilers, air and water pumps, laundry machines, and other products. The Stillson wrench was developed by Daniel C. Stillson while he was working as a mechanic for the Walworth Company. After World War II the Walworth Company left Boston and moved to Texas, where it continues to make valves.

In 1855 George Walker opened a store in Boston selling kitchen ranges and stoves. He joined with Miles Pratt, who manufactured stoves in his foundry in Watertown. The Walker and Pratt Manufacturing Company was a major supplier of kitchen equipment and produced the Crawford-brand cooking range.

SHIPBUILDING

In the era from 1790 to 1812, much of the commerce from Boston was carried by ships. These vessels were small, measuring around one hundred feet long

by thirty feet wide, yet they sailed as far away as South America and China. Boston competed with Newburyport, Salem, and other Massachusetts coastal towns in the building of these ships. In nearby Medford, along the Mystic River, ships were built using the wood of local oak trees. Boston and Charlestown shipyards concentrated on building naval ships, including the now venerable U.S.S. *Constitution*. The commercial fleet out of Boston Harbor soon grew much larger than the fleet in Salem.

The growth of population in the original Shawmut Peninsula offered little space for boat building. Boatyards, including that of Samuel Hall, developed across the harbor in East Boston (Morison, 1961). In 1844 thirty-four-year-old Donald McKay left Newburyport and opened his boatyard in East Boston. Other shipbuilders followed McKay, and the glorious age of Boston's shipping had begun. Timber for ships was carried down the Erie Canal to the Hudson River and then by coastal vessels to the dock at East Boston. McKay's sailing ships were soon engaged in the Boston-Liverpool cargo and passenger trade as part of the White Diamond Line. The McKay yard built the *Washington Irving*, the *Anglo-Saxon*, the *Anglo-America*, and six other ships for the White Diamond Line. The *James Baines* set the transatlantic record of traveling from Boston to Liverpool in twelve days and six hours. *The Great Republic*, at 4,555 tons, was the largest clipper ship ever built. By 1855 the age of the clipper ship was over, as shipping began the switch to steam-powered iron ships. The McKay shipyard could not compete and was closed in 1869.

The naval war of 1799 between the United States and France encouraged Congress to develop a coastal defense system. The Boston Navy Shipyard at Charlestown was one of the six sites chosen to build battleships to protect American shipping routes. The seventy-four-gun *Independence*, the *Merrimack*, and the *Cumberland* were some of the ships built at the Charlestown dry dock. For the most part, Charlestown served as a repair and supply center for the navy. The naval yard at Charlestown grew in importance during the Civil War and again during the Spanish-American War. The yard reached its peak during World War II when it overhauled and outfitted some 6,000 vessels and employed 50,000 workers. After that war work at the navy yard began to decline and it closed in 1973.

Charlestown is now part of the Boston National Historical Park. This historic site is the home of the *Constitution*, the world's oldest commissioned warship. Known as "Old Ironsides," this proud old ship was launched from Edmond Hartt's Shipyard in Boston on October 21, 1797. It was made from trees felled in Maine and was armed with cannons cast in Rhode Island. From 1803 to 1806, the *Constitution* was sent to the Mediterranean to help protect American ships from attacks by the Barbary pirates. It fought in the war with Great Britain (1812–1815) and traveled the world and visited American ports before returning to Boston in 1934, where it has remained (Bither, 1999).

Food

Chocolates and candies have been part of Boston life for many years. In 1780 Walter Baker started to work in his grandfather's small gristmill on the banks of the Neponset River in Dorchester. Part of young Walter's job was to grind cocoa. Out of this humble beginning grew Walter Baker & Company, which is the oldest chocolate company in America. By 1806 the company had six mills in Dorchester and Milton and maintained its head offices at 45 Broad Street in Boston. Its chocolates were sold worldwide. At its peak, 750 people worked for Walter Baker & Company. The company was sold in 1928 and became a unit of the Postum Company.

Oliver Chase started a confectionery shop in Boston in 1847. His product was a success and he developed the New England Confectionery Company (Necco) with its first factory in Cambridge, Massachusetts.

Soon after Baker began to sell his "delights," William F. Schrafft began making gum arabica drops in his small store. These hard candies were very popular with the soldiers during the Civil War. The company expanded into William F. Schrafft & Sons and opened an enormous factory in Charlestown, Massachusetts with some 1,600 workers. Loose-Wiles Biscuit Company began making breads for the "sea-going trade" but found a broader market with its *Sunshine* biscuits, which it produced in its Boston factory of 1,000 workers.

The folks of Romney Marsh (now part of Chelsea, Massachusetts) maintained a small tide mill, which was sold in 1827 to Henry Slade, who used the 1,800-pound wheel to grind spices. The D&L Slade Company packaged ground spices in its shops on State and Central Streets in Boston.

The Rum Trade

Rum is distilled from sugarcane juice or molasses and was given to the plantation slaves of the Caribbean islands to keep them sedated during their backbreaking work in the cane fields. The drink gained popularity in England and in the British North American colonies. A very profitable trade developed between the Massachusetts Bay Colony and Jamaica, Barbados, and other islands of the British West Indies in which dried fish, lumber, and livestock were sold and sugar, coffee, and molasses were brought back to Boston. The molasses was distilled into rum. As early as 1717 there were sixty-three distilleries in Massachusetts (Morison, 1961). Over time the quality of local rum improved and a lively export trade developed. The rum was exchanged for enslaved African men, women, and children who were delivered in shackles to the West Indies (O'Connor, 2002).

The Felton family arrived in the Massachusetts Bay Colony in 1640. One of their descendents, Luther Felton, was born in Marlborough, Massachusetts in 1798. As a young man he moved to Boston to work as an apprentice to a rum distiller. A few

years later he started his own distillery on Washington Street and took in his son Luther Jr. as a partner to form Felton & Son. The company was passed down until the Feltons were the last rum distillers in Boston. The company sold its rum in barrels to taverns. After 1893 its marketing became more elegant when it began to sell the rum in bottles as a drink, or to add to ice cream, candies, and cakes. Other rum companies included Joseph Burnett Company, which made "Burnett's," and Ben Burk, Inc., which made "Old Mr. Boston."

The Molasses Disaster of January 15, 1919 seriously affected the industry in Boston. On that unusually warm day, a round storage tank of the United States Alcohol Company, filled with two million gallons of molasses, burst open. The molasses poured out of the ruptured tank, knocking down buildings and vehicles, and drowning animals and humans. The force of the molasses snapped the supports of the Elevated Railroad, which fell to the ground. Twenty-one people lost their lives and over 150 were injured. Over one hundred claims were filed against the company that owned the tank and its contents. After a trial lasting six years, the United States Alcohol Company was found responsible. The tank, which was ninety feet in diameter and fifty-eight feet in height, was deemed too weak to hold all that molasses. It took many months to remove the molasses from the city streets and buildings and the company paid out nearly $1 million in claims.

THE SEWING MACHINE AND THE READY-MADE CLOTHING INDUSTRY

Elias Howe was born in Spencer, Massachusetts on July 9, 1819. The Howe family owned a small farm and a gristmill some ten miles due west of Worcester, in the same county that recognizes Eli Whitney as a native son. As a boy, Howe helped out about the farm and went to school only in the winter months. He was not educated beyond the local grade school and started working at age sixteen in a local textile mill before moving to the large factories in Lowell in search of more money and greater opportunities. The financial panic of 1837 ended his career as a machinist at the mills. He moved to Cambridge and found work in a machine shop, where he shared a room with his cousin Nathaniel Prentice Banks, who later rose to become speaker of the United States House of Representatives, governor of Massachusetts (1858–1861), and a major-general in the Civil War.

Elias Howe got to thinking about a machine that would replace handwork and would automate the process of sewing. After eight years of effort he finally came up with a machine with an eye at the end of its sharp point to push the thread through the cloth, forming a loop. A threaded arm moved through the loop and created a lock stitch when pulled tight. The first mechanical sewing machine was patented in 1846. Howe's lock-stitch mechanism did 250 stitches a minute and was quicker than five experienced people working by hand.

Despite his patent, Howe's sewing machine gave birth to many imitators and Howe spent ten years fighting legal battles until his rights to the machine were finally acknowledged. He negotiated a royalty of $5 on each machine made in the United States by his competitors and $1 for each machine sold abroad. These royalties brought him great wealth, but the legal battles wore him out and he died in Brooklyn, New York at forty-eight years of age.

Several sewing machine companies were formed in Massachusetts. The New Home Sewing Machine Company started production in 1882 in the town of Orange and had a branch in Lynn. By 1907 New Home Sewing Machine Company had a workforce of 740 and was making 150,000 sewing machines a year. But by the 1920s it was losing ground. The company was sold and production in Orange ended.

The White Sewing Machine Company was established by Thomas White in the small Massachusetts town of Templeton. The company diversified into bicycles, screw machines, roller skates, and even automobiles. The White Motor Company started production in 1906. At first it made steam-engine vehicles, but soon switched to gasoline.

The winner of the sewing machine stakes was Isaac Merritt Singer. He was born in 1811 in Pittstown, New York and became an apprentice machinist. At age forty he was still working as a technician in a machine shop in Boston. He designed a sewing machine mechanism that was an improvement on Howe's design. Singer paid royalties to Elias Howe, but continued to manufacture his own machine through the Singer Manufacturing Company. In 1860, over 100,000 Singer machines were made in the United States alone. The Singer machine was cleverly marketed and continuously updated and became the largest selling sewing machine in the world.

The first mechanical sewing machines were used in the clothing industry. These machines revolutionized the ready-to-wear clothing industry. Until 1845, garments were put together by hand-stitching in the workers' homes. After that date, the work became increasingly concentrated into large factories, following the pattern of the textile mills some fifty years before. This was known as "The Boston System," and depended on the cheap labor of a seemingly endless flow of immigrants. Each worker had a specific and standardized task, and the jobs could be quickly learned. These machines provided work opportunities for the thousands of unskilled immigrants who were then coming to Boston.

The Civil War created orders for thousands upon thousands of uniforms and helped to launch the clothing industry in Boston. However, Boston was never as big as New York as a center for clothing manufacture. In 1870 there were 7,033 employees engaged in Boston in the manufacture of men's clothing, compared with 17,684 in New York. By 1880, 11,246 people in Boston were listed as tailors (Handlin, 1972). The factory workers earned only $4.50 to $5.50

for a sixty- to seventy-hour workweek. The Irish were the first immigrant group to work in the clothing factories. By 1880 these jobs were taken over by Italians and Jews, who had worked as tailors in their native countries.

RAZORBLADES

In September 1901, King Camp Gillette (1855–1932) founded the American Safety Razor Company in an office above a fish shop at 424 Atlantic Avenue. The office was situated next to the wharf where Boston garbage was loaded onto barges ready to be dumped into the harbor. The Gillette family could trace its ancestors to French Huguenots who fled to England after 1572. Nathan Gillette sailed from England to Massachusetts in 1630 and some of his descendents moved west. King Camp Gillette was born in Fond du Lac, Wisconsin and was raised in Chicago. He worked as a traveling salesman for the Crown Cork & Seal Company. One day he hit upon the idea of the disposable razorblade. After several years of research, he found a method to produce thin sheets of sharpened metal for his double-edged safety razorblades. He moved to Boston, where much of his business for Crown Cork & Seal was centered. Here he pursued his obsession to develop the disposable razorblade. Gillette got his patent in 1901 and started selling razors with the disposable blades in 1903. The name of the company was changed in 1902 to the Gillette Safety Razor Company. In 1905 the Gillette Company moved into its large factory in South Boston. Soon King Gillette's picture would appear on countless millions of blade wrappers, making his mustached face among the best known in the world. Today the Gillette Company is still in Boston and is a world leader in the personal grooming business. It also sells batteries and oral-care products.

BOXES AND PACKAGING

Aaron Dennison hailed from Brunswick, Maine, where his father owned a cobbler's shop. Aaron was a creative boy and noticed that the English-imported boxes used to package jewelry and watches were rather plain. He began to fashion more attractive boxes and wrappings to please the customers. Aaron Dennison took his idea to Boston and set up shop on Washington Street. His reinforced tags were used by Union troops to ship supplies during the Civil War. In 1872 Dennison set up a factory in Roxbury, but the space soon proved too small. In 1897 the Dennison Manufacturing Company moved fifteen miles west to the town of Framingham to manufacture crepe paper, gift-wrapping, labels, sealing wax, and shipping tags. An even larger facility, in the traditional redbrick style of the New England mills, was built in Framingham in 1912. This five-story building with twenty acres of floor space still dominates the town's industrial area. Dennison became the largest employer in Framingham.

Farrington Manufacturing Company built a factory in 1902 at the corner of Green and Amory Streets in Boston. It manufactured eyeglass cases and small jewelry boxes. The factory had over 500 employees.

The square-bottomed paper bag, still widely used by supermarkets and stores the world over, was patented in Boston in 1872 by Luther Childs Crowell. Luther was born in West Dennis on Cape Cod and was expected to follow his father to a life at sea. Instead he devoted his life to inventions. Even as a boy, he spent many hours folding paper into different shapes. His primary backers were Galen Coffin of Boston and Luther Crane of Cambridge, Massachusetts. Luther Crowell had over 300 patents to his name, including a machine to fold newspapers and a device to put labels on bottles. In his old age he returned to West Dennis, where he died in 1906 (van Dulken, 2001).

BANKING AND FINANCIAL SERVICES

After the War of Independence, Boston's leading merchants assembled at the Exchange Coffee Club on Congress Square, which served as an informal social and business center. In 1828 a group of these men met at the Coffee Club and decided to establish a bank. The Atlantic National Bank was founded that year as Boston's first commercial bank. The Shawmut Bank, founded in 1836, also had its origins in the same coffeehouse. The Boston Safe Deposit & Trust Company followed in 1867. By 1878 Boston had fifty-nine national banks, of which a large number had their head offices in the city. These banks financed the massive industrial growth of Greater Boston. Lee, Higginson & Company was founded in 1848 at 70 Federal Street. This company offered credit services to travelers, importers and exporters, and manufacturers.

The Boston Symphony Orchestra was founded in 1881 by Henry Lee Higginson and has remained the city's cultural jewel. When Higginson's hopes for a musical career were dashed by a hand injury, he went to work in the family financial firm instead. His money and leadership helped to bring serious music to Boston. The 2,625-seat Symphony Hall, on the corner of Huntington and Massachusetts Avenues, opened on October 15, 1900 and has been the home of the Boston Symphony Orchestra ever since. Symphony Hall is regarded as one of the world's great concert houses.

Symphony Hall is also used by the venerable Handel & Haydn Society, which has graced Boston's musical scene since 1815. The Handel & Haydn is the oldest continually performing arts group in the country. Handel's *Messiah* was premiered in 1818 and Haydn's *The Creation* was performed in 1819. Each year since 1854, the Handel & Haydn Society has performed *The Messiah*.

In 1824 twenty-year-old John Eliot Thayer, the son of a Unitarian minister from Lancaster, Massachusetts, moved to Boston. He started a business on Central Wharf dealing in foreign currency. Two years later Thayer moved his offices to 47 State Street, in the heart of Boston's banking business. He

continued to deal in foreign exchange, but also assisted clients in their investments. These investments were mostly in New England banks, textile manufacturing companies, and railroads (Carosso, 1979). Thayer was an early investor in the Boston & Worcester and the Eastern Railroads and developed a reputation for integrity and ability. He was one of the original thirteen brokers to establish the Boston Stock Exchange in 1834.

Nathaniel Thayer, John's younger brother, also moved to Boston and gained experience on Long Wharf dealing with the West Indies trade and whaling. In 1839 John took his brother into the business, which then became known as J.E. Thayer & Brother. The company began to reach beyond Massachusetts and made investments in railroads in Michigan, New York, Pennsylvania, and other states. Thayer & Brother also invested in land deals and textiles companies. After John died, Nathaniel ran the company with increasing success. In 1865 he retired from the business to focus on his own investments. (When he died in 1883, he was worth $16 million.)

Nathaniel handed the business over to the three clerks who had already worked for Thayer & Brother for some years: Henry P. Kidder, Francis H. Peabody, and his brother Oliver W. Peabody. Nowadays, we associate the Kidder and Peabody names with privilege and wealth, but this certainly was not the case in 1865 when the firm of Kidder, Peabody & Company was formed. Kidder was one of twelve children of a Boston fish and meat inspector. He attended Boston Latin School, but did not go on to college. He worked as a clerk for the Boston & Worcester Railroad before joining Thayer & Brother. The Peabody brothers came from Springfield, Massachusetts where their father was a Unitarian minister. They attended public school, but had no college; instead, they worked as clerks in a bank before moving to Boston to work in the Thayer firm. Kidder, Peabody & Company built on the reputation left to them by the Thayer brothers. The firm gained an international reputation as a private investment establishment. The firm remained associated with Boston for many years before moving its main office to New York.

In 1880 William A. Paine and Wallace C. Webber opened a brokerage office known as Paine Webber on Congress Street in Boston. Other Boston financial houses that were established in the late nineteenth century included Hayden, Stone & Company, Estabrook & Company, and E.H. Rollins & Son. Over time, there have been numerous mergers among the brokerage houses founded in Boston. Now, their links with Boston and its leading families have all but disappeared. In 1942 Paine Webber merged with another Boston firm, Jackson & Curtis (founded in 1879 by Charles Cabot Jackson and Lawrence Curtis). The combined firm moved to New York in 1963 and acquired a number of other brokerage firms. In 1995 Paine Webber acquired Kidder Peabody to become a full-services securities firm.

Head Offices

Many companies had their head offices in Boston. The American Woolen Company, with over fifty mills all over New England and elsewhere, had its headquarters at 245 State Street. William M. Wood Jr., who ran the company, lived on Fairfield Street in the Back Bay. The Gillette Company had its factory in South Boston and its head office downtown. The Liberty Mutual Insurance Company, the John Hancock Mutual Life Insurance Company, and the New England Mutual Life Insurance Company were all founded in Boston in the 1860s and had their head offices in the city. The Boston Rubber Shoe Company had its factory in Malden, but the head office was on Causeway Street in Boston. Many head offices were established on State, Federal, Devonshire, and Broad Streets. The U.S. Customs House, the main post office, and the Board of Trade were close by.

Industrialists who Served as Mayors of Boston

Boston was incorporated as a city in 1822 when Josiah Quincy was still in office. Several of the mayors during the next sixty years were merchants or manufacturers.

Martin Brimmer, mayor from 1843 to 1844, was an avid collector of paintings. His collection of paintings by the pre-Impressionist French painter Jean-Francois Millet was passed down in the family before being donated to the Museum of Fine Arts.

Henry L. Pierce, mayor from 1873 to 1877, started his work career as a clerk in the Walter Baker chocolate factory. After the owner died, Pierce leased the chocolate mill and continued to operate it as Walter Baker & Company. Under his management, the company grew to worldwide acceptance and a huge new chocolate factory was built on both sides of the Neponset River. The Pierce School and Pierce Square in Dorchester are named after him.

The industrialists Samuel Cobb, Frederick Lincoln, Otis Narcross, and Joseph Wightman also served terms as mayors of Boston.

Merchants and Industrialists who Became Governors of Massachusetts

Boston's success in manufacturing encouraged many of the captains of industry to enter politics and to move to the city. A number of these men became governors of Massachusetts and many served in senior positions in the United States government.

Henry Joseph Gardner ran a dry-goods business in Boston before becoming governor from 1855 to 1858.

Nathaniel Prentice Banks was the son of a foreman who worked in the textile mills in Waltham. As a boy he worked in the same factories as his father. Nathaniel went on to a spectacular career, which included running a railroad,

speaker of the U.S. House of Representatives, and governor of Massachusetts from 1858 to 1861.

William Claflin was educated at Brown University after which he worked for his father's shoe-manufacturing company in Milford, Massachusetts. He started his own shoe company in St. Louis before returning to Massachusetts to rejoin his father's business. He served as governor from 1869 to 1872, and then returned to the family shoe business. The Claflin family helped charter Boston University as a Methodist college. They also provided funds to establish Claflin University, the Methodist school in South Carolina.

William Barrett Washburn graduated from Yale University and then entered the chair-manufacturing business in Greenfield and Erving, Massachusetts. He served in the U.S. Congress before returning to his home state. He served as the governor of Massachusetts from 1872 to 1874, and then returned to the western part of the state to resume his business activities.

Thomas Talbot grew up in Northampton and worked in a textile mill. At twenty-two years of age, he joined his brother to start a broadcloth factory. He served as acting governor from 1874 to 1875 until he was elected to a full one-year term in 1879. He supported a bill to limit the laborers' workday to ten hours.

Alexander Hamilton Rice, the son of a local paper manufacturer, was born in Newton Lower Falls. He worked in a paper wholesale company before starting his own company. He moved to Boston and served as mayor. During his term, plans for the Back Bay were developed. Rice served in the U.S. House of Representatives before returning to Massachusetts where he served as governor from 1876 to 1879. He focused on social reform, and several state mental hospitals were built during his term of office.

The shovels made at the Ames Shovel Factory of Easton were widely used by farmers who were opening up the lands of the Midwest, as well as by the western gold diggers. Oliver Ames was born into the fabulous wealth created by the shovel. The Ames family gained a controlling interest in the Union Pacific Railroad. Thousands upon thousands of shovels from Easton, Massachusetts were used to build that railroad. Oliver Ames served as governor for three terms from 1887 to 1890 before returning to the family business.

Some of these politician-industrialists lived rags-to-riches stories, carried out by great strength of character and talent. Others of them were born into great wealth, yet fought for their own identity and success. One of these was Winthrop Murray Crane, whose father had made a fortune in the Crane & Company paper-manufacturing business in Dalton, Massachusetts. This company was a supplier of woven paper on which the United States banknotes were printed. Crane served three terms as governor from 1900 to 1903, and later served in the U.S. Senate.

William Lewis Douglas had a much harder early life. At age seven he started working in the shoe trade. He served in the Civil War and was wounded in the

battle of Cold Harbor. After the war he went out to Colorado to make his fortune in shoes and returned to Massachusetts to build the W.L. Douglas Shoe Company in Brockton. The factory was a great success and was making 20,000 pairs of shoes each day. These were sold around the country at the W.L. Douglas Shoe Stores. Douglas was elected mayor of Brockton. He served in the Massachusetts Senate before being elected governor in 1905. He served until 1906. After that, he returned to Brockton to run his shoe factory.

The power of the industrialist-turned-politician came to an end with Eugene Noble Foss's term as governor from 1911 to 1914. He was born in Vermont and his father was a factory manager. Foss studied law before moving to Massachusetts. He started work at the B.F. Sturtevant Company, producers of industrial exhaust fans and other products. He married Lilla, the boss's daughter, and went on to become president of the company.

During that period strife between workers and management was rife. The various unions fought against Foss's election as governor. In 1812 he was at the center of the textile workers' strike in Lawrence. The mills were closed and the city declared bankruptcy. Foss called out the state militia. Two demonstrators were killed and many others injured in confrontations with the military. Foss put pressure on the factory owners and they reluctantly increased the weekly pay of workers by 5¢ to 25¢ a day. Governor Foss instituted a system of compensation for injured workers but failed in his attempt to obtain a fourth term as governor and returned to private life.

INVENTIONS

Some of the key inventions of the nineteenth century were made in and near Boston or by people born there. One of the most important was the previously described invention of the sewing machine by Elias Howe Jr. (patented in Cambridge in September 1846). Isaac Singer, working in a machine shop in Boston, made significant improvements on Howe's machine. In 1846, chemistry professor Charles Jackson and dentist William Morton, both of Boston, patented the use of inhaled sulfuric ether as an anesthetic for surgical operations. Alexander Graham Bell, working in Boston with Thomas Watson, invented the telephone. In 1876, a patent for the telephone was filed by Bell in Watson's hometown of Salem, Massachusetts. Charles Goodyear experimented with rubber in Boston for years until he discovered the process of vulcanization. The patent for his discovery was issued in New York. King Camp Gillette labored for years in his workshop on Atlantic Avenue in Boston until he came up with the safety razor, which he patented in 1905. Luther Childs Crowell of West Dennis on Cape Cod invented the paper bag. This simple but still widely used invention was patented in Boston in 1867.

Other local inventors produced devices with more lethal consequences. Oliver Winchester was born in Boston in 1810. He began as a shirt

manufacturer. After moving to New Haven he bought a share of a company that manufactured firearms. At that time, guns had to be manually reloaded after each shot. Winchester's company developed a rifle that repeatedly loaded after each firing—perhaps following the same idea used in the sewing machine. The Winchester repeating rifle was extensively used by police and bandits alike in the years after the Civil War. An even more lethal device was the automatic machine gun. This gun was the invention of Hiram Stevens Maxim, born in 1840, the son of a Maine farmer. He worked in his uncle's machine shop in Fitchburg, Massachusetts before beginning a career as an inventor. The Maxim machine gun was patented in 1885 in London. The Maxim gun was employed with devastating effect by the British army in the Matabele War of 1893. The Maine farm boy settled in England and became an English gentleman. Hiram Maxim was knighted in 1901 and died in 1916 with over one hundred patents to his name (van Dulken, 2001).

INDUSTRY IN NEARBY TOWNS

The slow rate of change during the first two centuries of settlement of Massachusetts Bay and the rapid changes that occurred during the second half of the nineteenth century can best be observed by looking at a single community. I have chosen, more or less at random, the town of **Medford**, which lies on the Mystic River a few miles north of Boston. In his 1886 *History of the Town of Medford*, Charles Brooks observed that for many years before the War of Independence, the community did not have any banks, post offices, or newspapers, let alone good roads or stagecoaches. The town later developed a shopping center where local merchants offered a variety of goods including sugar, tea, chocolate, English linens, and Irish lace. Farm products from New Hampshire and Vermont were also available. The town had developed a brick industry and local distilleries were producing rum from molasses. These products were sent to Boston and the wagons returned with iron and steel goods. Jonathon Parker arrived in town in 1773 and later opened a store selling "English goods obtained before the Revolution." Cash, rather than barter, had become the preferred means of payment.

Shipbuilding got its start in 1805, with timber obtained locally from the forests of nearby towns. The cost of the wood was $6 per ton, cut and delivered by the seller. The wood was carried to Medford down the Middlesex Canal close to the Mystic River on large rafts. The *Columbiana* was the first of the 600-ton ships built in Medford shipyards and was followed by the *Ocean Express*, the *Shooting Star*, and the *George Peabody*. Between 1832 and 1837 sixty vessels were built and by 1844 the pace of ship construction had quickened. In that year, twenty-four vessels were built. One quarter of the ships constructed in Massachusetts were built in Medford shipyards, including those of Calvin Turner, George Fuller, John Sparell, and Jonathon Stetson. Between 1803 and 1873, 567 ships were built in Medford with an average tonnage of 480. The shipbuilding industry started to decline after 1860 and the last Medford ship was completed in 1873.

It seemed that Medford failed to keep up with changes in ship design, so instead of ships the town turned to wagon building and leather tanning. George Stearns ran a linseed business, and Waterman & Litchfield manufactured doors, blinds, and window-sashes. John Albee operated a wool mill.

Coaches began running in 1780 between Medford and Boston. At the start there was only one trip daily in each direction, but by 1836 horse-drawn omnibuses ran three times a day between Medford and Boston. These were larger than stagecoaches and could carry eighteen persons each. As many as sixty people per day were conveyed in each direction. The initial fare of 37¢ each way proved too high and was soon reduced to 25¢. Cunningham & Company operated coaches between Medford and West Medford that charged 7¢ in each direction. During the second half of the nineteenth century, the town of Medford experienced a boom. Immigrants as well as Bostonians were moving into the town, leading to an increase in the housing stock.

At the start of the nineteenth century Cambridge and Somerville were still largely farming communities with fewer than 5,000 people apiece. Chelsea, Malden, and Everett were even smaller. These towns—close to Boston—had not yet shown the spectacular growth experienced by the textile and shoe towns further out. By the close of the nineteenth century, the university town of Cambridge had been transformed into a major industrial city with over 100,000 residents. Somerville had grown from a farming community to one with over 70,000 people.

The city of Boston, even after incorporating Roxbury, Dorchester, Charlestown, and West Roxbury, lacked affordable land to accommodate all the industry that was beginning to boom within its boundaries. This land was needed to house Boston's fast-growing population, which increased from 136,881 in 1850 to 670,585 in 1910. Some factories were built in Boston, mainly in South Boston, Hyde Park, and Dorchester. Now a new pattern was developing.

Many of the manufacturing companies that grew large during the second half of the nineteenth century began humbly in small shops and factories within Boston proper. They were usually started by bright and determined young men such as Francis Lowell, Patrick Jackson, and the Lawrence brothers, who moved to Boston from the small towns of Massachusetts. Aaron Dennison came to Boston from Maine, Jonas Chickering and the Appleton brothers from New Hampshire, and Henry Houghton and Eugene Noble Foss from Vermont. As their Boston businesses grew, they expanded into nearby buildings and were scattered over several locations. Open, cheap land in nearby Cambridge, Somerville, and Chelsea offered sites for large factories. The railroads had arrived by 1840 and there were bridges across the Charles River. These towns had their own municipalities but were economically joined to Boston. Generally, the companies' head office remained in Boston, but many of the factories were in the adjoining towns.

The university hamlet of **Cambridge** is a good example of this development. It began as a farming community with a market square (now Winthrop Square) and its famed university was started in 1636 after the death

of John Harvard, a young pastor from Charlestown, who left the school his library and £600. Harvard University shaped the reputation of the town for many years. By the early part of the twentieth century, there were over 370 different industrial plants in the city—mainly in East Cambridge and Cambridgeport, situated a few miles east of the university. The town's 25,000 blue-collar workers earned collectively $30 million each year. Cambridge was third after Boston and Worcester as the state's most industrialized city and was now as much of a factory town as it was a college town.

Cambridge had the oldest pottery company in America, A.H. Hews & Company, known for its hand-turned flowerpots. The Shaw Furniture Company (started in 1765) used convict labor from the nearby Charlestown State Prison and made furniture for local clubs, hotels, and lodges. Cambridge was also a major soap-making town. Livermore, Crane & Whitney started production of soaps as early as 1804 and Curtis Davis & Company soon followed. Lever Brothers of England bought Curtis Davis and expanded it to make Lux and Lifebouy soaps for the American market. Lever even had its own whaling fleet to ensure its supply of whale oil. The Cambridge soap factory had over 1,300 workers.

The firm of Little, Brown & Company began in 1784 in a small bookstore. It was bought by Samuel Cabot and, in 1837, was acquired by Charles C. Little and James Brown. The head office of the company was for many years at 34 Beacon Street, Cabot's former home, and the production plant was across the river in Cambridge. Little Brown gained a splendid reputation as a publisher of histories, biographies, travel books, and law books, as well as bestsellers. Ginn & Compnay was founded in 1870 by Edwin Ginn. His Athenaeum Press was started in Boston and moved to Cambridge in 1897. The company employed some 850 workers and the head office was at 15 Ashburton Place in Boston.

Henry Oscar Houghton was born in Sutton, Vermont in 1823. As a youngster, he worked as a printer's apprentice at the Burlington Free Press. He moved to Boston to become a cub reporter on the *Boston Traveler* but his love of books led him to publishing and to borrow the money to set up a printing firm on the banks of the Charles River in Cambridge in 1849. He called it The Riverside Press. Houghton merged his company with Ticknor & Fields and, in 1872, formed a partnership with George Mifflin. The new company was called Houghton & Mifflin. The company gained an international reputation for quality work. Their printing plant was in Cambridge, where 900 people were employed. These firms and others made Cambridge the largest producer of school and college books in the world.

Cambridge had a glue-manufacturing plant, several glass companies, and a church organ maker. In 1834 woodworker Charles Davenport built the first horse-drawn omnibus in New England. It ran on a regular route from

Cambridge to Boston. With the coming of the railroads, Davenport and his company were commissioned to build wooden carriages for the Boston & Worcester and for the Eastern Railroad Companies.

The National Casket Company of Cambridge was the largest producer of coffins, caskets, and undertaking supplies in New England.

Cambridge became the world's largest producer of inks, carbons, and typewriter ribbons as well. William Carter started his wholesale paper business in Boston in 1858. As a sideline he began to make inks, which proved popular with his customers. The coming of the typewriter was a threat to the ink business. Always quick-footed, the Carter Ink Company added carbon paper, typewriter ribbons, and even pens to its product line. The company built its plant in Cambridge in 1909 and employed some 500 workers.

The migration from Boston to Cambridge was not limited to factories alone. In 1916 the Massachusetts Institute of Technology left its cramped quarters in the Back Bay and moved to Cambridge to face Boston across the Charles River.

The city of **Chelsea** was originally known as Winisimmit and was settled in 1624, six years before Boston. It occupies a small area of land across the Mystic River to the north of Boston. In the second half of the nineteenth century it was enveloped by the industrial development of Boston. Both the Boston & Maine and the Boston & Albany Railroads ran through the town. Chelsea had four miles of waterfront where ocean-going liners could dock. By the early part of the twentieth century, there were over 200 separate manufacturing companies in Chelsea with a total annual payroll of over $8 million.

In 1842 James Cross set up a coal-tar boiling plant near one of the town's salt marshes. It grew into the New England Felt Roofing Company, which used a combination of tarred paper and gravel to make roof shingles. The business was bought by Samuel Cabot, who applied to it the knowledge of chemistry he had learned at the Massachusetts Institute of Technology. Charles Cabot, Inc. became one of America's leading suppliers of waterproof roofing tars and shingles.

The Richard T. Green Company moved its shipyards from East Boston to Chelsea where is constructed several ships and made a business of overhauling steamers. William H. Forbes started his printing business in 1862 at 365 Washington Street in Boston. After the building was destroyed in the Fire of 1872, he moved his company to Chelsea.

The Forbes Lithographic Manufacturing Company occupied eighteen buildings and ten acres of manufacturing space in Chelsea. The company produced posters for theaters, as well as advertising cartons and can labels. By the 1920s, the Forbes company employed 1,000 people in Chelsea and had offices elsewhere in the United States.

The Collins-Lee Company (founded in 1890) specialized in fish curing and smoking. The fish came from the Boston fish piers and was delivered fresh

to the Chelsea plant for processing. The Chelsea Clock Company is one of the gems of the city. Founded in 1890, the company became famous for its marine clocks and ships' bells. The Chelsea banjo clock is well worth owning. The company employed 200 people and had its head office at 10 State Street in Boston.

Among the many other industries in this small city were the Austin Dog Bread & Animal Food Company on Marginal Street, the Atwood & McManus Wooden Box Company, the Thomas Strahan Wallpaper Company, and the A.G. Walton Shoe Company. The Walton Company specialized in children's shoes, which were sold all over America. The Boston Blacking Company was founded in Chelsea in 1889 and produced adhesives for the shoe industry. In 1929 it was taken over by the United Shoe Machinery Corporation and still survives as Bostik (now in Australia), a maker of adhesives and waterproofing products.

One of the largest industries in Chelsea was the Magee Furnace Company, located on Marginal Street. The company was started in 1864 with headquarters in Boston. The foundry in Chelsea was the largest producer of stoves and furnaces in the United States and was sited close to the waterfront to ship its Magee Ranges and Boston Heaters all over the world.

The small town of **Brookline**, which juts into Boston to the west, chose not to be incorporated into Boston and has remained a separate municipality. It has been a largely residential town with only a brief industrial period. Charles Holtzer built his factory on Station Street in 1887, but the company moved to Boston in 1915. Brookline attracted wealthy families who built their grand estates within easy reach of Boston.

The industrial growth of the second half of the nineteenth century affected other towns close to Boston. In 1842 **Somerville** has 1,013 inhabitants. It was helped by its location on the Mystic River. The Middlesex Canal ran near the town. Two railroad lines and the northern terminal of Boston's Elevated Railroad served the city. By the 1920s its population had reached 100,000. This densely-packed city had over 140 manufacturing plants making bricks, ladders, textile machinery, steam engines, and glassware. Somerville was also a meat-processing center.

Malden became a center for the manufacture of rubber shoes and sports sneakers. Chelsea's neighbor **Everett** had over 120 manufacturing plants that provided employment for 6,000 people, one of the largest of which was the Carpenter-Morton Company, which began in Boston as a small paint shop and became a major manufacturer of varnish stains.

During the second half of the nineteenth century Boston and the surrounding towns became an industrial powerhouse. The number of separate industrial concerns numbered some 2,000. Taken together, printing and publishing were the largest businesses, followed by women's clothing;

machinery; boot and shoe manufacture; confectionery, bread, and biscuit making; coffee and spices; medications; furniture; and razorblades.

The verdant sections of Cambridge around the university catering to the wealthy students and academic faculty have remained highly desirable real estate. By contrast, the eastern part of Cambridge, together with the towns of Chelsea, Somerville, and Everett, had narrow streets lined by three-decker homes. The factory laborers and skilled workers lived in these cramped houses, which were located close to the factories. They earned low salaries and were completely dependent of the success of the factories where they worked.

MANUFACTURING IN TOWNS FIVE TO TWELVE MILES FROM BOSTON

We will consider Lynn, Malden, and Beverly in the chapter on the footwear industry. Let us now turn to other towns beyond Cambridge, Medford, and Somerville.

The city of **Newton** was part of Cambridge until 1688, when it was incorporated as a separate town. Newton began as separate villages, each with its own character. The villages at Upper and Lower Falls on the Charles River saw the development of mills as early as the seventeenth century. Thomas H. Perkins (who endowed the Perkins School for the Blind in Watertown) financed the building of two textile mills at Newton Upper Falls. In 1800 Rufus Ellis completed a dam at Newton Upper Falls and built the Newton Iron Works and a cotton mill. The fall of the water below the dam was sixteen feet and provided power to turn the wheels of the mills. Ephraim Jackson built a paper mill at Lower Falls that was bought by Thomas Rice and, for forty years, made the paper for the *Boston Evening Transcript*. Reuben Ware and William Clark built a machine shop that employed forty men, and William Hoogs had a tannery at Lower Falls (Clarke, 1911).

The Gamewell Fire Alarm Telegraph Company opened its factory at Newton Upper Falls. The company built an electromagnetic steam-whistle blower and a bell striker that would set off an alarm to warn of a fire. Gamewell was known to make the finest alarm systems during the late nineteenth century and they were extensively used throughout the country.

In 1834 the Boston & Worcester Railroad began running trains through Newton. A few years later, the Boston & Woonsocket Railroad added more stations and improved the town's access to Boston. In the 1890s an extensive electric streetcar system linked the villages of Newton and provided connections to the surrounding towns and to downtown Boston. At the end of the nineteenth century Norumbega Park opened in Newton at the end of the Commonwealth Avenue streetcar line. Sailing and canoeing on the Charles River became very popular. By the start of the twentieth century Newton passed beyond its industrial phase and settled to become an affluent commuting town within easy reach of Boston.

The railroad helped in the development of the industrial life of Needham. The old town center along Central Avenue gave way to a new commercial center along Great Plain Avenue near the Needham Center railway stop. Willett's coal, wood, and ice business and Crossman's farm animal supply store were on Chapel Street. Woodruff and Son's General Store was on the corner of Great Plain Avenue and Chestnut Street. Thomas Sutton's Market was across the street. Needham's town hall, facing the town square at Great Plain Avenue, opened in 1902. The high school was built nearby on Highland Avenue and the Kimball Elementary School was sited on Chestnut Street. Homes were built along Chestnut Street and Great Plain Avenue within walking distance of the train station, shops, and churches.

A second industrial area developed around the Highlandville station on Highland Avenue. William Carter's knitwear manufacturing company became known worldwide. The Saxony Knitting Mills and Moseley and Company soon followed. The cotton textiles produced in the town of Woonsocket were probably sent up the rail line on the steam trains. Other factories, producing paper, bricks, and cotton, were built on the Needham side of the Upper and Lower Falls to take advantage of the water power. Close by these factories, little townships formed to house the workers.

Waltham lies along the Charles River to the west of Watertown. The area was first settled in 1650 and in 1738 Waltham separated from Watertown and was incorporated as a town. This town saw the beginning of the Industrial Revolution in America. At the beginning of the nineteenth century several paper mills were built along the Charles River. In 1814 the Boston Manufacturing Company, under the leadership of Francis Cabot Lowell, converted one of these paper mills into the first complete cotton textile mill in the country. The American Crayon Company was opened in 1835 by Dr. Francis F. Field, who invented the process for making chalk crayons. In 1843 the Boston & Fitchburg Railway started its run through the town. Thirty years later, a horse-drawn streetcar service was started.

In 1853 David S. Marsh, Aaron Dennison (the same young man who started the Dennison Company of Framingham), and a Mr. Howard combined their skills to open the Boston Watch Company in Waltham. After a shaky start, the company emerged as the American Waltham Watch Company, and still later as the Waltham Watch Company. By 1890 it was the largest watch factory in the world. The company became famous for its railroad watch, adopted by railroads the world over, which helped to make sure that the trains ran on time. Over a one-hundred-year period, the Waltham Watch Company produced forty million watches, as well as clocks and compasses. The company ceased production in 1957.

The **Quincy** shipyards lie some seven miles southeast of Boston. The region was first settled in 1625 by Captain Wollaston, and its original name was

Mount Wollaston. In 1782 it was renamed in honor of Colonel John Quincy. The town is renowned as the birthplace of second President of the United States John Adams and his son, John Quincy Adams, who was the country's sixth President. John Hancock was also born in Quincy.

Since the eighteenth century the town was known for its granite quarries. This stone was used in the building of King's Chapel in Boston and the Bunker Hill Monument in Charlestown. In 1826 the Quincy Granite Company began hauling the stone in horse-drawn carts along rails. This method is credited as the precursor of the railroads in America. Granite quarrying and, later, shipbuilding changed Quincy from a quiet agricultural village into a busy and prosperous town.

Quincy's growth as a major shipbuilding town owes a debt to the invention of the telephone. The Scottish-born Alexander Graham Bell (born in 1847) began his scientific career seeking a method to teach speech to the deaf. He came to Boston in 1871 and opened a school to train teachers of the deaf. In 1873 he was appointed professor of vocal physiology at Boston University. Bell was not mechanically adept. In 1874 he hired the twenty-year-old Thomas Augustus Watson (1854–1934) as his assistant. Watson came from Salem and went to work at age fourteen. Despite his limited education, he was filled with curiosity and technical inventiveness. Bell and Watson spent many hours tinkering with a device to transmit speech. On March 10, 1876, from an attic room at 109 Court Street in Boston, Bell spoke into his device and said, "Mr. Watson, Come here. I want you." Thomas Watson, who was in the next room, responded to Bell's request. This was the first demonstration of the electric transmission of speech and the telephone was born. Alexander Graham Bell founded the Bell Telephone Company and appointed Watson his head of research with a financial stake in the company.

In 1881 Thomas Watson retired from the Bell Telephone Company and bought a sixty-acre farm with a half-mile of shoreline along the Fore River in East Braintree. Newly married and still inventive, the twenty-seven-year-old Watson tried his hand at farming. Soon, he began tinkering with engines to power yachts and tugs. He established the Fore River Engine Company with only one employee, and Watson's tiny company grew into one of America's largest ship builders. In 1900 the company moved two miles downriver to its new shipyard located in the town of Quincy. The company built numerous merchant ships as well as ships for the U.S. navy. In 1913 the Fore River Ship & Engine Company was bought by Bethlehem Steel and was sold fifty years later to General Dynamic. The third owner was not able to generate enough shipbuilding to support the yard, and in 1986 the Quincy shipyard was closed and over 6,000 workers lost their jobs.

Chapter Five

OTHER INDUSTRIAL REGIONS IN EASTERN MASSACHUSETTS

One can place a finger almost anywhere on the map of eastern Massachusetts and find a place with industry. The first settlers farmed the land, but soon discovered the riches of the ocean, the power of the rivers, and the abundance of the forests. They used the available knowledge to harvest this wealth. Early on they were farmers and local fishermen determined to support their families and survive the cold winters. Later they built ships to sell the dried, salted fish and timber to markets in England, Jamaica, and other islands of the British West Indies. By the late eighteenth century coastal towns like Salem, Marblehead, and Newburyport developed a trade with the Far East. The small sailing ships built in these towns were able to travel around the Americas to the northwest coast to buy animal skins for barter in China. By the middle of the nineteenth century, the people of eastern Massachusetts were building a mighty workshop using water, steam, and electric power, not only to meet all their own needs but also for export throughout the United States and abroad. They even found a way to export blocks of ice from New England's frozen lakes to the warm climes of South America.

INDUSTRY ALONG THE MERRIMACK RIVER

The powerful Merrimack River begins in the White Mountains of central New Hampshire and flows south into Massachusetts. Beyond the town of Chelmsford, the river turns northeast and flows through Lowell, Lawrence, Haverhill, Merrimac, Amesbury, and Newbury before meeting the Atlantic Ocean at Newburyport. The river is only 110 miles long and its lower twenty-two miles are tidal. The capital city of New Hampshire lies on the Merrimack, as does the state's largest city, Manchester. At this site, the river drops fifty-five feet and produces tremendous power. The enormous cotton mills of the Amoskeag Manufacturing Company are at this site.

The story of the industrialization of the Merrimack River in Massachusetts is much more than the story of textiles in the planned nineteenth-century manufacturing cities of Lowell and Lawrence. The major shipbuilding was done along the lower reaches of the Merrimack River from Haverhill to Newburyport. Between 1793 and 1815 over 1,100 ships were built along the banks of the Merrimack River. **Newburyport** was settled by English colonists in the year 1635. It was originally part of the town of Newbury, and rapidly

grew as a fishing and trading settlement. Shipbuilding was a major industry. Some sixty ships from the town were engaged in cod fishing and one hundred more were in overseas trade. Ships from Newburyport were active in the trade with Europe and the West Indies. Fish, timber, and rum were exported, and sugar, wine, cloth goods, and tea were brought back.

The prosperity of the town was further increased with trade along the Merrimack River. The Pawtucket Falls on the Merrimack between the towns of Chelmsford and Dracut created an obstacle to river traffic, so in 1796 a canal around the falls was completed with funds supplied by the Newburyport shipbuilders. Now boats could continue into southern New Hampshire and timber for shipbuilding, firewood, and farm products from eastern Massachusetts and southern New Hampshire were transported along the length of the river to Newburyport. The town also prospered from the taxes on shipping. The merchants, sea captains, and ship owners built grand homes in the town, and Main Street was filled with carriage-trade shops. Newburyport had watchmakers, goldsmiths, cutlery makers, and publishing houses (Morison, 1961). Shipyards were built along the banks of the Merrimack River. Donald McKay and John Currier Jr. both had shipyards in Newburyport before they moved on to bigger ventures.

Newburyport's golden age of shipping lasted from 1790 to 1812. The opening in 1803 of the Middlesex Canal from Chelmsford to Boston reduced the importance of Newburyport. As with Salem, the town faced ruin on account of restrictive federal policies and the War of 1812. Shipbuilding and maritime trade came to a virtual halt as shipping centered more and more on the port at Boston. Newburyport's population declined and the town began to suffer. Like so many other Massachusetts towns, Newburyport hoped that textiles would bring back prosperity. Steam-powered cotton mills were built in the town close to the port, but textiles offered low wages and there was fierce competition with the many other mills in New England. After the failure of textiles, Newburyport fell into a long, deep sleep.

Shipbuilding, farming, shoemaking, and textiles were the businesses of the other Massachusetts towns along the Merrimack River. **Amesbury** (settled in 1642) became a major shipbuilding center early in the eighteenth century. Over 600 vessels reaching up to 800 tons were built in its shipyards. Many hundreds of flat-bottomed dory fishing boats were built at local shipyards, which proved useful in navigating the shallow harbors along the New England coast.

Later in that century Amesbury developed a specialty in carriages and became known as "The Carriage Town." In its heyday, the town had over one hundred carriage manufacturers and was one of the country's leading carriage centers. The completed carriages were sent out by rail on the Boston & Maine line. The carriage business declined after 1910 with the coming of the automobile. To the west of Amesbury is the town of **Merrimac** (settled in the

1650s), which also had carriage factories. The town of **West Newbury** (settled in 1635) became known as a comb manufacturing center that used animal horns for the raw material.

Haverhill was settled in 1640 by Puritans who came from the nearby towns of Ipswich and Newbury. The town was named after the Haverhill in Suffolk, England, which was a Puritan town in the early seventeenth century. Haverhill started as a farming community, but soon developed fishing and shipbuilding industries. In the early 1800s the town became the regional cattle market with cowhide as a major byproduct.

The town's first shoemaker was Andrew Greely, who came to Haverhill in 1646. By 1817 there were 200 shoemakers in Haverhill and a distribution network was set up to market their products. In 1850 Haverhill had less than 6,000 inhabitants. Fifty years later, its population had grown to nearly 40,000. By 1900 Haverhill had over 200 shoe companies and tanneries employing some 11,000 workers. They made up over 80 percent of all industrial workers in the town.

Haverhill developed a vibrant town center with shops and theaters. One of these was the 600-seat Gem Theater, built in 1900 as a vaudeville house. In a few years the theater had lost its audience and had become run down. In 1907 the Gem was bought by twenty-two-year-old Lazar Mayer, who renovated it into a movie house named the Orpheum Theater. Mayer moved to Haverhill from Boston, where he barely made a living in the junk trade. His early success with the Orpheum encouraged Mayer to expand. In 1911 he opened the 1,600-seat Colonial Theater, also in Haverhill, and over the next few years he expanded his holdings into the largest movie theater chain in New England. By 1918 the young man originally from Minsk, Russia had changed his name to Louis B. Mayer and moved to California to start what became the country's largest film studio, Metro-Goldwyn-Mayer (Crowther, 1960).

Methuen was organized as a town in 1725 and named in honor of Sir Paul Methuen, who was a friend of the governor. The Methuen Woolen Mills were built in the 1820s at the falls on the Spicket River and the town was also known for its shoe and hat factories. The economy of the town was overshadowed after the 1840s when the southern part was sold to the Essex Company to build the great textile town of Lawrence.

The presence of three very wealthy families left its mark on Methuen. The most flamboyant was Edward F. Searles, who was born in Methuen in 1841 and moved to New York City to become an interior designer. There he met Mary Hopkins, the wife of the late Mark Hopkins, who had made his money as a founder of the Central Pacific Railroad with Leland Stanford. Searles and Mary Hopkins married and moved to Methuen. When Mary died in 1891 Edward Searles inherited her vast fortune and indulged in a building spree. He

enlarged his estate, built a vast house with seventy-four rooms, and laid out a park with a statue of George Washington as its centerpiece. He also built the Searles High School and other buildings in the town. Searles was interested in organ music and bought the old Methuen Woolen Mills and converted the buildings into the Methuen Organ Company. He paid for the construction of St. Andrews Episcopal Church, which housed a Methuen organ. His ambition was to establish Methuen as a cathedral city. Searles's enthusiasm and cash kept the Methuen Organ Company afloat, but after his death the business went into decline. The buildings were abandoned in 1942.

SALEM, GLOUCESTER, AND OTHER PORTS

Salem was settled in 1623—seven years before Boston—by settlers sponsored by the Dorchester Company of England. The growing population and the lack of fertile farmland encouraged some to seek their livelihood from the sea and as early as the 1630s Salem had developed into a busy fishing port. Its merchants began to seek new markets for the dried salt fish, as well as for timber cut from the forests. They developed trade with the British West Indies and on their return to Salem, the ships carried sugar and molasses. Even before the American Revolution, Salem's trade had expanded to England, Spain, and the Russian port of St. Petersburg.

Salem was an important port, especially in the China trade. In 1790 its population was under 8,000—far less than Boston—yet its China trade equaled that of Boston. Salem had a different marketing strategy from that of Boston: its merchants and sea captains preferred the eastern route to China. Ships left Salem carrying salted fish, soap, gin, hams, candles, saddles, lard, tobacco, and chocolate. The ships called at the West Indies ports or headed for the Baltic countries. From there, they traveled to the Cape of Good Hope and took on wine, brandy, raisins, and almonds. After Cape Town the ships headed for Mauritius, traveled on to India, and then to Java and China. By 1805 ships from Salem were doing a massive trade with Canton.

The Salem vessels roamed the world looking for new markets. These ships imported pepper and spices from Java, and Salem became known as the pepper capital of the world. Later, Salem ships stopped at Arabian ports and brought back coffee. Much of these imports were transshipped to other markets in the United States or abroad.

The success of the China trade made a number of Salem merchants exceedingly wealthy. Elias Hasket Derby and Simon Forrester each left estates of more than $1.5 million and William Gray had twice that wealth. These merchants built their grand homes on Washington Square and Chestnut Street. They paid their crews good wages and the prosperity of Salem grew with the China trade.

Salem's shipping came to a halt with the Embargo of December 1807. After the embargo was lifted, Boston began to dominate the sea lanes. After losing the China trade, a number of ship owners looked south to the Brazilian state of Para, where large quantities of rubber were being tapped in the forests. In 1824 Captain Benjamin Upton sailed up the Amazon River and brought back to Salem a consignment of rubber overshoes. Despite their clumsy construction and stiffness in cold weather, these shoes proved useful in the wet and snow (Morison, 1961) and Salem became a major importer of rubber overshoes. The market for raw rubber redoubled following Goodyear's discovery of vulcanization. Rubber-shoe factories were built in Malden and other Massachusetts towns. By that time, Boston and New York came to dominate the Para rubber market and activity at the port of Salem ebbed away. By 1845 Salem was no longer an important seaport.

In 1838 the Eastern Railroad linked Salem to Boston and helped the town's industrial development. Cotton textiles, tanneries, and shoe mills replaced the maritime trade. In 1850 a second railroad was built that connected Salem with the textile cities of Lowell and Lawrence on the Merrimack River. Raw cotton and wool, as well as coal, were transported from Philips' Wharf to the textile mills. In 1847 some 1,500 local residents bought stock in the Naumkeag Steam Cotton Company, built on Salem's waterfront. At its peak, the textile company employed over 2,000 people.

An appealing chapter in Salem's history is the career of a boy by the name of George S. Parker. Born in Salem in 1867, he was the youngest of three sons and was an inventive child who enjoyed games. When only sixteen years old he invented a game he called "Banking." The players speculated with paper money they borrowed from the bank. The winner of the game was the one with the most money at the end. George invested $40 to have 500 sets of his game printed and "Banking" proved so popular that his two older brothers joined the business. They set up a gaming company, which they named Parker Brothers, and over the years Parker Brothers has published over 1,800 games. George Parker himself invented over one hundred games and wrote the rules for each one of them. Perhaps the most famous of their games is "Monopoly," which was introduced in 1935. Monopoly is published in over twenty-five languages and is sold all over the world. This real-estate speculation game is adapted for different localities: in England, the location is London; in Spain, it is Madrid; and in France, it is Paris.

George Parker died in 1953 at the age of eighty-six. His company became a Salem institution and provided employment to generations of local folk. Parker Brothers remained family-owned until 1968. Its new owners closed the Salem plant and moved game manufacturing elsewhere.

Salem's loss of the port, textile factories, and Parker Brothers reduced the town's economic base. The past, however, left this old town with a deep

heritage. Salem is known for the notorious Witch Trials of 1682, the outstanding architecture of its Federal period, and the wonderful collection of objects brought back to Salem by its maritime merchants and sea captains. In 1799 these merchants founded the East India Marine Society Museum to assemble in one place some of the finer ceramics, silken garments, paintings, and carvings brought back from China, India, and Japan. Also included are maritime objects dating back to the seventeenth century, including ship models, navigational instruments, tools, and weapons. In 1867 Salem received the sum of $140,000 from George Peabody to establish a museum bearing his name. The Peabody Essex Museum now displays this collection, which is based on Salem's trade with the East.

The coastal town of **Gloucester** (founded in 1623) is one of the oldest along the Massachusetts coastline. It was founded by settlers of the Dorchester Company, who named it for the cathedral town of Gloucester in England. The town lies some thirty miles northeast of Boston and fishing has been its primary industry from the start. Gloucester men sailed as far as Iceland and Greenland. Their catch often exceeded local need and they would preserve the fish with saltine and brine. Over the years, the quintessential fishing town of Gloucester has lost 10,000 of its native sons at sea. The Fisherman's Memorial facing Gloucester Harbor was raised in tribute to these men. Since the end of the nineteenth century, fishermen from Portugal and Italy have joined the Yankees in the elusive search for fish. Gloucester prospered when the catch was abundant, but the town continues to face hard times when the boats return empty.

Around 1850 a local blacksmith by the name of Nathaniel R. Webster saw the need to provide the fishing industry with a ready supply of ice to preserve the cod and halibut. He dammed up a local stream to create Webster's Pond and during the cold winters, the pond's ice was cut and stored in hay and sawdust until it was needed. Competitors entered the field and icehouses were soon built elsewhere in Gloucester and in other towns. Crushed ice was loaded onto the fishing vessels to store the catch while still out at sea. Enterprising merchants even developed an export trade in ice, taking blocks of ice to the southern states and even to foreign markets.

Many other towns along the Massachusetts coastline made a living from the codfish. The towns of Marblehead, Swampscott, Scituate, and Plymouth, as well as towns on Cape Cod, built boats and had fleets of fishing vessels but the concentration of trade at the port of Boston gradually reduced the industry elsewhere. By the 1820s fishermen from some of these ports spent their winter months building shoes in order to help support their families. Within a generation they had left the sea and were working in the shoe factories.

OTHER INDUSTRIAL TOWNS

Taunton was settled in 1639 and named "in memory of our dear native country" for the town of the same name in Somerset, England. A church, meetinghouse, and courthouse were built, and in 1746 Taunton became a shire town. Until 1810 it had barely fifty houses, but the waterpower from the river encouraged industry.

Taunton had the good fortune not to become a one-industry town like Fall River, Brockton, and New Bedford. The town had brick factories, machine shops, copper companies, and several companies that manufactured nails and screws. Taunton became famous for the cooking ranges made there. Wood- and coal-burning ranges were manufactured in Taunton by Nathaniel Wheeler at his little foundry. Later in the nineteenth century the Oscar C. Thomas Company, the Glenwood Range Company, and the White & Warner Company began manufacturing wood- and coal-burning stoves.

Another major industry was the Taunton Locomotive Engineering Company with over 800 workers. The Mason Machine Works manufactured locomotives in Taunton from 1852 until 1890. These steam locomotives were used in railroad systems throughout the country. Cotton textiles were made at the Whittenton Manufacturing Company at a site previously occupied by gristmills and sawmills. Taunton was also the site of a state lunatic asylum.

One of Taunton's most enduring enterprises is the family-owned Reed & Barton Company, which began in 1824 as a pewter manufacturer. Henry G. Reed and Charles E. Barton were gifted craftsmen who produced high-quality pewter ware. Their company later expanded into silver-plating and sterling-silver tableware. The factory has provided employment for generations of Taunton residents.

By 1850 Taunton's population had reached 15,000 people, and by the start of the twentieth century the town had some 30,000 people. Main Street and City Square carried the Mason & Son's shoe shop; Pierce's Hardware Company; Goodnow-Morse-Brooks Company, which sold men's and women's clothing; Dean Brothers' shoe store; Carlow's Corner Pharmacy; the New York Lace Store; the Bostock Furniture Company; and many other places of business.

The first choral societies in Taunton were the Beethoven Society (founded in 1821) and the Mozart Society. Gilbert and Sullivan operas were performed

at the Music Hall and musicians from Boston and New York regularly appeared in Taunton. The town soon gained a reputation as the best music center in Massachusetts, after Boston and Worcester.

By 1820 Taunton had become an important port. Vessels brought in coal, iron, copper, lead, lumber, and foodstuffs and ships from Taunton left with bricks from local brickyards, shovels, nails, and stoves. As many as twenty schooners and sloops participated in the coastal trade from Taunton to New Bedford, New York City, Providence, and other cities. Many of these ships were built in local yards.

Horse coaches rumbled in and out of Taunton well before the American Revolution. After 1836 steam-driven locomotives linked Taunton with Boston and Providence and in 1840 the Taunton & New Bedford Railroad was opened. Horsecars started to move along Taunton's Main Street in 1871. By 1893 the routes were fitted with electricity and the era of the electric street trolley had come to Taunton.

Fitchburg is located in north-central Massachusetts, some fifty miles from Boston. The site was first settled in 1740 and is named for John Fitch. The Nashua River provided Fitchburg with waterpower and the arrival of the Boston & Fitchburg Railroad in the 1840s increased its industrial development. The line was later extended westward through the Hoosac Tunnel and on to Albany, New York.

Immigrants moved from Boston to work in Fitchburg's sawmills, textile mills, and factories to produce saws, chains, guns, bicycles, shoes, and chairs. The town's population grew from 3,800 in 1845 to over 31,000 in 1900. Fitchburg's industry prospered during the Civil War. It developed a lively commercial center with shops, an opera house, hotels, schools, and churches, but after 1900 its fortunes began to decline and many of its factories were shut down.

Nearby **Leominster**, also on the Nashua River, specialized in the manufacture of combs made from animal horns. Leominster was incorporated as a town in 1740 and is named for a town in England. It is the birthplace of John Chapman (1774–1845), who is better known as the legendary "Johnny Appleseed" who gave apple seedlings to the pioneer farmers of the Midwest.

Lying twenty-five miles west of Boston on the Assabet River is the mill town of **Maynard**. The town is named for Amory Maynard who, in 1840, built a dam to provide the waterpower for his woolen mill. The Assabet Manufacturing Company grew during the Civil War by making blankets and clothing for the Union army. After several ups and downs, the business was taken over by the American Woolen Company and in the early 1920s it was the largest woolen mill in New England. As with so many of the other Massachusetts mills, production declined during the Depression and because of the movement of

industry to the South. The decline of the town was eased in the 1960s when Digital Equipment Corporation occupied part of the old wool mills. For a time, Digital was one of the country's major computer manufacturers. Unfortunately, the company went into decline and was later bought by Compaq, which, in turn, was bought by Hewlett-Packard (Gertner, 2003).

The town of **Gardner** is close to Fitchburg and Leominster and is named after Colonel Thomas Gardner, who was killed during the Battle of Bunker Hill. The town is known as the "Furniture Capital of New England." Its specialty is chairs, which have been made in Gardner since the 1830s. In the early 1900s, some four million chairs were made each year. This niche industry has endurance. Even today, Gardner remains the premier maker of chairs for colleges and universities.

COMPANY TOWNS

There are several places in Massachusetts where a single family built a single industry that dominated the town and gave it world renown. These one-company towns were fashioned by the values and benevolence of their founding fathers.

The Boston & Woonsocket Railroad and the line from Worcester to Woonsocket opened up the area of Massachusetts lying southwest of Boston. The towns along the Blackstone and other rivers already had gristmills and sawmills, as well as small textile factories. The railroads and the entrepreneurial drive of a few families created large industries in the towns of Hopedale, Whitinsville, and Millis.

Millis (settled in 1658) was known as East Medway until 1885. It remained largely agricultural until the early nineteenth century when cotton and paper mills were established. In the 1880s wealthy railroad tycoon Lansing Millis built his summerhouse in the town. He developed a dairy farm and a milk-bottling plant. The people of the hamlet were so taken by the man and his generosity that when it was incorporated as a town, they named it after him.

Lansing Millis's son Henry started his own business bottling a sparkling cider. The drink was popular with his friends and he decided to market it to the general public. He added other flavors to it as well, including sarsaparilla, root beer, and ginger ale. It was ginger ale that proved most popular. Using Jamaican ginger and Cuban cane sugar, Henry Millis began marketing his product in 1881 under the label of "Cliquot Club." Henry sold his company, but the plant remained in Millis. Cliquot Club grew so large that bottling plants were opened in over one hundred cities in the United States and elsewhere. The company left its home base in 1965.

The town of Milford lies some ten miles southwest of Millis. It was known for its granite quarries and its shoe factories. The character of the town began to change after 1842 when the Reverend Adin Ballou and 170 of his followers

moved there to start a Socialist Christian community. The group purchased 600 acres in the southern part of the town and established their Fraternal Community Number One. They built their houses and commenced their social experiment of combining religion, farming, and industry with temperance and mutual responsibility. The community could not long sustain its ideals and arguments soon broke out between the members. The enterprise ended in bankruptcy, and George and Ebenezer Draper took over the property.

The Drapers were well aware of the textile boom then sweeping across Massachusetts. They began to manufacture cotton textile looms and by 1880 the Draper Company possessed 400 patents. In 1886 the 600 acres and the company became a separate town named **Hopedale**. In 1892 the Draper Company introduced its Northrop loom, which was a brilliant success. To cope with the worldwide demand for its machinery, the Draper Company built a colossal plant to house over 5,000 workers. In 1903 alone the little town of Hopedale produced 78,000 Northrop looms and by the beginning of World War I, most of the textile looms used in the United States were made in Hopedale.

Ebenezer Sumner Draper (1858–1914) attended the Massachusetts Institute of Technology in Boston before joining his father's company. He was lieutenant governor of Massachusetts from 1906 to 1908, and served as governor from 1909 to 1911. The Drapers continued their paternalistic control over Hopedale well into the twentieth century. They provided good housing at low rents and their town benefited from a new high school, recreation facilities, health services, and good utilities and roads.

In time the Northrop loom wilted under pressure of new machinery made elsewhere. The town of Hopedale barely survived when its factory closed. A visit to Hopedale today will show only part of the vast factory still standing; even what is left is over one-third of a mile long and four stories high. Most of the windows are broken and "For Lease" signs flutter in the wind.

The third of our one-company towns southwest of Boston is **Whitinsville**. The town was originally part of Northbridge. Paul Whitin traced his heritage back to the early settlers of Dedham, Massachusetts. In 1809 he moved to Northbridge to marry a local girl. He found work in his father-in-law's forge and on the farm. Together with some local men he founded the Northbridge Cotton Manufacturing Company on the banks of the Mumford River. This modest mill was soon followed by a second built along the same river. Paul Whitin bought out his partners to make room for his sons to enter the business and the company became Paul Whitin and Sons.

John Crane Whitin was the son who built up the company. In 1831 he designed a cotton-picker machine that was superior to others then on the market. The Whitin brothers shifted their interests from textiles to making

machinery for the mills. The Whitin Machine Works responded to the "Mill Mania" then sweeping New England. The Whitins built a massive factory with close to two million square feet of workspace. The foundry consumed 4,500 tons of steel per year and the power plant used 20,000 tons of coal per year. The Whitin Machine Works expanded production into international markets and became one of the largest companies in the textile machinery industry.

"The Shop," as it was called by the locals, dominated the town. Immigrants came to Whitinsville looking for work. The Whitins built four-family row housing for workers along North Main Street and High Street, and built stately mansions for themselves. The Whitin family built the town's memorial hall, library, and the school.

In the 1860s the sons expanded the business. The brothers built the Rockdale Mill, the Riverdale Mill, the Whitinsville Cotton Mill, the Linwood Cotton Mill, and the Whitinsville Spinning Ring Company. The Whitin Machine Shop adapted to the changing times and remained active well into the twentieth century. The machine shop reached its peak capacity in 1948 when over 5,600 men and women worked there. In the 1970s the company left the town in which it had built and moved to North Carolina.

Yet another experiment in industrial utopianism took place in central Massachusets in the town of Northampton. A silk industry based on the mulberry tree developed there as early as 1830. In 1842 members of the Northampton Association of Education and Industry formed a factory village, which they named Florence, after the town at the center of Italy's silk trade. The community practiced racial and sexual equality and religious tolerance. The members believed in sharing their work and their domestic tasks. Their hope was to develop an industry-based society free of the competition and class structure then rampant in the other industrialized towns in Massachusetts. Black abolitionist Sojourner Truth lived in the Northampton community for a number of years. Unfortunately, these noble values of group participation did not lead to sound business decisions and the Association of Education and Industry soon got into debt. The treasurer of the association, Samuel Hill, took over the management of the silk factory and the idealistic community disbanded in 1846. The silk industry in Northampton continued until the Great Depression.

The region to the south of Boston, including the towns of Whitman and Brockton, became a major boot and shoe center. We will focus on the town of **Easton**, which became known worldwide as the home of the Ames Shovel Company. The town was originally the "East End" section of Taunton. This name was later shortened to Easton.

John Ames was a local farmer whose Puritan ancestors arrived in Massachusetts in 1638. The metal shovels then used by Massachusetts farmers in their daily toil were imported from England and John figured he could make

a better and cheaper shovel at home. Using local woods and the plentiful supply of bog iron, he built shovels in a local iron shop. During 1803 Oliver Ames moved the shovel business to Easton and the output of his little factory was lifted by the surge of American growth and people's preference for locally-made goods. The building of the canals, the farming of the West, the development of roads and railroads, and the California Gold Rush all vastly increased the need for shovels. During the Civil War the demand for shovels outstripped the company's resources.

Oakes Ames directed the shovel business while his brother Oliver widened their business interests to railroads. Oliver Ames (born in 1779) became president of the Union Pacific Railroad. The Ames family was also involved in the Missouri Pacific and the Texas Pacific Railroads. Oliver Ames's nephew, also called Oliver (1831–1895), served as lieutenant governor of Massachusetts from 1883 to 1887 and as governor from 1887 to 1890.

Members of the family built their mansions near their factory. Examples of the family's benevolence can still be seen in the town of Easton, as the Oakes Ames Memorial Hall, the town library, and the railroad station were gifts from the family. These buildings were designed by H.H. Richardson, Boston's foremost architect of the time.

The shovel business in Easton was kept going during World War II, but following that war the Ames Shovel Company, which had so dominated the town for over one hundred years, closed its doors and moved to West Virginia.

West of Boston, on a branch of the Nashua River, lies the town of **Clinton.** The abundant waterpower encouraged the growth of textile mills and, by 1850, some 3,000 people were living in the area. The real growth took place after the brothers Erastus and Horatio Bigelow started their company weaving ornamental cloth bordering known as "coach lace." Erastus and Horatio, the sons of a local farmer and chair manufacturer, were born in West Boylston. Although he lacked formal education and started working at age ten, Erastus had a keen mind and taught himself mathematics and how to play the fiddle. He hoped to attend Harvard University and study medicine, but concentrated on inventing machinery instead.

In 1837, at age twenty-three, Erastus invented an efficient power loom, which lowered the cost of coach lace from 22¢ to 3¢ a yard. The Bigelow brothers named their factory the Clinton Company, allegedly because they had enjoyed their stay at the DeWitt Clinton Hotel in New York. Erastus Bigelow also built a power loom to make counterpane (a raised-design cloth) and a loom for gingham cloth. Even greater success came in 1839 with his invention of a carpet loom. In all, Erastus Bigelow had thirty-five separate patents in his name. The Bigelow power loom for weaving carpets shaped the future of the industry. As the demand for their carpeting increased, the Bigelows expanded their factories, which attracted thousands of immigrant workers to the booming town.

In 1850 the industrial area of the town split off from rural Lancaster and was incorporated as the town of Clinton. In 1877 the Bigelow Carpet Company introduced the broadloom carpet and became one of the leading carpet manufacturers in the world. Bigelow carpets were laid down in the White House, the U.S. House of Representatives and Senate, and in the cabins and dining halls of the *Titanic*.

The inventive genius of Erastus, plus the business and organizational acumen of his older brother Horatio, built the town of Clinton. They gave the town its name, housed the workers, and financed the schools, library, and fire department. They established several of the banks and churches, as well as the town's park. Erastus did not stay long in the carpet business but instead moved to Boston and ran for Congress. He was an advocate of protective tariffs and wrote two books in support of his views. Erastus was a member of a commission that led to the founding of the Massachusetts Institute of Technology. Horatio remained in Clinton and became its leading benefactor. Through his efforts, the Worcester & Nashua Railroad passed through Clinton. After the death of the Bigelow brothers, their carpet company merged with Lowell Carpets. Carpet production in Clinton ceased in the 1930s and moved to South Carolina.

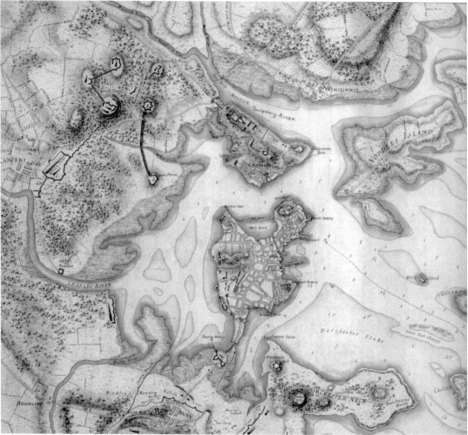

This map of Boston, 1775, shows the Shawmut Peninsula, rivers, and harbor islands. This was how Boston appeared before landfill was added to create Back Bay and the South End.

Here is an image of the Court in the Boston Public Library.

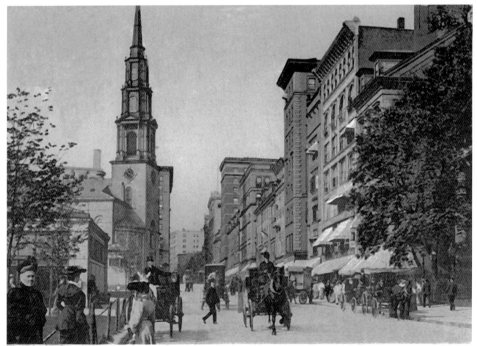

This image shows Tremont Street. The entrance to the Park Street subway station is on the left.

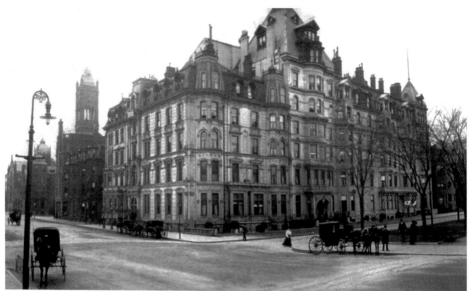

The Hotel Vendome on Commonwealth Avenue, shown here in 1901, was in the Back Bay.

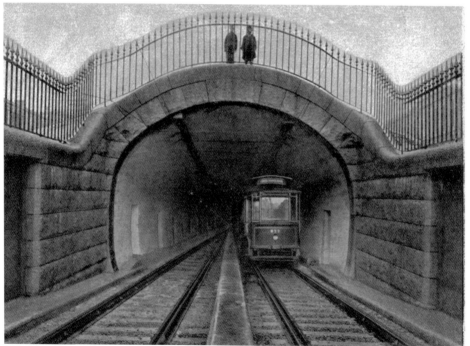

The East Boston Tunnel opened in 1904. It travels under the Boston Harbor to Scollay Square.

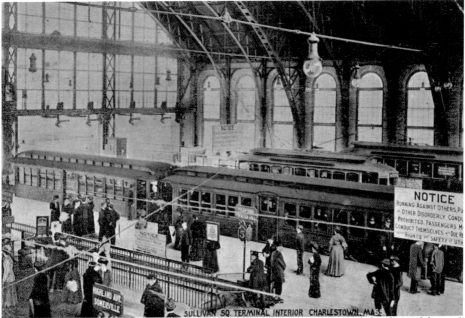

Sullivan Square Station in Charlestown was the northern terminus of the elevated line. A posted sign reads, "NOTICE: Running Against Others, Pushing or Other Disorderly Conduct is Prohibited. Passengers Must Conduct Themselves with Due Regard to the Rights and Safety of Others."

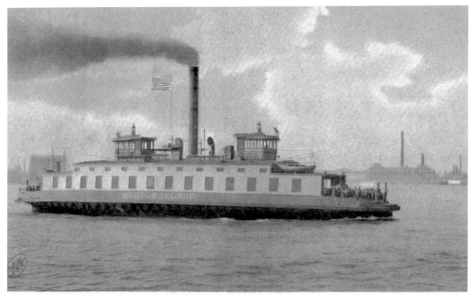

The Noddle's Island ferry traveled from East Boston.

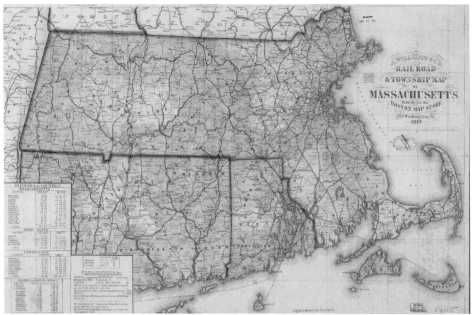

This 1879 map shows railroads leading to Boston. (Courtesy Library of Congress.)

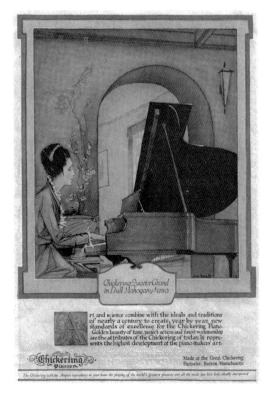

Chickering Pianos, Boston. These pianos were built at 781 Tremont Street and piano concerts were held at Chickering Hall, near Symphony Hall.

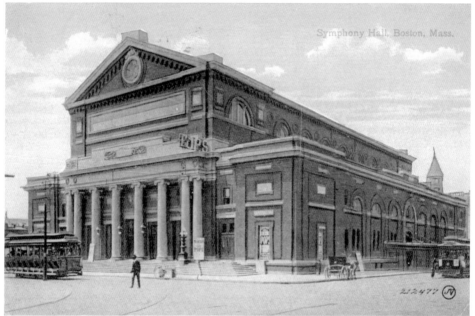

Boston Symphony Hall faced Huntington Avenue. It is shown here on Pops Night.

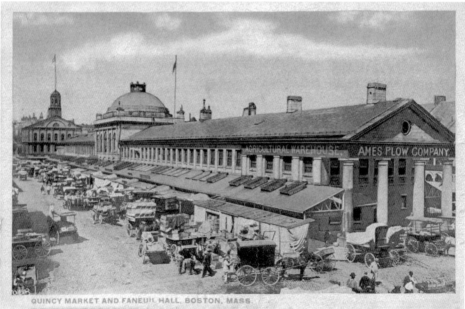

Here are the produce markets at Quincy Market and Faneuil Hall.

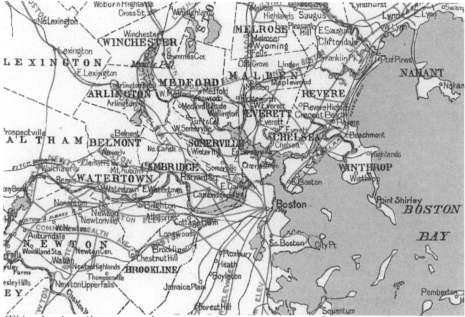

This electric railway map shows connections to towns near Boston in 1899. (Courtesy Library of Congress.)

In this picture of Needham, we see Carter's Mill No. 1 on Highland Avenue.

The Boston Marathon through Wellesley was held on April 19, 1906, the day after the San Francisco earthquake. The race, which had 105 entrants, was won by eighteen-year-old Tim Ford with a time of 2 hours, 45 minutes, and 45 seconds.

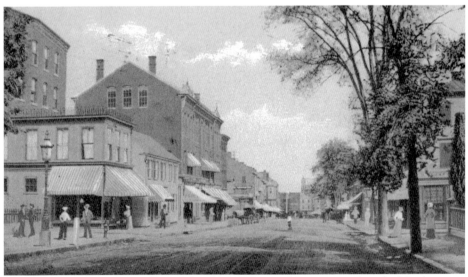

Newburyport, State Street. Famed for shipbuilding and international trade, Newburyport went into decline after the opening of the Middlesex Canal in 1803 and the blockade during the War of 1812.

New Pattern Drawing Frame. (Front.)

New Pattern Drawing
Frame. (Back)

The drawing frame, a type of machinery made at the Whitin Machine Works, Whitinsville, Massachusetts, is shown here.

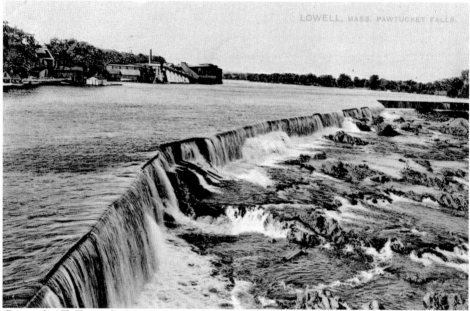

Pawtucket Falls on the Merrimack River is in Lowell.

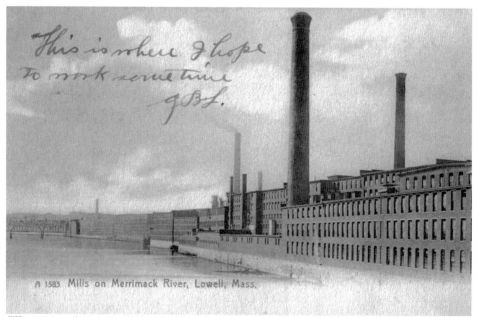

This image shows one of the giant textile mills on the Merrimack River in Lowell.

Commonwealth Ave. looking south, Boston, Mass

This image shows Commonwealth Avenue in Boston's Back Bay.

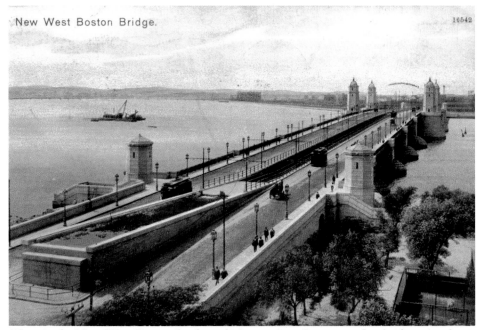

New West Boston Bridge. 16542

Here is the New West Boston Bridge, which goes from Boston to Cambridge. An electric trolley travels in the foreground.

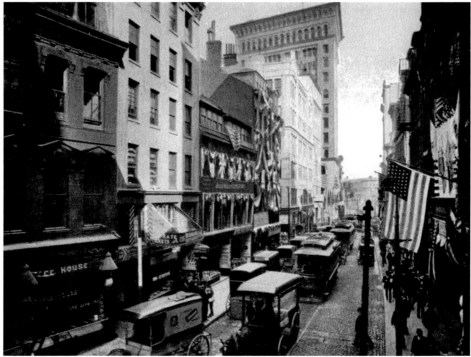

Washington Street is shown here with electric trolleys and horsecarts.

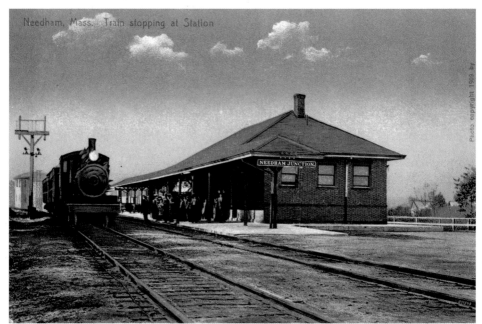

Needham Junction Station was on the Boston-Woonsocket line, which was completed in 1851.

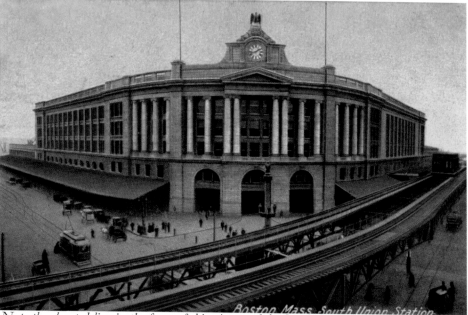

Note the elevated line in the front of this picture of the South Station Terminus of the New York, New Haven & Hartford Railroad and the Boston & Albany Railroad. It was completed in 1898.

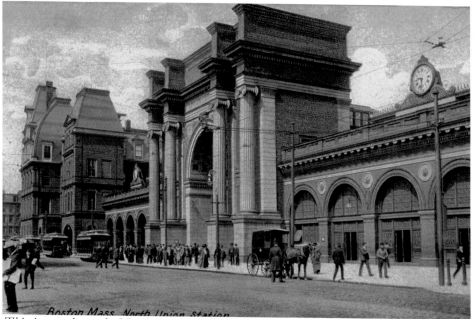

This image shows the North Station terminus of trains from northern New England.

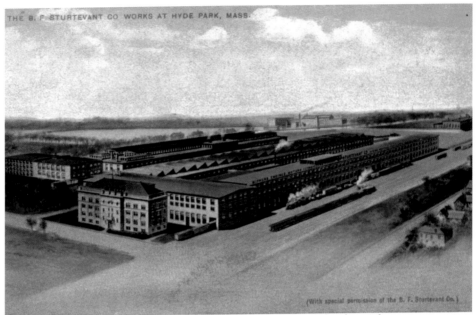

The B.F. Sturtevant Company at Hyde Park made industrial exhaust fans.

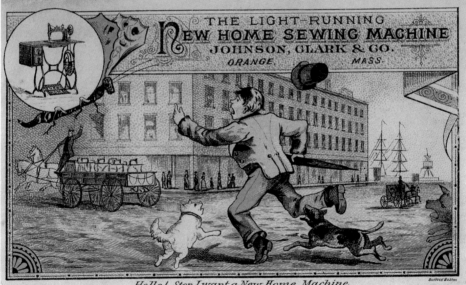

Bufford & Company's drawing of the New Home Sewing Machine in Orange, Massachusetts, is shown here. Winslow Homer, a Boston-born painter, started his career at Bufford. This trade card dates to c. *1870.*

James C. Davis & Son were soap-makers in Boston. These trade cards date to c. *1890.*

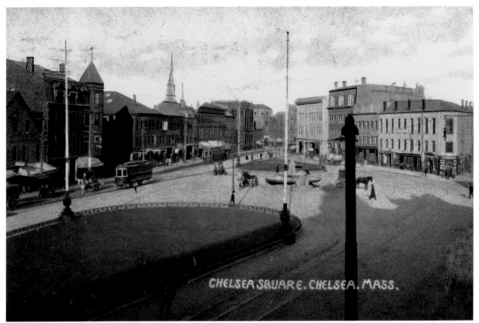

Here is an image of Chelsea (formerly Winisimmit). It was the site of many factories.

This trade card from the Magee Furnace Company dates to c. 1885.

Magee Furnace Company made cooking apparatus and furnaces. It was established in Chelsea in 1864. This trade card dates to c. 1885.

A.H. Taylor was based in Salem, settled in 1623 and known for its witch trials, its involvement in the China trade, and Parker Brothers.

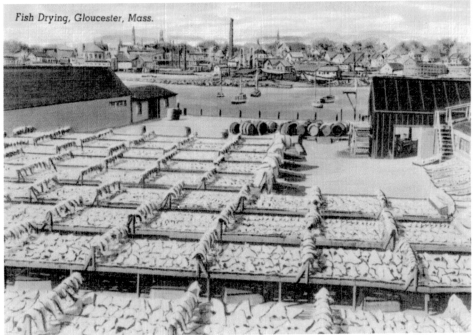

Gloucester was settled in 1623. It is the oldest fishing port in New England. This image shows fish drying.

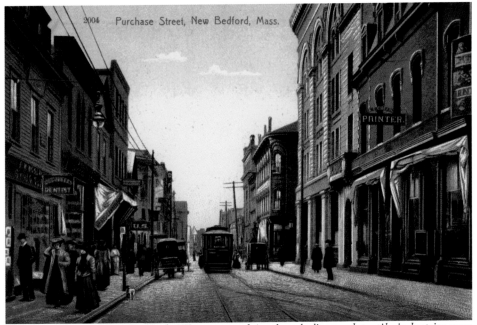

Purchase Street, New Bedford. Wages earned in the whaling and textile industries were spent in the shops along Purchase Street.

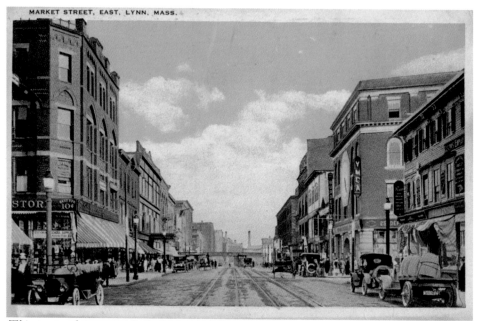

This postcard portrays the beginnings of the automobile age on Market Street in Lynn.

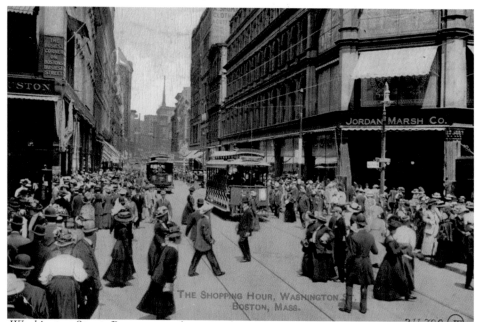

Washington Street, Boston, was the main shopping street and site of many theaters.

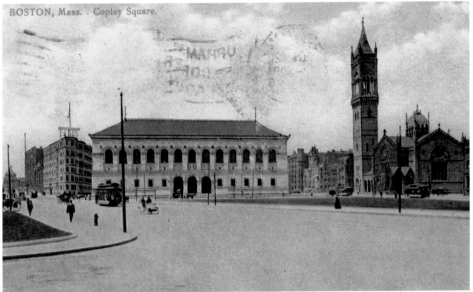

Copley Square was named for the artist John Singleton Copley, who was born in Boston in 1738. This postcard shows the Boston Public Library and Old South Church.

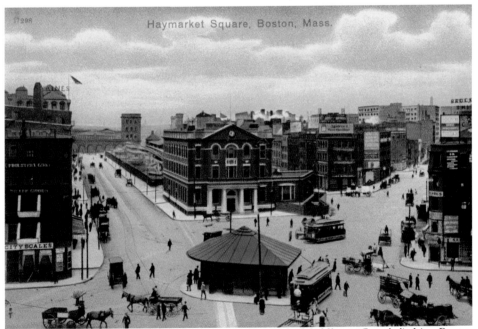

Haymarket Square was the hub for barge traffic on the Middlesex Canal, linking Boston with the upstate farms.

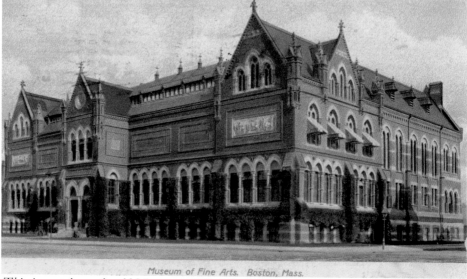

Museum of Fine Arts. Boston, Mass.

This image shows the old Museum of Fine Arts.

The Boston City Hospital, built in 1864, is in the South End.

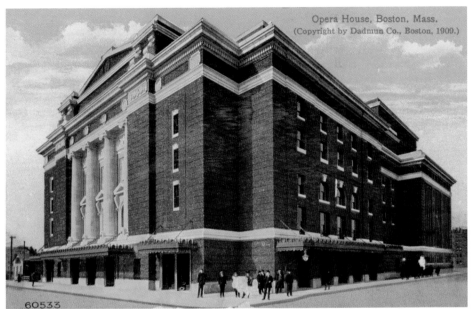

Unfortunately, the Opera House on Huntington Avenue has been demolished.

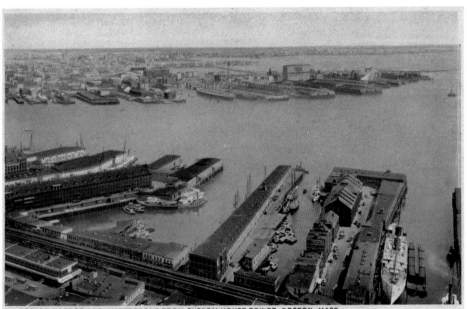

This image portrays Boston Harbor with shops and warehouses along its banks. The elevated train runs along Atlantic Avenue.

This trade card, c. 1885, advertises the Glenwood Kitchen Range, made in Taunton, Massachusetts.

The Smith American Organ and Piano Company was located on Tremont Street, known as "Piano Row," in Boston.

Another product by J.C. Ayer and Company of Lowell was Ayer's Hair Vigor. This trade card dates to 1890.

The Great Arlington Cotton Mills were on the Merrimack River in Lawrence, Massachusetts.

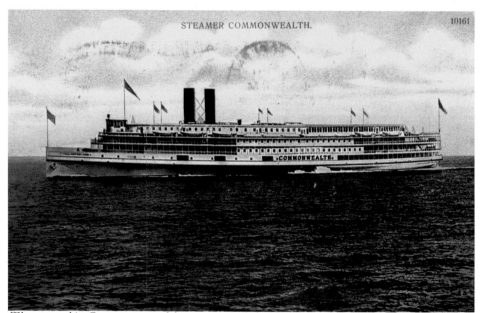

The steamship Commonwealth *was part of the Fall River line. It traveled from Boston to Fall River, and on to New York City.*

J.C. Ayer and Company made Ayer's Sarsaparilla in Lowell. This trade card dates to c. *1880.*

C.I. Hood and Company had a sarsaparilla laboratory in Lowell, Massachusetts.

E.W. Hoyt and Company made German cologne. This trade card dates to c. 1885.

The town of Lawrence, Massachusetts, was named after Abbott Lawrence.

Abbott Lawrence

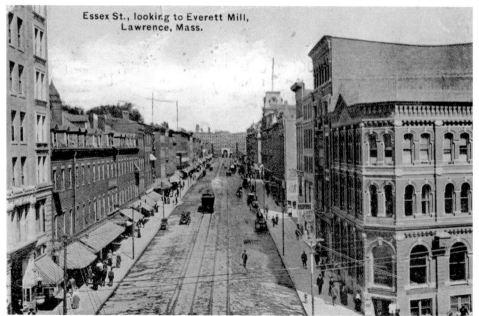

Essex St., looking to Everett Mill,
Lawrence, Mass.

The Everett Mill, facing Essex Street in Lawrence, is shown here. On January 11, 1912, the workers at this mill went out on strike and marched down Essex Street. This was the start of the "Bread and Roses Strike" that continued for sixty-three days.

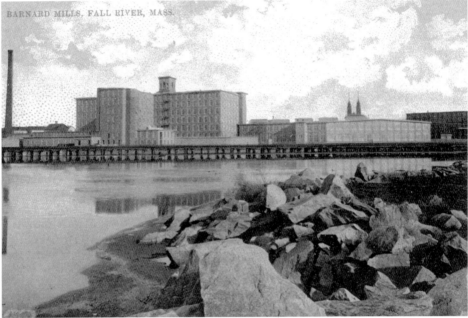

The Barnard Mills in Fall River were steam-powered.

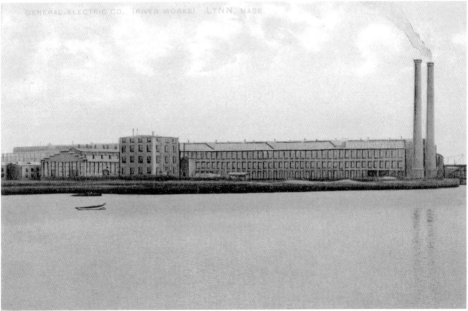

The General Electric Company river works were in Lynn.

This trade card shows Lydia E. Pinkham's Vegetable Company, using the Brooklyn Bridge as the backdrop. The card dates to c. 1890.

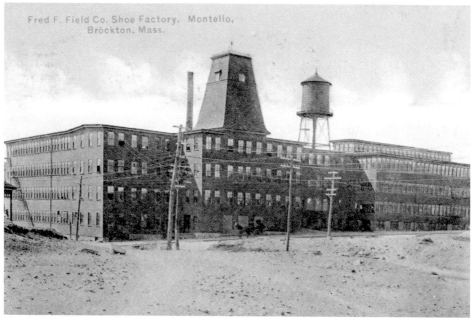

Fred F. Field Company Shoe Factory was located in Brockton.

Malden Square was near the shoe companies of Malden, Massachusetts.

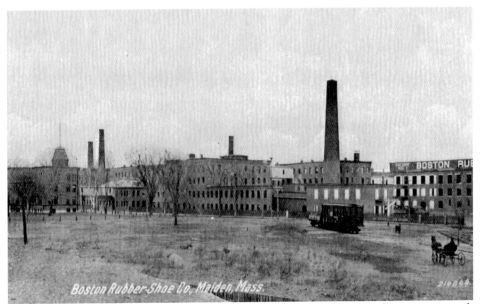

Boston Rubber Shoes in Malden. Situated a few miles north of Boston, this company made waterproof rubber shoes and overshoes.

LYMAN BLAKE.

GORDON McKAY.

Lyman Blake and Gordon McKay were inventors of shoe machinery. (Courtesy Boston Public Library.)

Sidney W. Winslow Jr. was president of the United Shoe Machinery Corporation. (Courtesy Boston Public Library.)

SIDNEY W. WINSLOW, JR.

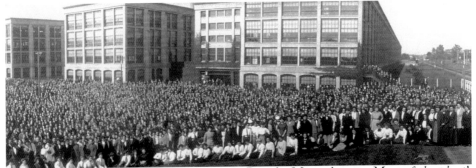

United Shoe Machinery Corporation was in Beverly, Massachusetts. Most of the plant's 3,500 workers are shown here in 1911.

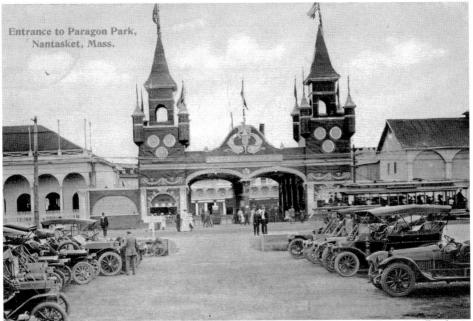

This postcard portrays the beginnings of the automobile age in Paragon Park in Nantasket, Massachusetts.

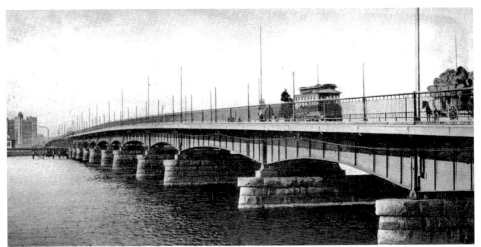

Harvard Bridge links Massachusetts Avenue in Boston to Massachusetts Avenue in Cambridge.

This is a cereal trade card, c. *1890.*

TEXTILES

The small family farms of Massachusetts grew crops and raised animals. The early settlers brought with them sheep and the flax plant, which adapted well to the conditions in New England (Rivard, 2002). During the long winter nights the women of the household would busy themselves with the arduous process of making linen from the flax and cloth from the wool. These natural substances had to be combed and spun into yarn on the spinning wheel, woven into cloth and dyed, then sewn into items of clothing. During the course of time cottage industries developed, which allowed the family to take its raw wool and flax to be processed at a mill. As early as 1638 weavers who came from Yorkshire were making woven fabric from wool and linen. Five years later, a wool mill built by John Pearson opened for business in the town of Rowley, lying some fourteen miles to the north of Salem. These homespun fabrics were rather rough-and-ready and could not easily compete with the finer cloth that was imported from England and sold in the local shops.

The China trade out of the ports of Salem, Newburyport, and Boston was the American equivalent of the English East India Company, which imported coveted silks and fine cloth from the East. These elegant materials found a ready market among the wealthy merchant and ship-owning families in Boston and other coastal towns.

Cotton

The cotton plant grows best in warm and humid climates, such as that found in the South. The pods of the cotton plant (called bolls) mature and burst into fluffy balls of seed with attached fibers. For every pound of fiber, there are roughly three pounds of seed. Separating the fibers from the seeds, cleaning the cotton, and then brushing the fibers to lie parallel for spinning (a process called carding) was very labor-intensive. The cultivation of cotton was much assisted by discoveries in England that greatly increased the efficiency of turning cotton fibers into thread.

In 1767 weaver James Hargreaves invented the spinning jenny (named for his daughter, Jenny). By turning the handle of one large wheel, a worker could spin as many as eighty threads at one time. A few years later, Richard

Arkwright (1732–1792), who started as a wig maker, developed an improved spinning frame but it was too large to be operated by hand. After trying horsepower, Arkwright hit upon the idea of the waterwheel to drive the machinery to produce cotton yarn ready for warp. His machine was known as the Water-Frame. Within a few years, Arkwright and his partners developed a centralized factory system to replace the method of outsourcing, where the work was done in the home.

The first textile factories built in rural England were alongside the fast-flowing streams and rivers needed to turn the waterwheel. Later, steam power enabled cotton mills to be built in established towns, especially Manchester. Now the workers would live near the factory and all phases of textile manufacture—from raw material to spun cloth—could be carried out in one location. Dirt poor Englishmen and women were drawn to the factories despite the meager wages and bad conditions. The factories employed children as young as six years old, who were drawn from England's notorious poorhouses and orphanages. The workers' houses were poorly built and slums soon developed in the environs of the textile mills.

SLAVE-GROWN COTTON

The first commercial planting of cotton for weaving in the American colonies took place near Chesapeake Bay in 1736. After the American Revolution, cotton production received a hefty boost from the invention by Eli Whitney of the cotton gin. Whitney was born in 1765 into a farming family from Westborough, some thirty miles to the west of Boston. After graduating from Yale University, he traveled to the South in the hope of landing a teaching position. Instead he found himself on a Georgia plantation without a career and little money. Whitney learned that when the cotton boll bursts open, the black cottonseed adheres firmly to the white fibers and has to be laboriously separated by hand. Whitney set his Yankee mind to work and, in 1793, the twenty-eight-year-old Massachusetts native constructed a machine to speed up the process of cleaning the cotton. By pulling the fiber through narrow openings, it became separated from the seed.

Whitney's invention greatly increased the area of cotton cultivation from the southeastern states to the lower South and westward to Texas. In the South, cotton became king and was the leading export crop—replacing tobacco. The raw cotton was shipped to the great port of Liverpool and sold to the burgeoning mills in Manchester and other English textile towns.

The rising demand for cotton fiber led to the expansion of the plantations and to the growth of the slave trade. With the aid of the mechanical gin, a single worker could now process fifty pounds of cotton thread a day.

Textiles

The South became a slave society driven by the highly profitable cotton fiber. The states of South Carolina, Georgia, Alabama, Mississippi, and Louisiana dominated in the production of cotton. In these states, slaves made up nearly half of the population. By the year 1850, two out of three slaves working on the plantations were engaged in the production of cotton. In that year, some three million bales of cotton were produced in the South. Two-thirds of all the raw cotton exported in 1861 was grown in the United States.

The American Revolution disrupted the trade links with England and, for a period, imported goods were not available. When trade started again, the British, because of their technological advances, were able to flood the American market with high-quality, relatively cheap cotton textiles. Cotton spinning in New England was little known before the Revolution; however, some enterprising businessmen found a niche in the sale of lower quality goods. At first, they encouraged piecework done at home by the farmer's wife and his daughters.

In 1790 America's first cotton-spinning mill was started in Pawtucket, Rhode Island and many of the home weavers came to this riverside village to work in the mill. The early success of the Pawtucket mill encouraged others to start mills at sites along the Blackstone Valley, where they used the waterpower of the river. Outstanding among these early enterprising men were Moses Brown of Providence, Rhode Island, who combined his financial talents with the technical skills of Samuel Slater. Slater had worked in a factory in England using the Arkwright system. After arriving in America, he applied his mechanical knowledge to the production of cotton textiles in Rhode Island. Slater built a copy of the Arkwright water frame from memory and trained numbers of local millwrights in its use. Within a few years, many cotton mills from Pawtucket, Rhode Island to Worcester, Massachusetts were built along the Blackstone River, making it the most highly industrialized river in the nation. The town of Woonsocket—formed by the merger of several milling villages—became a major cotton center. Most of these Rhode Island mills were small undertakings with precarious financial underpinnings.

THE BEGINNING OF THE AMERICAN INDUSTRIAL REVOLUTION

Boston and the lower reaches of the Charles River did not prove to be a useful site for large-scale textile manufacture. The sluggish flow of the river and the lack of waterfalls did not offer enough power to drive the machinery. The great development of the Massachusetts textile industry would start early in the nineteenth century with the introduction of a business model known as the Waltham-Lowell System. The creative genius of this system was Francis Cabot Lowell (1775–1817).

The Lowell family hailed from Newburyport and was engaged for generations in commerce. Francis was the son of Judge John Lowell, who had made his fortune disposing of British ships captured by New England privateers during the War for Independence. Judge Lowell moved his family from Newburyport to Boston and Francis went on to graduate from Harvard where he excelled in mathematics. After graduation he remained in Boston and began a prosperous business career. He joined with Uriah Cotting to develop India Wharf in Boston Harbor. In its time, their company was one of the largest docking and warehouse enterprises in Boston.

Nevertheless, Francis Cabot Lowell's vision turned to manufacturing. He was much influenced by his uncles John, Andrew, and George Cabot, who operated a horse-powered cotton mill in the town of Beverly in 1787. President George Washington toured the Beverly Cotton Manufactory on October 30, 1789, during his triumphal tour of Massachusetts. The mill made corduroys, velvets, and jeans but, alas, was not a success and the Cabot brothers lost money in their venture.

Francis Cabot Lowell disregarded the experience of his uncles and decided to seek his fortune in the manufacture of cotton textiles. In 1810, already well-to-do at age thirty-five, Lowell, his wife, and their two children left Massachusetts to spend two years traveling in Europe. The stated purpose of the trip was pleasure and to improve his health. However, the secret purpose was to study the tremendous advances in English cotton manufacture, especially Richard Arkwright's water-powered spinning wheel, which had brought about a revolution in the manufacture of cotton textiles. The British well knew the value of these machines and forbade their export. Even skilled textile workers or diagrams of the machinery were prohibited from leaving the British Isles. Lowell visited the Lancashire textile mills and the towns that had grown around the factories and committed everything to memory.

On his return to Boston in 1812 Lowell laid out his plan to his brother-in-law Patrick T. Jackson and an up-and-coming man of business, Nathan Appleton. His plan called for the creation of a well-financed company that would build several cotton mills near Boston and alongside a river with a flow powerful enough to turn the looms. These looms would be copies of the machines Lowell had seen in England. The cotton would be shipped from the South to the port of Boston and carried upriver to the mill site. This reciprocal relationship—between slave-grown cotton and northern manufacturing—would continue until the Civil War. Lowell's plan was to have the whole process of cotton textile manufacture—from the raw cotton to the finished cloth—done in a single factory.

Lowell wanted to avoid creating the squalid living conditions he had seen around the mills in England. He and his group decided to hire healthy young women, preferably the daughters of farmers who had made textiles at home. These young women would be carefully supervised and would live in company-run boardinghouses. They would be offered short contracts of work and encouraged to save some of their earnings for marriage and to help pay for the family farm. Lowell's genius lay in the combination of his entrepreneurial vision, financial acumen, and organizational skills.

Lowell, Appleton, and Jackson formed the Boston Manufacturing Company. They offered shares to their friends and to other wealthy Bostonians. Each share sold for $1,000, to be paid in installments of around $100 at a time. They planned to raise $400,000, which was a very sizeable sum in those days and ten times the capital available for the first mills in Rhode Island. Several years would pass before the shares were paid for in full. Francis Lowell and Patrick Jackson were major shareholders with a stake of $80,000 each. Israel Thorndike and his son each invested $40,000, as did Jackson's brother Charles. Uriah Cotting, who was Lowell's partner in the India Wharf, also made an investment.

The company bought the land of the Boies Paper Mill on the banks of the Charles River at Waltham, about six miles upstream from Boston. Near the mill was a large lake, which was close to a ten-foot drop in the water level. Here in 1814 the Boston Manufacturing Company erected a six-story stone and brick cotton mill. Lowell hired Paul Moody as the company's chief mechanic. Moody, who was born in Byfield, Massachusetts, developed a close working relationship with Francis Cabot Lowell, not unlike the Rhode Island partnership between Moses Brown and Samuel Slater. As a young man, Moody had worked on a handloom and was part owner of a small mill called the Amesbury Manufacturing Company. In 1814 Moody sold his interest in Amesbury and moved with his family to Waltham. It was Moody's task to construct the machinery based on the sketches Lowell had made on his return from Great Britain. This Moody did with great skill, even improving on the machine design and patenting new devices, including a regulator for the waterwheel, a dead spindle, and a double spindle (Stone, 1930). Moody's role was so important that the directors offered him shares in the Boston Manufacturing Company. Moody Street in Waltham—the town's principal shopping street—and Moody Street in Lowell are both named for Paul Moody.

The Boston Manufacturing Company built a second mill in 1818 and a third in 1820. By then, they had come to the limit of the waterpower of the Charles River in Waltham. The early success of the Waltham mill

encouraged others to build mills along the Charles River. Only a few miles upstream at Newton Lower Falls, Rufus Elliot (who already owned the Newton Iron Works at the site) built a cotton factory with 3,000 spindles to weave sheeting (Clarke, 1911). The Aetna Mill was built downstream at the falls in Watertown.

The enterprise of the Boston Manufacturing Company in Waltham proved a huge financial success and established the model for Boston money and organizational skill to finance the development of mills along rural rivers with water flows powerful enough to turn the machinery. The success of the Waltham mills persuaded others to shift their money from shipping and commerce to the manufacture of cotton textiles. During the early decades of the nineteenth century, New England was gripped by "cotton fever." In short order, cotton replaced the use of flax in the production of cloth. Venture capitalists from Boston and Salem went out to the country to search for sites along powerful rivers and falls where they could locate their cotton mills. The Piscataqua and the Salmon Rivers in New Hampshire were suitable sites, but it was the Merrimack River that offered the greatest possibilities.

THE BOSTON ASSOCIATES

This "Enterprising Elite"—to borrow the phrase of Robert F. Dalzell Jr. (1987)—was made up of a small body of young men who had moved to Boston. Francis Cabot Lowell was from Newburyport, Massachusetts. The Lawrence brothers—Amos and Abbott—left the family farm in Groton. The Appleton brothers hailed from New Ipswich, New Hampshire. The Cabots and the Thorndikes were from Beverly and the Jacksons came from Newburyport. These men and their friends became known as the "Boston Associates." They joined the same clubs, conducted business together, and built their homes around the Boston Common and on Beacon Hill. There were strong family ties among the Associates.

Cotton textile manufacturing was their best-known venture. Various combinations of the Associates were involved in the development of mills in Waltham, Lowell, Lawrence, Chicopee, and Holyoke, as well as in Manchester, New Hampshire and Saco, Maine. By 1830 innovations in cotton slowed down and the Boston Associates branched out into new ventures. By 1845 an estimated eighty men formed this closed circle.

Some of the Boston Associates were involved in the building of the Boston & Worcester, the Boston & Albany, and the Boston & Lowell Railroads. The Associates played a key role in Massachusetts banking and insurance. Their Massachusetts Hospital Life Insurance Company provided much of the loan capital to build the textile mills. The Associates helped establish the Boston

Athenaeum, the Massachusetts General Hospital, the McLean Hospital, and many other institutions. They sent their sons to Harvard and married off their sons and daughters into the families of their associates. They formed a benign elite known as the "Boston Brahmins."

An example of this inbreeding can be seen in the short life of Charles Russell Lowell Jr. (1835–1864). His mother was the daughter of Patrick Tracy Jackson (brother-in-law to Francis Cabot Lowell), who married her cousin Charles Russell Lowell. Charles Jr. graduated from Harvard in 1854. He entered the Union army and, in April 1863, became colonel of the 2nd Massachusetts cavalry. Lowell married Josephine Shaw, a sister of Colonel Robert G. Shaw, who led the 54th Massachusetts Infantry, made up of free black soldiers. Shaw lost his life in the battle at Fort Wagner, South Carolina. Charles Russell Lowell Jr. was fatally injured at Cedar Creek. He was buried in the Mt. Auburn Cemetery in Cambridge, Massachusetts.

How East Chelmsford Became America's First Planned Industrial City

The well-capitalized Boston Manufacturing Company, with its three mills in Waltham and hundreds of workers, was the largest industrial enterprise in Massachusetts. The rather coarse fabric it produced found a ready market in New England—especially among the farming community. The company was successful despite the flood of cheap and good textiles imported from England. Mass production kept prices low, so Waltham was able to compete against Manchester, England.

Francis Cabot Lowell died in 1817 at the age of forty-two. After his death his principal partners, Nathan Appleton and Patrick Jackson, carried his vision forward. The success of the mills in Waltham persuaded the Boston Associates to enlarge their plans and develop a great industrial city along the banks of the fast-flowing Merrimack River. As a site they chose the sparsely populated village of East Chelmsford, Massachusetts, which was located near the Pawtucket Falls where the Merrimack River drops thirty-two feet. The surge of these falls offered abundant energy—very useful indeed for the cotton mills.

There were a number of other reasons to recommend this site for a textile-manufacturing city. At the end of the eighteenth century, the two-mile-long Pawtucket Canal was built to circumvent the Pawtucket Falls and make the Merrimack a navigable river well into New Hampshire. This canal project had been financed by the shipbuilders of Newburyport, an important town at the mouth of the Merrimack River. The shipbuilders wanted ready access to the timber of New Hampshire to build their ships, which provided much of the town's wealth. The embargo of 1808 put an abrupt end to shipping from Newburyport and led to the dwindling of its

fortunes. As a result, the canal was neglected for some years. The Boston Associates were quick to see that the canal offered an additional source of water flow along which more mills could be built. Furthermore, the nearby Middlesex Canal, built in 1802, provided access from the Merrimack River to the port of Boston only twenty-seven miles away. Before the coming of the railroads, this canal was the cheapest and quickest way to transport people and goods from the northern interior of Massachusetts to Boston.

Starting in 1821 individual shareholders of the Boston Company quietly bought up the land in East Chelmsford. Before word got out, the Boston Company owned the land, the water rights, and the Pawtucket Canal. They named their new town in honor of the late Francis Cabot Lowell. These Boston capitalists formed the Merrimack Manufacturing Company with a capital of $600,000, which developed Lowell into America's first planned industrial city. The company set about to build a system of feeder waterways, which were linked to the old Pawtucket Canal to create additional power canals.

Seven mills were built during the first phase of construction. These where the Lowell, Tremont, Suffolk, Appleton, Hamilton, Lawrence, and Merrimack Mills. Six of these mills were built along the new canals, with only the Merrimack Mill built alongside the natural river and using the full thirty-foot drop of the Pawtucket Falls. These mills were typically 155 feet long and forty-four feet wide. Each mill had five floors facing the river and four floors facing the street. The enormous waterwheel in the basement provided the force to drive the machinery. On the first floor were the machines to prepare the cotton for spinning. The next floor had the spinning machines, and the weaving room was above that. The top floor contained the machines to prepare the warp for weaving.

In 1847 an additional canal was built to accommodate even more mills. In all, the Merrimack Manufacturing Company built seventeen mills, which they offered for lease. The income generated from these leases was over $500,000 per year. The first mill began operation in September 1823. Instead of the plain sheeting cloth produced in Waltham, the Lowell mills specialized in different products. One mill produced fancy calico cloth, another stockings, a third colored sheeting, a fourth underwear, and so on. The headquarters and principal officials of the Merrimack Manufacturing Company stayed in Boston. Raw materials from the South and machinery (much of it of English manufacture) were purchased from Boston for shipment to the mills.

Companies other than Merrimack Manufacturing also built mills along the canals. By the end of 1845 there were thirty-one mills on the canal system

containing in all over 200,000 spindles and over 6,000 looms. In 1842 Charles Dickens visited Lowell during his tour of America. He took the train from Boston to Lowell and found the new city already "a large, populous, thriving place." Dickens visited a woolen factory, a carpet mill, and a cotton factory and compared them favorably with the mills in his native England. Dickens was impressed by the mill girls, who were well-dressed and healthy and not "degraded beasts of burden." These young women, mostly farmers' daughters from Maine and New Hampshire, lived in boardinghouses near the factories. Dickens noted that, in July 1841, "no fewer than nine hundred and seventy-eight of these girls were depositors in the Lowell Savings Bank: the amount of these joint deposits was estimated at one hundred thousand dollars, or twenty thousand English pounds." Dickens was also impressed by the intellectual vigor of these young women, many of whom subscribed to circulating libraries and contributed to a periodical called *The Lowell Offering*. Their alertness was all the more remarkable given that they worked in the mills "upon an average, twelve hours a day." Dickens seemed pleased that the young women remained in the mills for only a few years and then returned to live with their families (Dickens, 1842).

Two men—Kirk Boott and James B. Francis—in particular, were responsible for transforming the village of East Chelmsford into the mighty textile city called Lowell. Kirk Boott was born in London in 1790. Around 1811 he met Boston merchant Francis Cabot Lowell. Boott was so taken with the vision of the enterprising American that he later moved to the United States to serve as chief agent for the Merrimack Manufacturing Company and to supervise the construction of the new industrial center. It is recorded that he wished to call the town Derby, after his ancestral home in England, but he bowed to local pressure and named it Lowell in memory of Francis Lowell, who had died a few years before.

Boott did much of the planning for the canals, the construction of the mills, and the development of new machinery. He died at the early age of forty-seven. The Boott Millyard of Lowell—consisting of six linked mills sited between the Merrimack River and the Eastern Canal—was named in his memory. As with the other mills in Lowell, the Boott Millyard first depended on waterpower but was later modified to steam power and finally to electricity. Today the Boott mill buildings are part of the Lowell National Historic Park.

The second key official responsible for the development of Lowell was James B. Francis. Also English-born, Francis (1815–1892) served as chief engineer of the canal system. It was his task to ensure a steady flow of water through the canals and down the Merrimack River. Francis controlled the lakes feeding the Merrimack and used them as reservoirs during the dry

periods. He remained with the company for over forty years and oversaw the expansion of the canal system and the transfer from water to steam power.

THE BOSTON ELITE AND THE TEXTILE INDUSTRY

The original members of Francis Cabot Lowell's group did very well out of their investment in the Waltham mills. Many of them were also involved in the new cotton ventures in Lowell. Most made their money as merchants and then shifted to textile manufacturing for its more regular and larger stream of profits. Patrick Tracy Jackson (brother-in-law to the late Francis Cabot Lowell and a major shareholder in the Boston Manufacturing Company) financed the construction of the Boston & Lowell Railroad and imported steam locomotives from England. Later, locomotives were built locally at the Lowell Machine Works. The opening of the Boston & Lowell Railroad in 1835 greatly increased the traffic between the two cities. From Boston, the railroad stopped at Medford, Winchester, Woburn, and Billerica before reaching Lowell. Later the line was extended north of Lowell to Manchester, with its huge Amoskeag Manufacturing Company, and on to Concord, New Hampshire. In short order the city of Lowell was connected by rail to the nearby towns of Nashua, New Hampshire as well as to Salem, Massachusetts (Malone, 1991).

Amos Lawrence and his younger brother Abbott left their home in Groton, Massachusetts and moved to Boston where they made their fortune in commerce. Their firm, known as A&A Lawrence & Company, was founded in 1814 and quickly became one of America's major mercantile houses, importing goods from England. With their stake in local mills, the firm began selling cotton and woolen goods on commission. Textiles and clothing from the Lowell Mills were marketed to the American South and West, as well as to markets abroad, including Central and South America, Russia, and even China. The firm of A&A Lawrence & Company greatly expanded the market for American made goods at a time when European commerce was disrupted by the Napoleonic Wars. The Lawrence brothers invested funds in the Suffolk and Tremont Mills. In 1831 they agreed to finance the building of the Lawrence Manufacturing Company. This move further enhanced their role as owners, manufacturers, and the major selling agents for a number of the mills in Lowell. Lawrence Manufacturing was directed from offices in Boston. The company maintained its own cotton warehouses in New Orleans. From the South, the cotton was shipped to the company storerooms near Boston Harbor and then sent on to the factories in Lowell.

As they relinquished their business interests, both Amos and Abbott set about their political and philanthropic adventures. Amos donated money to

several schools, including Williams and Bowdoin Colleges. He also gave $10,000 to the building of the Bunker Hill monument. Abbot Lawrence promoted several railroads, including the Boston & Albany. He left money to Harvard University and made gifts to the Boston Public Library.

Nathan Appleton (1779–1861) started life in New Ipswich, New Hampshire, as one of ten children born into a poor family. At age fifteen he moved to Boston to work as a clerk in his brother Samuel's store where he quickly showed a talent for commerce. While on a visit to Edinburgh in 1811 he met his distant cousin, Francis Cabot Lowell, and was attracted to his vision to develop textile manufacturing in America. Both Appleton and Lowell were shocked by the human degradation associated with the English textile industry and vowed to provide better conditions for their own workers. Appleton invested $5,000 in the Waltham mills and was among the first to be involved in the East Chelmsford venture. In 1830 he was elected to the U.S. House of Representatives and became one of Boston's richest men. He died at age eighty-two and was buried in the Mount Auburn Cemetery.

OTHER INDUSTRIES IN LOWELL

Although dominant, cotton was not the only industry in Lowell. In 1833, fifteen-year-old James Cook Ayer arrived at his uncle's house in Lowell. He got a job in Jacob Robbins Apothecary Shop and worked for a few years while studying medicine under the tutelage of Dr. Samuel Dana. James Ayer was a creative and ambitious young man. At age twenty-two, he bought Robbins's shop and started to manufacture patent medicines. He introduced Ayer's Cherry Pectoral and Ayer's Hair Vigor. Ayer bought out his competitor, Reuben P. Hall Company, and came out with Hall's Hair Renewer. Dr. Ayer's great success was with Ayer's Sarsaparilla. The root of the sarsaparilla vine was used for centuries as a medicine by the indigenous peoples of South and Central America. The root was introduced into Europe in 1536, and was used for the treatment of rheumatism and syphilis. It was registered in the U.S. Pharmacopoeia as early as 1820. In charming advertisements featuring blond, blue-eyed, healthy children, Dr. Ayer informed his customers that he employed only the finest Honduras sarsaparilla. His sarsaparilla preparation was alleged to purify the blood, as well as cure liver and kidney diseases, jaundice, dropsy, "and other serious disorders." The company issued fifteen million almanacs each year and advertised across the nation. Dr. J.C. Ayer & Company continued in Lowell until the 1940s.

Another Lowell enterprise, C.I. Hood & Company, advertised their sarsaparilla in competition with Ayer's. This product too was advertised as a

blood purifier and as a remedy for many other ailments. Hood broadened its business by offering cookbooks and a painting book. *Hood's Painting Book* could be obtained by sending a label off a sarsaparilla bottle together with eight 2¢ stamps.

In 1893 the Consumers Brewing Company was established in Lowell. Within a few years, the company had built a large brewery on Plain Street. During its early years, most of the workers were drawn from the German immigrant community. In 1898 the name was changed to the Harvard Brewing Company. The first president of the company was John J. Joyce of Lawrence, Massachusetts. Joyce was an immigrant from Ireland who became very wealthy. He owned several large companies and was an early investor and principal stockholder of the Gillette Safety Razor Company in Boston.

The success of Harvard Brewing was threatened by the growth of the temperance movement. The company tried to adjust by disguising itself as a manufacturer of non-alcoholic drinks. During the era of prohibition, the factory was raided and over 100,000 gallons of full-strength brew were found on the premises. The company reopened its brewery following the repeal of prohibition and, by 1933, capacity reached 1,000 barrels of beer a day. The Harvard Brewing Company limped along afterWorld War II with declining sales and rising debt. The Lowell brewery finally shut its doors in 1956 and the production of beer was moved elsewhere.

LAWRENCE, MASSACHUSETTS

By 1840 there were over thirty textile mills in Lowell and the waterpower was taxed to capacity. Some of the Boston Associates, led by Abbott Lawrence, cast about for a site for yet another great textile manufacturing center. They chose Bowdell's Falls with its abundant waterpower, some eleven miles down the Merrimack River from Lowell. This site offered the opportunity to build a dam to better control the flow of the water.

The Merrimack Water Power Company was incorporated in March 1843 with a plan to harness the waters of the Merrimack River at this site and to use the power for another planned manufacturing city. Two years later, on March 20, 1845, the Essex Company was incorporated and quickly raised a capital of $1 million. The directors of the Essex Company were largely the same as those of the Boston Manufacturing Company of Waltham and the Merrimack Manufacturing Company, which created the textile city of Lowell. They included Abbott Lawrence, Nathan Appleton, Patrick T. Jackson, John A. Lowell, Ignatius Sargent, William Sturgis, and Charles S. Storrow. Storrow served as the superintendent of the Boston & Lowell Railroad—the first passenger railroad in New England—before his

appointment as resident manager of the new project. The new town was to be called Lawrence in appreciation of the efforts of the Lawrence brothers, who had staked their fortune on the success of the new textile town (Dorgan M.B., 1924).[2]

Charles Storrow was the first mayor of the town of Lawrence. Vast sums of money were spent to develop the infrastructure of the factory town. Storrow supervised the installation of gas and water pipes and the building of streets. A great machine shop was built together with fifty brick buildings, boardinghouses for the workers were erected, and the dam across the Merrimack River was completed in 1848. The granite blocks were laid thirty-five feet thick at the bottom of the river, tapering to a width of thirteen feet at the surface of the water. The flow of water at the edge of the dam was 900 feet wide. This dam would ensure a more steady flow of water for the planned mills even when the weather was dry and the flow upriver was slow. In addition, Storrow supervised the building of a north and a south canal to further increase the area for mill construction. Sawmills and railroads were built and construction materials poured into the site. It was estimated that between 100,000 and 200,000 bricks were delivered *every day* to Lawrence during the main phase of construction. The city attracted laborers and skilled workers from far and wide.

Laborers were paid 85¢ to $1 a day while masons, carpenters, stone-cutters, and other skilled workers were paid $1.50 to $2 a day. Land for houses and stores were first put up for sale as of April 1846. A post office opened that year, soon to be followed by a bank, a hospital, churches, and the public library. The first grammar school opened in 1848 and, the following year, Lawrence High School opened with seventeen students. By 1848 the town's population exceeded 6,000 people of whom two-thirds were native-born and one-third immigrants from Ireland.

[2]Lawrence, Massachusetts is not the only town to be named for this family. In 1854 the possibility that Kansas would become a slave state deeply troubled the people of Massachusetts who were passionately opposed to slavery. The Emigrant Aid Society was established in Massachusetts to fight against this move, and to help Massachusetts's people to move to Kansas and bolster the demand for a slave-free state. Amos Adams Lawrence, the son of Amos Lawrence, was among the first to endorse this movement and to offer financial support. In 1854 he became treasurer of the Emigrant Aid Society. His involvement encouraged other prominent Bostonians to support the movement for a slave-free Kansas. A delegation of Massachusetts men was sent out to Kansas to seek a suitable location for the new community. They settled on an area between the Kansas River and the Wakarusa River. The first group of emigrants left Boston on July 17, 1854, and arrived in Kansas two weeks later to set up the first free town in the state. Altogether, the Emigrant Aid Society sponsored some 1,300 settlers to Kansas. The proposed town was laid out, roads developed, and lots were sold. A meeting was held to decide on a name for the new town. They chose the name "Lawrence" in gratitude for the support given to them by Amos A. Lawrence of Boston. Amos was so thrilled by the honor that he gave an extra $12,000 to establish a college in the new town, which became the University of Kansas at Lawrence. The main street in Lawrence, Kansas, is Massachusetts Street.

In short order, the new town was connected by railroad to Boston, Lowell, Salem, and Manchester, New Hampshire. Starting in 1867 an extensive network of tracks for horse-drawn trolleys linked the downtown with the suburbs. After 1890 the system was electrified and extended to southern New Hampshire and to Lowell and Haverhill. A trolley line led to Canobie Lake Park where the folks would go for relaxation. The steamship, appropriately named *The Lawrence,* sailed the Merrimack River between Lawrence and Newburyport.

The first mill in Lawrence was named the Bay State (later renamed the Washington Mills). It entered production in 1847. The Bay State Mill was followed by the Atlantic Cotton Mills; the Pacific, Pemberton, and Lawrence Duck Mills (1853); the Everett Mill (1860); the Lawrence Woolen Company (1864); and the Arlington Mills (1865). Each mill had its specialty. The Bay State Mill, for example, produced shawls and blue flannel coats, while the Arlington Mills produced mohair goods. The Pacific Mills were renowned for the quality of their printed, dyed, or bleached cotton goods. In their time, the Pacific Mills were among the largest in the world. The seven-story factory was over 800 feet long and seventy-two feet wide.

The mills stressed labor and the wide range of specific jobs acquired colorful yet descriptive names. There were wool sorters, mule spinners, carders and combers, twisters, loom fixers, dyers and finishers, and weavers. There were also web drawers, jack spoolers, perchers, slasher dressers, drawing-room helpers, hand folders, shippers and packers, and warp dressers and beamers. Above these workers were the ever-present supervisors. The directors mostly lived in Boston and controlled the mills through their local managers.

The early years of Lawrence were not easy. The city was faced with a number of destructive fires, as well as the financial crisis of 1857. In 1860 the Pemberton Mill collapsed, killing over eighty workers. The Civil War led to the suspension of cotton textile production in several mills. Many workers lost their jobs during the war and 2,600 men enlisted to fight for the Union.

Amos Lawrence also used his wealth—derived from the textile mills of Lowell and Lawrence—to purchase land in Wisconsin. In 1849 he financed the settlement of the town of Appleton (his wife's family name) in northeastern Wisconsin and donated money to set up a college. Lawrence University in Appleton, Wisconsin, was chartered in 1847 and is named in his honor. Harry Houdini (born in Budapest in 1874 as Erik Weisz) grew up in Appleton. He ran away from home at age twelve to begin his illustrious career in vaudeville.

THE WOOL MARKET

The town of Lawrence differed from Lowell in that it became mainly a woolen textile center. This was partly in response to the suspension of cotton sales from the South during the Civil War. The town was known as the worsted wool center of the world. This material was used both for men's and women's clothing. The wool trade closely linked the wool textile towns of Massachusetts with the city of Boston. Simply put, Boston became the great wool market because New England—and principally Massachusetts—was the birthplace of the nation's wool industry. By 1915, New England had 448 wool mills that employed over 100,000 people. This concentration of mills made up more than half of the whole nation's collection and so Boston controlled half of the nation's wool trade. By the early part of the twentieth century, Boston even rivaled London as the world's largest wool market.

The wool was sent by boat to the port of Boston and stored in warehouses for shipment to the mills. It was said that the Boston wool market was so large that a man could buy as much wool as he wanted without boosting the price. There were many wool brokerage companies in the area around Boston's customhouse. After the fire of 1872, the wool importers moved mainly along Summer Street beyond South Station (see Henry Kidder's chapter on the "Boston Wool Trade" in Bacon, 1916). These wool importers had their agents wherever wool was produced. Wool came into the port of Boston from other American states, as well as from Australia, South America, New Zealand, and the Cape Colony. Wool importers such as Alexander Wright, George William Bond, and Matthew Luce became wealthy men and were major figures in nineteenth-century and early twentieth-century Boston.

THE AMERICAN WOOLEN COMPANY

The enormous growth in woolen textile production began during the last years of the nineteenth century and was due largely to the vision and enterprise of one man—William Madison Wood Jr. He built the American Woolen Company into the world's largest wool company.

The story of the American Woolen Company offers a fascinating glimpse into the history of Massachusetts during the Golden Age of the textile industry. Wood (1858–1926), of Portuguese and English ancestry, was born on the island of Martha's Vineyard. His family moved to New Bedford when he was four years of age. His father, William Sr., found work on the New Bedford whaling ships. After his father's death, William Jr. left school at age fourteen and sold apples out of a barrel to support his family. He later got a job in the counting room of the Wamsutta Cotton Mill in New Bedford. In

the evenings he taught himself Latin, French, German, and mathematics. His intelligence and resourcefulness came to the notice of the mill owners, who encouraged his career.

After a stint in a Philadelphia brokerage house, Wood returned to Massachusetts to work as the paymaster of the Border Mills in Fall River. In 1885 William Wood was persuaded to move to Lawrence as assistant to Frederick Ayer, who had recently bought the bankrupt Washington Mills. Frederick was the younger brother of James C. Ayer of Lowell, who had made his fortune in patent medicines and sarsaparilla. Frederick took over the sarsaparilla business after James died. Frederick wanted to get into the bigger textile business, about which he knew little. Wood again proved himself very effective and brought the mill out of bankruptcy. In 1899, Ayer and Wood consolidated eight mills into a trust named the American Woolen Company. Other partners were Charles Fletcher of Providence, James Phillipps Jr. of Fitchburg, and Augustus D. Julliard of New York. When he died in 1919, Julliard had a fortune of $20 million. He left a large endowment to New York's Institute of Musical Art (founded in 1905), which sought to rival the European music conservatories. The institute was renamed the Julliard School in his memory.

Under the leadership of Ayer and Wood, the American Woolen Company expanded in Lawrence and other sites to became the largest woolen and worsted fabric maker in the world. By 1921 the American Woolen Company owned fifty-eight mills, mostly in New England. American Woolen employed over 40,000 people (of whom 15,000 worked in Lawrence) and produced one-fifth of all the textiles in the United States. The company paid a regular dividend of 7 percent and was regarded as a splendid investment. One of its major sites outside of Lawrence was in Maynard, a town some twenty-five miles west of Boston. The American Woolen Company bought the failed Assabet Manufacturing Company and expanded it into the largest wool factory in New England.[3]

Wood was the brains and the drive behind the American Woolen. He embarked on a major program of mill expansion. The largest of them—the Wood Mills of Lawrence—carried his name. This monster mill was six stories high, 1,937 feet long (one-third of a mile!), and 126 feet wide. The second new mill, named for Frederick Ayer, was more modest in size. Wood also enlarged some of the older mills in Lawrence.

By 1920, the American Woolen Company was the largest employer in New England with a weekly payroll of $1 million. One writer estimated that

[3]The Maynard mills closed in 1950, leaving empty over one million square feet of space. Some of this space was later occupied by the Digital Equipment Company, which looked to become one of the country's leading computer companies. Digital was later bought by Compaq, which, in turn, was absorbed into the Hewlett-Packard Company.

100,000 sheep the world over were sheared each and every week to keep up with the demands of the American Woolen Company. The annual output of woolen and worsted cloth of this great company was eighty million yards— enough to provide twenty-two million suits—one for every adult male in the United States at that time. In addition, American Woolen had contracts to provide uniform cloth for the United States army and navy. For the first five years, the company generated annual net profits of nearly $3 million. The company hit upon the then-novel idea of selling directly to the public and eliminating the cost of the middlemen.

William M. Wood married Frederick Ayer's daughter, Ellen. She was well educated, having attended finishing school in France before going on to Radcliffe College in Cambridge, Massachusetts. The Wood family had a winter home on Fairfield Street in the Back Bay and country homes in Andover and Prides Crossing. William Wood was a brother-in-law to General George S. Patton. While at West Point, Patton dated Frederick Ayer's other daughter, Beatrice, and married her in 1911. In 1924 William Wood suffered a stroke and retired to Florida. On February 2, 1926, he committed suicide.

TEXTILE PRODUCTION EXPANDS TO FALL RIVER AND NEW BEDFORD

Lowell and Lawrence lie along the banks of the Merrimack River close to the border between Massachusetts and New Hampshire. Both towns were planned from scratch as industrial cities and grew with the textile industry, with money supplied by the wealthy Boston merchants and ship owners. Boston men and Boston money, by contrast, were much less involved in the coastal towns of Fall River and New Bedford where the next great expansion of textile manufacture took place. These towns were settled in the seventeenth century as a natural expansion of the colony in Plymouth. New Bedford and Fall River started as fishing and agricultural communities and became rich from whaling. It was this wealth that helped launch the textile industry in southern Massachusetts.

In our time, Fall River is better known for the tale of Lizzie Borden, who was suspected of axing her father and step-mother to death in 1892. The Borden family in Fall River went back several generations before Lizzie, and in kinder times, the Borden name was associated with enterprise and civic responsibility rather than with gruesome murders.

In 1659 settlers from the Plymouth Colony bought land from the Wampanoag and Pocasset Indian tribes. Running through the land is a small river that cascades down steep falls before entering the Taunton River. In the space of a half-mile, the river drops some 132 feet over granite formations and creates enormous power. It is known as Quequechan (meaning "falling water"). For the period from 1804 to 1834, the town was

known as Troy, but this was changed to Fall River to celebrate its special river. Before 1746 much of the Quequechan River lay within the state of Rhode Island and the town of Fall River fell within the orbit of Little Rhodie. A royal commission was set up to resolve the conflict between the two states. Fall River was given to Massachusetts and nearby Tiverton went to Rhode Island (Earl, 1877). Fall River lies fifty miles south of Boston, but is only fourteen miles east of Providence.

In 1813 David Anthony and his partners built the Fall River Manufactory, and Oliver Chace and his group established the Troy Cotton and Woolen Manufactory. Each group had a capital of some $50,000 and planned to build mills sixty feet long and forty feet deep, each with 1,500 spindles and a staff of thirty-five. Most of the money for the mills was raised in Fall River, Tiverton, Newport, Swansea, Somerset, and the other small towns and villages nearby. The model was Samuel Slater's small mill in Pawtucket, Rhode Island, rather than the much larger undertaking of the Boston Manufacturing Company in Waltham.

David Anthony grew up on a farm in nearby Somerset. In 1808, he moved to Pawtucket and worked in Slater's mill before setting out on his own. The Fall River and Troy mills were fortunate to begin their operations at a time when foreign cloth imports were restricted from entry into the United States.

Over the years, other local men raised money to set up small textile factories in Fall River. In 1824 Andrew Robeson built a calico printing shop with money raised in New Bedford. The enterprising Bradford Durfee established the Annawan Manufactory with 7,000 spindles. Holder Borden established the American Print Works, specializing in calico printing, in 1835. The Durfee and the Borden families together developed the Fall River Iron Works. This company converted scrap iron into hoop-iron for the oil casks used on the New Bedford whaling ships. Later, the company built steamships for the run between Fall River and Providence. The Bordens also financed a railroad link between Fall River and Boston.

The pace of Fall River's development picked up quickly after the Civil War. In 1865, the town had fifteen cotton mills. Ten years later, there were thirty-eight with over 1.2 million spindles. With the invention of the steam engine, waterpower became redundant and the new mills were near the harbor. By 1910, Fall River had well over one hundred textile mills employing altogether 30,000 workers. It became known as the "Spindle City." The Tucumseh, Wampanoag, Narragansett, Massasoit, and Wamsutta Mills carried Indian names. The Robeson, Durfee, Duval, Osborne, Barnard, and Chase Mills were named for their principal owners. At their peak, the mills operated twenty-four hours a day. Fall River exceeded Lowell to become the largest cotton textile center in the United States.

New Bedford was founded where the Acushnet River enters the Atlantic Ocean. Native Americans hunted in the woods, planted crops on the plains, and fished in the estuary. Thirty-two years after the landing at Plymouth, Myles Standish and other settlers from the Plymouth Colony bought land from the Indian chief Massasoit. This large parcel of land encompasses the present communities of New Bedford, Fairhaven, Dartmouth, and Achushnet.

The newcomers settled down to a life of farming and fishing. Shipbuilding started on a large scale in the eighteenth century when the whaling industry moved to New Bedford from the island of Nantucket. During the War for Independence, the town was a hotbed for privateers. The British retaliated in 1778 by attacking the town and destroying the ships, wharves, and stores. Whaling recovered after the peace settlement with Britain and remained the dominant industry until the middle of the nineteenth century. Ships with names like *Panther, Bear, Hunter,* and *Tropic Bird* were built locally and sailed from New Bedford to the Arctic regions and Hawaii to hunt the whale. The wharves were regularly lined with returning ships off-loading casks filled with whale oil. Processing plants near the harbor refined the oil for use as lubricants, lamp oil, and to make soap and candles. Metal works were set up to produce the copper sheathing for the boats and to build the pumps, ships' bells, and other fittings. Hastings and Company was engaged in the manufacture of whale oil. The company bought and refined some 40,000 barrels of oil a year and competed with Delano and Company, W.A. Robinson and Company, and Samuel Leonard and Son. All of these companies processed whale oil.

Business begets business. The Gosnold Iron Works of New Bedford processed scrap iron imported from Europe into hoop iron and rods. The company found a local market for its goods, and sent its products by boat to Boston and New York. The manufacture of carriages became a big business in New Bedford. William White and Company and Brownell, Ashley and Company competed for sales. The New Bedford Cordage Company, established in 1842, supplied the ropes for the ships. New Bedford had sailmakers, chandleries, and agencies serving the maritime trades.

The wealthy ship and factory owners, as well as the merchants—including the Russell, Rotch, Rodman, Grinnell, and the Howland families—built their mansions on the Country Road overlooking the harbor. When George Howland died in 1852, he left an estate of over $600,000, which was comprised of his home, nine whaling ships, a wharf, and a candle factory. It was said that New Bedford had forty to fifty men as wealthy as old George Howland. By 1854 the population of the town reached 20,000 and the fleet

brought in $11 million worth of whale oil and whalebone. With over 300 whalers (one-third of all the whaling ships in the world), New Bedford became known as the Whaling Capital of the World. The city had become a very wealthy place indeed.

New Bedford's golden age of sail came under threat in 1859 with the discovery of petroleum in Pennsylvania, leading to a fall in the demand for whale oil. The Civil War (1861–1865) and the loss of many whaling ships in the Arctic waters further undermined the industry. Shipping kept going for a few more years by hunting the baleen whale in the frigid Arctic waters. The bones of the baleen were long used by the Inuit Indians for ceremonial and decorative purposes and the Japanese used baleen in their sword handles, as well as in tea trays and shoehorns. In the second half of the nineteenth century, the use of baleen was comparable to modern-day plastics. It was used in making corsets, petticoats, and umbrella handles. As fashion changed and new materials became available, this too began to fail. By the early 1900s New Bedford's life as a whaling port had come to an end.

The success of nearby Fall River—only twelve miles to the west—encouraged some entrepreneurs to shift their money from whaling to textiles. Captain Abraham Howland, who had sailed ships around the coast of southern Africa on to Madagascar and India, decided to settle down in New Bedford and to try his hand at a new enterprise. He got his brother-in-law interested in his project to start a cotton factory to be called the Wamsutta Mills. The two of them set about to interest the town's well-to-do citizens in their project. They got lucky when they approached the seventy-year-old Joseph Grinnell, one of the town's most distinguished men. Grinnell was born in 1788, one of several children of the whaling captain Cornelius Grinnell and his wife Sylvia. Joseph was one of the town's leading merchants and the president of the First National Bank. From 1843 to 1851, Grinnell was a U.S. Congressman representing the 10th Massachusetts district. In 1840 he financed the railroad between New Bedford and Taunton, against powerful opposition from the stagecoach lobby. "Honorable Joe," as he was known, also had interests in whaling and in the China trade. Grinnell agreed to invest $12,000 of his own money in the Wamsutta cotton mill.

The Wamsutta Mill opened in 1848 with Joseph Grinnell as its first president. It was the first successful textile mill in New Bedford. Wamsutta grew into a six-mill complex employing over 2,300 workers. Additional mills were built after 1880 when whaling was in decline. The Potomska, Grinnell, Acushnet, and the Oneka Mills were built with money made in New Bedford during the whaling days. These were steam-powered mills, built along the shore of the Acushnet River. Close by were the railroads, which delivered the raw cotton and shipped out the textile fabric.

Instead of whaling ships, the docks were now filled with schooners bringing in stone and lumber to build the mills. The city opened the New Bedford Textile School (1899), which offered training in the manufacture and distribution of textiles. By 1920, there were over forty textile mills in New Bedford with over 30,000 workers. The labor-intensive textile industry demanded ever more workers, and immigrants flocked to the town. The population had swollen to 120,000, with textiles far and away the city's dominant industry. The mills in New Bedford produced high-quality cotton goods. New Bedford was a close third behind Fall River and Lowell in the number of operating spindles (Whitman, 1997).

The Quakers who dominated the affairs of early New Bedford strongly opposed slavery and were more welcoming of African Americans than most other towns. During the heyday of the whaling trade, New Bedford became home to mariners from the Cape Verde Islands, Africa, and Asia, who worked on the whaling ships. As early as 1830 the black community in New Bedford numbered over 1,000, including many runaway slaves. Their children entered New Bedford's public schools and Portuguese became the second language of the town.

Frederick Grinnell (1836–1905) was a great-grandnephew to Joseph Grinnell. He was a director of several banks and textile manufacturers in New Bedford and trained as a mechanical engineer and built steam engines for ships and locomotives. He was the inventor of the first automatic fire sprinkler. Both the Wamsutta and the Grinnell product names remain today, but now form parts of larger companies.

TEXTILE MILLS IN OTHER MASSACHUSETTS TOWNS

Cotton and wool mills were also built in North Andover, Haverhill, Amesbury, Newburyport, and many other Massachusetts towns. The village of North Andover lies near Lake Cochichewick and is a few miles to the south of Lawrence. Early in the nineteenth century the three Scholfield brothers, who had recently immigrated to the United States, tried their hand at wool manufacture in a small mill on the lake. Local farmers brought their wool to the mill to have it spun and woven. The Scholfield brothers learned their trade from Samuel Slater, but their factory went into debt and was sold to William Sutton. The Sutton forebears had arrived in North Andover around 1640 from Lincolnshire, England. William Sutton developed a flourishing business where the Scholfields had failed.

The Stevens flannel wool mill, founded by Moses Stevens, was situated nearby. In 1865 a dam was built to hold back the waters of the Cochichewick Lake and to better control the water flow to the mill. The Stevens mill employed forty-two workers, earning between $32 and $36 a month. The

factory produced white flannel, magenta, and blankets. The success of his factory gave Stevens the life of a country gentleman. He built himself a magnificent brownstone mansion on his 500-acre estate complete with stables, greenhouses, and farm buildings.

In 1790 Samuel Slater set up the first American spinning wheel in Pawtucket, Rhode Island. He went on to establish several more cotton and woolen mills, some of which were in Massachusetts. The mill in Rehoboth was small, being only a two-story building, forty feet long and thirty feet wide. The Webster Woolen Mill was established in southern Massachusetts and named for Daniel Webster.

Nearby Uxbridge started as an agricultural community. The Blackstone River, which passes through the village, soon attracted grist and sawmills, and later textile mills. In 1827 Graham Rogerson erected a magnificent granite mill, which he named the Crown & Eagle in homage to his English heritage. The Uxbridge mills attracted immigrants from Poland and Ireland. Soon, over 500 workers in Uxbridge were producing 2.5 million yards of cotton and woolen cloth each year.

"Mill fever" gripped Massachusetts for much of the nineteenth century and provided a profitable replacement for shipping and farming, which were in decline. The large Naumkeag Steam Cotton Company was built along the waterfront in Salem in 1847. Financed with local money, this mill employed over 2,000 workers.

New England, especially Massachusetts and Rhode Island, dominated the American textile industry. By 1874 nearly sixty percent of all the textile mills in the United States were located in New England (Massachusetts 22 percent, Rhode Island 13 percent, and Connecticut 12 percent of all U.S. mills). The mills in Massachusetts were larger than those in other New England states and had many more looms and spindles. The dominance of the textile industry in this region continued into the early part of the twentieth century, with even larger mills being built in Lawrence, New Bedford, and Fall River.

MACHINERY FOR THE TEXTILE MILLS

Massachusetts became a leader in the manufacture of tools and machinery. Large plants were established in Lowell, Lawrence, Taunton, Worcester, and Manchester, New Hampshire, to manufacture machinery for the cotton textile industry. These shops built and maintained the machinery used in the mills. Looms built in Worcester by the Crompton Loom Works and at the Knowles factory were extensively used. Innovations at these factories soon spread to other industries, particularly to the manufacture of locomotives for the fast-growing railroad system. A good example of this was the Mason Machine Works of Taunton.

Textiles

William Mason was born in 1808 in the seaport town of Mystic, Connecticut. At age fourteen, he began an apprenticeship at a cotton mill where he soon showed his abilities in the maintenance and repair of the machinery in the factory. Cotton was a precarious business and, in the 1830s, many of the mills were bankrupt. In his early thirties, Mason moved to Taunton and set up the Mason Machine Works to build machinery for the textile industry. His obsession was the railroads. In 1850, he expanded his company and switched to the manufacture of locomotives. The Mason Machine Works was kept busy during the Civil War and remained a major locomotive builder after the war. Markets for Mason locomotives were found in the Midwest, New England, and abroad. The Mason Machine Works ceased building locomotives in Taunton in 1890. Mason steam locomotives ran along the Boston, Revere Beach, and Lynn lines from 1875 until electrification in the 1930s. (The growth of the towns of Hopedale and Whitinsville, where machinery for textile mills was built, have been discussed earlier in this book.)

THE TEXTILE TOWNS

While textile manufacturing in Massachusetts was king, the towns of Lowell, Lawrence, Fall River, and New Bedford grew and became prosperous. When he first saw East Chelmsford in 1821, Nathan Appleton envisaged a town of 20,000 people. By 1850, Lowell already had over 30,000 residents and was the twenty-second largest town in the United States. By the beginning of the twentieth century, the population was well over 100,000, with more than 20,000 working in the textile mills.

Lawrence's greatest development was from 1890 to 1924. The town attracted immigrants from Ireland, French Canada, Poland, Russia, and many other countries. By 1916, the population of Lawrence reached 100,000, of whom nearly 20,000 were schoolchildren. About half the population of Lawrence was foreign-born with especially large numbers coming from French Canada, England, Ireland, Italy, and Russia. In Massachusetts, Lawrence was second only to Boston in terms of value of manufactured goods. The payroll of nearly $1 million a week supported the stores, churches, and city services. Textiles—in particular woolen textiles—dominated the city of Lawrence, but many other businesses provided jobs. These included the Champion-International Company that made newsprint and high grade coated paper; the Lawrence Scouring Company, makers of wool scourers; and even a shoe factory, specializing in shoes for ladies and children.

The mill workers of Fall River—mostly new immigrants from Portugal, French-speaking Canada, and Ireland—lived in their own neighborhoods and attended separate Catholic churches. The Yankee mill owners resided some distance away in an area called the Highlands. Textiles were the

dominant industry of Fall River, but the town also had shipyards, ironworks, and machine manufacturing plants. Fishing was a major industry and the city also had a whaling history. By the start of the twentieth century, Fall River had a population of over 105,000. The annual payroll of the Fall River mills and factories in 1910 exceeded $25 million and brought prosperity to the city. The town had a textile school to train the next generations of workers, many of whom started working in the mills before reaching their fourteenth birthday.

Fall River was connected to Boston by the Old Colony Railway line. Steamboats of the Old Colony shipping line sailed daily between Fall River and New York. At its prime, Fall River had many imposing public buildings, including the courthouse, town hall, post office, and customhouse. The four-story Durfee High School (named for Bradford Mathew Charloner Durfee, who died at the age of twenty-nine) was equipped with laboratories, a gymnasium, and an astronomical observatory complete with a revolving dome. The building was finished in 1883 at a cost to the Durfee family of $1 million—a fortune at that time. It was regarded as one of the finest school buildings in the country.

New Bedford was the oldest and most established of the towns that came to dominate textile manufacture in Massachusetts. Its wealth—based on whaling—was evident before textiles came to town. The town sported a handsome city hall, a customhouse, and several solid banks. The wealthy built their summer homes at Horseneck Beach and the budding middle-class built their cottages at Nonquitt. On Sundays during the summer months, the trolleys carried regular folk for a day's outing at the Acushnet Park. The New Bedford Fishermen's Club fished for striped bass at Pasque Island. New Bedford Harbor was home to an active sailing club. Textile mill construction in New Bedford started in 1848 and continued until the first quarter of the twentieth century.

South Main and Pleasant Streets in Fall River were lined with elegant buildings and shops selling foodstuffs, clothing, shoes, furniture, and jewelry. The sidewalks were filled with well-dressed shoppers and the streets echoed with the sounds of horse-drawn carriages and electric trolleys. The same scene could be found along Purchase Street in New Bedford, Broadway in Lawrence, and Merrimack Street in Lowell. The wealthy and the workers lived in separate parts of the town. They shopped in its stores and used the local banks. Each of these towns had its theaters, libraries, clubs, and parks.

The prosperity from the textile industry began to ebb even before World War I. The great labor strikes in Fall River and Lawrence shook up the industry. The bosses refused to invest in new machinery and instead began to move manufacturing to southern states where labor costs were less and the

labor unions less militant. The Great Depression was a blow to these Massachusetts cities. Most of the factories closed or moved out, leaving thousands of workers without jobs. City taxes were not paid and, in 1931, Fall River declared bankruptcy. The cities of Lowell, Lawrence, New Bedford, Fall River, and others were left with abandoned and decaying mills and high unemployment. There has not been a sustained second or third act to replace textiles. All these cities have yet to recover from the loss of their nineteenth-century textile industries.

THE GARMENT TRADE

The vast quantities of cotton and woolen textiles from the Massachusetts mills were sold through wholesalers, many of which were located in Boston. Parker, Wilder & Company at 4 Winthrop Square represented a number of mills, including the Boott Mills of Lowell and the Naumkeag Steam Cotton Company of Salem. Wellington, Sears & Company was started up in 1845 by members of the Boynton, Sears, and Wellington families and represented mills in New England and later in the South.

The Reece Button-hole Machine Company (founded 1881) had a remarkable machine that could cut and sew buttonholes on coats and suits. One operator could make 8,000 buttonholes a day. The Reece factory was located at 500–514 Harrison Avenue in Boston's South End.

The abundance of locally-made cotton and woolen textiles helped the growth of the ready-made clothing industry in Massachusetts. Before the introduction of mass production methods, most garments were made by women, working at home or in small tailor shops. In 1832 there were 1,300 women, 300 men, and 100 boys working in the various tailor shops in Boston. By 1837, the number of women garment workers in Boston had increased to 2,500 (Abbott 1909). The invention of the sewing machine dramatically changed the clothing industry. In 1845 William C. Browning brought paper patterns from England to cut the cloth for men's suits in regular sizes. Others followed his lead to standardize the industry.

One of the leaders in Boston was Leonard Morse. This gentleman was born in Bavaria and came to the United States in 1848. After working as a peddler in New Hampshire, he moved to Boston and set up a clothing store at the corner of Washington and Brattle Streets. He began to make ready-to-wear clothing and soon had several factories, employing 1,500 workers in all and producing 3,000 garments a day.

The Leonard Morse Company bought textiles from all over, but preferred the worsteds from Lawrence, Massachusetts. Other garment manufacturers in Boston were Macullar-Parker & Williams, Whitten, Burdett & Young Company, and Talbot & Company. The Boston clothing industry flourished

from the 1860s to the early 1890s. Goods worth $30 to $40 million were made each year in the Boston garment trade.

After 1850 large factories with hundreds of sewing machines and hundreds of workers were set up in Boston and other towns. Italian and Jewish male immigrants, who had worked as tailors in their home countries, found employment in the factories and the number of women working in the industry began to decline. Wages ranged from $6 a week and up to $18 weekly for the highly-skilled cutters, trimmers, and overseers. The Massachusetts clothing industry became highly specialized. Some firms made work clothes or underwear, while others made finer clothes for the home and for social occasions. There were coat makers, pants, shirt, and vest makers, and suit makers, as well as workers who made the buttonholes, cuffs, and collars, and those who pressed the clothes to be ready for sale. After 1895 the business shifted to New York where most of the immigrants were settling.

Englishmen with a background in the clothing industry started coming to the small town of Needham around the time of the Civil War. John Turner hired a number of his countrymen to make knitwear in his shop. Turner was followed to Needham by the Beless family from Leicestershire, who made gloves, stockings, and jackets. Jonathan Avery built a sizeable knitwear factory in Highlandville (now Needham Heights) and the William Carter Company produced children's underwear in a nearby factory. John Moseley and Company produced gloves and children's underwear. By 1875, Needham had seventy-three factories—mainly in knitted goods—providing employment to nearly 800 workers.

A vast distribution system for ready-to-wear clothing developed in Boston. The goods from the various knitting shops were sold to wholesale merchants who then resold them to stores in New England and throughout the United States.

COLLAPSE OF THE TEXTILE INDUSTRY

Textiles, shoes, and other industries had transformed Massachusetts into an urbanized state with a dwindling rural base. Large mills dominated the textile towns. New Bedford put whaling behind it and concentrated over 80 percent of its workforce on textile manufacture. In Fall River, the concentration was 78 percent, in Lawrence 76 percent, and in Lowell 62 percent (Brown & Trager, 2000). Boston, Salem, Newburyport, and other eastern Massachusetts communities were less dependent on textiles. Over 100,000 people in the state worked in the textile industry. During the second half of the nineteenth century, textiles had seen several dark periods, but managed to bounce back. The American Woolen Company pulled several large mills from bankruptcy

and, for a while, formed a strong company. After 1920 the textile industry (together with the shoe trade) began a gradual decline from which it did not recover. There were periods—such as World War II—when the government placed huge orders for textiles. Nevertheless, the die was cast and the Massachusetts textile age was coming to an end.

Many factors contributed to this decline. The twentieth century brought more government regulation and much more trade union activity than the company directors had to cope with during the earlier years. The National Labor Relations Act (NLRA) monitored the rights of the workers and the responsibilities of management. The unions, such as the International Ladies Garment Workers Union (ILGWU), fought vigorously to improve wages and working conditions. Changes in the price of raw cotton and wool, transportation costs, and overseas competition all affected the profitability of the Massachusetts mills. Furthermore, the sheer number of cotton and woolen mills led to overproduction, which further depressed the price of finished textiles and put pressure on workers' wages.

Textile manufacture was moving to the South. In the year 1900, the North Carolina Agricultural and Mechanical College (later North Carolina State University) developed a program on textiles, with courses in manufacturing, carding, spinning, dyeing, and textile design. Students were taught how to operate textile mills. In 1901, the state of North Carolina gave $10,000 toward the construction of a school for textiles. One of the first members of the faculty was Thomas Nelson, formerly at the Lowell Textile School. In 1906 he was appointed head of the North Carolina State Textile School, a position he held for many years.

In Lowell, the Middlesex and Lowell Manufacturing Company closed. The Hamilton Company went into receivership, and the Tremont mill buildings were demolished. The mill established in 1824 by George Appleton pulled up stakes in Lowell and moved to the South. The Middlesex mills were closed. By 1929, most of the Lowell mills were shut down and their assets moved to the South. The great Lowell Machine Shop was torn down and the Massachusetts Mills were auctioned off. It is estimated that, between 1923 and 1927, some $100 million worth of mill capital left New England to be used to set up plants in the South (Gross, 1991). By 1930 only the Merrimack, Lawrence, and Boott remained among the great mills of Lowell.

The Boott Mill—incorporated in 1835 and named in honor of Kirk Boott, one of the key persons in the development of Lowell—failed in 1904. The mill soon reopened under new management. The Boott faced the same pressures endured by all the mills in New England. The directors calculated that the lower labor and transportation costs in the South made it virtually impossible for the Lowell plant to compete. In 1929 the directors bought a

mill in the South. They were able to continue some manufacturing in Lowell since they were suppliers to a number of the large Boston department stores, including Jordan Marsh, Filene's, Gilchrist, and R.H. Stearns. Towels made in the Boott Mills were sold by Sears, Montgomery-Ward, Woolworth's, and other national chains. Huge orders from the United States navy kept the Lowell plant at full speed during the war years. But signs of decay were everywhere. To keep costs down, the management neglected the one-hundred-year-old mill buildings and failed to buy new equipment. A large team of mechanics was needed to keep the old machinery running. When the old Boott plant was finally closed in the 1950s, the equipment had no value other than to be sold for scrap (Gross, 1993).

The fortunes of Lowell were briefly improved in the 1970s when the Wang Company started to manufacture computers in some of the renovated cotton mills. Soon, Wang became the dominant industry in the town, employing over 25,000 people. However, Wang guessed wrong and the demand for its product rapidly declined with the rise of the personal computer. Wang was forced to lay off its workers and the old mills of Lowell fell silent again.

The fall of the Lowell Mills was echoed throughout Massachusetts. The Great Depression was a severe blow. Many more mills closed and thousands of workers lost their jobs. Raw wool and cotton were no longer shipped into Boston Harbor and textiles no longer shipped out. The whirl of sewing machines in the garment trade was muffled. Without enough taxes, city services declined and the once-proud city of Fall River declared bankruptcy. The city could no longer pay its teachers, police, firefighters, or other city workers. Many of the shops in downtown Lowell, Lawrence, Fall River, and New Bedford lost their customers and were forced to close. The electric trolley system and the extensive railroad system lost freight and custom. They too had to consolidate or close down entirely.

The rise and fall of the textile cities is reflected by shifts in their population over the past 200 years. According to the U.S. Bureau of the Census, in 1800, America was still largely a farming and fishing country. Boston then had a population of less than 25,000 people. The seafaring towns of Salem, Newburyport, Nantucket, Marblehead, and New Bedford—each with a population of less than 10,000—were among the largest urban places in the country. By 1850 Lowell, with 33,383 people, had grown in the space of a quarter of a century from a mere idea to become the twenty-second largest town in America. The newer textile centers of New Bedford, Fall River, and Lowell were fast gaining in numbers. They reached their population peak around 1920, when New Bedford (121,217), Fall River (120,485), Lowell (112,759), and Lawrence (94,270) grew mightily with their textiles mills. These towns were among the seventy-five largest U.S. urban cities. With the collapse

of the textile industry, these cities stopped growing and indeed have lost much of their population.

Nothing has yet come to revitalize these once-great manufacturing towns. After many years, the huge mills are still empty and decaying. Some have been converted into apartments for the elderly and the needy. The carriage-trade shops, Five & Dimes, department stores, furniture stores, restaurants, and theaters have long closed their doors. Some of these grand buildings were torn down to make room for parking lots in the faint hope of keeping commerce in the old downtown. This only added to the look of desolation and decay. The remaining buildings were boarded up and the town centers of these once-prosperous cities slowly died.

A myriad of social service agencies now occupies some of the remaining downtown Victorian buildings. The old ethnic neighborhoods populated by the Irish, Poles, French Canadians, Portuguese, Jews, and Italians have changed their character as newer immigrant groups have moved in. In the course of time, the automobiles and the highways have bypassed the old towns. The venerable downtowns have decayed or been torn down and replaced by office parks and shopping malls located in the suburbs and along the highways.

Chapter Eight

SHOES AND BOOTS

The Massachusetts Bay Company "took great care . . . to secure men skilled in those trades which were necessary to make the enterprise self-supporting" (McDermott, 1918). Indeed, the Puritans and other settlers sponsored by the company were industrious and skilled in the manufacturing crafts then practiced in England. Cattle were sent from England to Salem as early as 1629. During the same year, Experience Mitchell opened a tannery in Bridgewater and Francis Ingalls started a similar business in Lynn. Thomas Beard was given land to settle in Salem and to make shoes for the residents of that town. Tanneries sprang up "all over New England and the shoemakers were able to buy their leather at reasonable prices" (McDermott, 1918).

On June 14, 1642, one of the first laws passed by the General Court of the Massachusetts Bay Colony was to regulate the use of leather. By 1648 the shoemakers, glove-makers, and furriers in Boston formed a guild to better manage their interests.

The making of footwear and cloth were skills many settlers brought with them from England. Boot- and shoemaking were established early in Boston, as well as in Milford, Haverhill, Marblehead, Weymouth, and other villages. Micah Faxon of Brockton, Warren Sweetser of Stoneham, and Thomas Emerson of Newburyport were among the first to establish shoemaking in Massachusetts. During the long and cold nights of the New England winter, the farmers would prepare the leather and make the shoes and boots for their families and neighbors.

During the eighteenth century, some thirty Massachusetts towns developed cottage industries in the manufacture of shoes. Small workshops were built, either attached to or near the houses. Here, the master shoemaker would work with his sons and a few journeymen to cobble the shoes by hand. During the winter months, the master would employ local farmers or fishermen to make the shoes for sale in the village store or even as far away as Boston. As demand for shoes grew, some of these shoe shops contracted with local shoemakers working from home.

Shoemaking was men's work, while the womenfolk did the spinning and weaving of cloth. A cobbler would make a pair of shoes from start to finish

before going on to the next pair. The Massachusetts shoemakers continued to use these traditional methods for fifty years after textile manufacturers had shifted to mass production in factories. Steam power and new technology greatly increased productivity, while massive immigration increased demand. This led to an explosive growth of the shoe industry, especially in eastern Massachusetts. During the second half of the nineteenth century, hundreds of shoe factories were opened. The shoe industry did not develop in planned new towns like Lowell and Lawrence. Rather, the shoe trade grew in dozens of established towns. Some, such as Lynn and Newburyport, are older than Boston.

Lynn and Haverhill became major shoe towns to the north of Boston, specializing in women's shoes. Nearby Peabody and Woburn were centers for the tanning of leather. Close to Boston, the town of Malden became a major producer of rubber shoes and rubber overshoes. Brockton and other towns to the south of Boston produced men's shoes. Boston itself was content to be the money and distribution center, but lagged far behind the smaller towns as a shoe-manufacturing center. The flow of raw materials and finished goods followed the same pattern seen in the textile industry. Raw hides were imported into Boston Harbor from other parts of the United States and from abroad. Leather brokers handled these imports and sent the materials by rail to the footwear factories. The finished shoes and boots were sold by Boston-based wholesalers and sent to markets all over the world.

LEATHER AND TANNERIES

The leather for the Lynn and Haverhill shoe factories first came from nearby **Peabody**. The town was settled in 1626 and was originally part of Salem. The first settlers were farmers. By 1670, a tanning industry was developed using cowhide, as well as the skins of wild animals. The early tanneries were family-owned, but the scale of operation changed with the introduction of steam boilers. In 1865 over 500 people were employed in Peabody. They processed over 325,000 sides of leather. By then, Peabody was the major producer of tanned leather for the shoe factories in Essex County.

The town was first called South Danvers, but was renamed for George Peabody, who was born there in 1785. Despite his humble beginnings and limited education, Peabody became an outstanding man of business. He had early success selling American cotton to the English and importing English finished goods to the United States. He sold Maryland bonds to the English and helped avert the state's bankruptcy. Peabody moved to London where he amassed a fortune. His money established the Peabody

Institute of Baltimore, Maryland, as well as Peabody Museums at Harvard and Yale Universities and in the town of Salem. After the Civil War, he set up the Peabody Education Fund to help the destitute children of the southern states. Peabody was sensitive to the suffering of working people in Britain and provided housing for them. He was one of very few Americans awarded the "Freedom of the City of London." He died in London in 1869 and his body was returned to the United States for burial in the town of his birth.

The demand for leather grew with the shoe industry. Agricultural towns like Shrewsbury developed large cattle herds to send the hides to the tannery towns like Peabody and Woburn. The decline of Massachusetts farming in the nineteenth century and the spectacular growth of the footwear industry led to a search for hides from other sources. As the railroads were expanded, the hides came from the midwestern states or were imported into Boston Harbor from Central and South America. A large wholesale leather business grew in Boston near the railroad terminals and the port. McDermott (1918) estimates that in 1856 there were over 200 jobbing and wholesale leather houses in Boston doing an annual trade worth $50 million. At that time, the Boston leather trade far exceeded that of New York, which had only fifty-six trading houses and a turnover of a mere $15 million.

Boston's Leather District today is known for its restaurants, art galleries, and loft apartments. In the late nineteenth century, this was the center of the leather trade. The Great Fire of 1872 destroyed most of these leather businesses, causing losses in excess of $10 million. So important was this industry that a new Leather District was built on South and Lincoln Streets, close to where South Station now stands. In these red brick, block-length buildings were housed over 300 wholesale leather brokers, as well as many other leather businesses. Some of these buildings were neo-Romanesque or Renaissance Revival in style. At street level were large plate-glass windows to display the leather. Within a few years after the Great Fire, the leather trade had fully recovered. The new Leather District had 229 wholesale shoe dealers, 200 leather dealers, and some one hundred other business related to the shoe and boot trade. One-third of the nation's wholesale leather business was concentrated in Boston.

Arthur R. Tirrell is a good example of the merchants in the Leather District of Boston. He was born in 1865 in Weymouth, Massachusetts, the son of a shoemaker. Arthur started working at age eleven in the stitching room of one of the small contract shops. At age sixteen, he was made foreman of the stitching room and was foreman of the whole factory just two years later. He joined the United Shoe Machinery Corporation and was

posted to Buenos Aires. While living there, he resigned from "The Shoe" and formed a partnership with a local leather exporter. Tirrell returned to Boston to take care of the company from this end. His firm became one of the leading leather dealers. Leather was imported to the United States, and finished shoes and other leather goods were exported to markets in South America and elsewhere. The fate of Boston's Leather District depended on the strengths or weaknesses of the shoe industry in the towns outside of Boston.

SHOE SHOPS

Edmund Bridges and Philip Kurtland arrived from England in 1635 and are credited with being the first shoemakers in the town of **Lynn**. After these two came Joshua Gore, Francis Moore, William Whitney, and many others. Writing in 1865, Alonzo Lewis in his *History of Lynn* writes that, in 1727, square-toed shoes and buckles were all the fashion in the town. John Adam Dagyr, a Welshman, brought with him samples of women's shoes from Europe. Dagyr set up a small factory and produced "shoes equal to the best made in England" (Lewis, 1865). By 1750 "Lynn took rank as the foremost place for the manufacture of ladies shoes in all of America" (Hurd, 1888).

Even before the American Revolution, Lynn was producing over 80,000 pairs of shoes per year. During the war, Lynn made boots for the troops and benefited from the ban on imports. In 1795 some 200 master shoemakers and 600 journeymen and apprentices worked in the town. By the beginning of the nineteenth century, production in that city exceeded 400,000 pairs a year. These shoes were sent to commission houses in Boston and were sold in other states or sent for export to Europe.

The factory system for shoe manufacture started after 1840, using steam power. Large brick shoe factories were built housing 500 or more workers, each completing a part of the shoe before passing it on to the next worker. Standardization was introduced and shoes were made in specific sizes. The leather was cut according to size on the first floor of these factories. On the second floor, the shoe uppers were matched to soles of the same size. On the third floor, each pair of shoes was passed from one workman to another to be lasted, bottomed, healed, polished, and prepared for shipping. The factory system greatly increased shoe output. In 1810, one million pairs of shoes were made in Lynn. Fifty years later, production had increased ten-fold.

Shoes from Lynn were exported to South America as early as 1829. These shoes sold for 75¢ a pair. By 1860, Lynn had 136 shoe and boot factories employing 5,767 men and 2,862 women. Six million pairs of shoes were made

in Lynn that year, worth nearly $6 million. The town also had factories that made morocco leather, shoe machinery, and shoeboxes. By 1880, Lynn shoe factories were producing $20 million in goods, with a gross profit of $3 million and a net profit of nearly $1 million (Hurd, 1888).

The Lynn shoe factories were relatively small in comparison to the mammoth textile mills. Among the largest shoe factories was the Alexander E. Little & Company with 1,200 workers. Gregory & Reed had 450 workers, Watson Shoes had 225, and Mitchell-Welch Show Company had only 150 workers. The George F. Daniel's Company and the Adams Shoe Company were located in the Vamp Building, reportedly the largest shoe building in the world.

Lynn was fortunate in having another major industry about to develop just as shoe manufacture began to decline. In the 1870s, Elihu Thomson was teaching chemistry and mechanics at the Central High School in Philadelphia. His friend Edwin J. Houston taught physics at the same school. The two of them were experimenting with electricity. In 1877, Thomson built a small dynamo capable of producing a beam of light. Thomson was an inventive genius and accumulated over 600 patents to his name.

Thomson and Houston sought financing to continue their experiments and to develop commercial uses for their discoveries. They set up the American Electrical Company in New Britain, Connecticut. The company got into financial difficulties and was bought by a syndicate of shoe-factory owners from Lynn. As part of the deal, they insisted that Elihu Thomson move to Massachusetts and continue his work there. The syndicate rented a building in West Lynn to manufacture arc lighting equipment. The new company was called the General Electric Company.

The men from Lynn understood that their new venture needed sound management. In 1883 they picked one of their own, Charles A. Coffin, to manage the company and to find commercial uses for Thomson's inventions. Coffin (1844–1926) was born in Fairfield, Maine and came to Lynn at age eighteen to work in his uncle's shoe factory. Coffin later opened his own successful shoe company. Working together, Thomson and Coffin—both men of genius—laid the foundations for a mighty company. Within ten years, General Electric of Lynn had spread into twelve buildings, all producing electrical equipment. One of their major products was the manufacture of motors and generators used extensively in the electrical trolley systems being built in cities all across America. By 1914 the plant in Lynn occupied 750,000 square feet.

General Electric has maintained a presence in Lynn for over a century. The first jet engine in the United States was built in the Lynn plant in 1942. By employing 12,000 workers, General Electric spared Lynn from the rapid

decline seen in other Massachusetts industrial cities during the first half of the twentieth century. GE kept Lynn as a vibrant blue-collar city until well after World War II. The good wages earned at GE, however, encouraged many workers to move their families to outlying towns where they bought spacious homes with large gardens. The workers commuted to work each morning and parked their cars in the vast GE parking lots. Without a wide tax base, the city of Lynn went into decline, and many vacant shops and abandoned houses appeared. In the 1980s, GE began to cut its Lynn workforce. The city of Lynn was now faced with declining property and business taxes. The new immigrants now moving into Lynn could not find the abundant and well-paying jobs previously offered in the shoe factories and in the GE plant.

Lynn is also the home of Lydia E. Pinkham's Vegetable Compound. In the 1870s, Pinkham's husband Isaac had lost all his money in real estate dealings and suffered an emotional breakdown. Lydia Pinkham was a resourceful lady and was determined to save the family from ruin. She recalled a remedy for women's diseases long used in her family. Starting in her kitchen and selling door-to-door, Lydia developed the first large-scale successful business in America run by a woman. Her factory at 235 Western Avenue sold bottles of her compound at $1 a piece (six bottles for $5). Pinkham printed her reassuring portrait on each bottle. Her vegetable compound was 20 percent alcohol, and also contained licorice and dandelion root among other ingredients. It promised to rid women of all ills, including ovarian tumors and symptoms related to the change of life. Flatulence, weakness of the stomach, depression, sleeplessness, kidney troubles, and many other maladies were all alleviated after taking Pinkham's compound. Customers were advised not to be without her liver pills, which cured constipation, "billiousness," and "torpidity of the liver." Lydia Pinkham died in 1883, but the business carrying her name was continued by her sons well into the twentieth century.

The city of Lynn also had snuff, chocolate, wallpaper, and silk factories, and even had a business in winter selling blocks of ice from its frozen ponds.

Shoe manufacture to the south of Boston was centered in the town of **Brockton**. The area now known as Brockton was first settled in 1649 by colonists moving from Plymouth. In its early days, it was a farming community called North Bridgewater. Early industries included a hat factory and a fork and hoe factory. The town had a number of furniture shops, as well as soap and saddle makers, but it was shoes that made the town its reputation. A cottage shoe industry started as early as 1750. In 1811, Micha Faxon rode his horse wagon from Brockton with one hundred pairs of shoes. He sold the

shoes to the commission house of Monroe & Nash, located on Long Wharf in Boston. At that time, Brockton had fewer than 2,000 inhabitants. In 1837, 750 men and 375 women were working in the town's shoe shops. The industry received a boost after 1860 with the introduction of new machinery driven by steam power. During the second half of the nineteenth century, larger shoe factories were built. In 1874, the town fathers felt it needed a more dynamic name befitting its industrial ambitions; they decided upon Brockton, which is the name of a town in Ontario, Canada.

By 1875, Brockton had seventy-three different shoe factories, which employed 3,977 workers (3,090 men and 887 women). At the peak, Brockton had one hundred shoe factories employing well over 20,000 workers. In contrast to Lynn, most shoes made in Brockton were men's shoes.

Some of the Brockton shoe companies were large. The mammoth W.L. Douglas Shoe Company was the creation of William Lewis Douglas (1845–1924). Douglas was born in Plymouth and began shoemaking as a seven-year-old boy. He started the company in 1876 with $875 he borrowed. In the early days, Douglas himself took the finished shoes to sell in Boston and returned to Brockton with leather for the next day's production. The company grew into the town's major employer with over 3,000 workers. At its peak, the factory produced 20,000 pairs of shoes a day. Douglas entered politics and became the mayor of Brockton and, in 1904, governor of the Commonwealth of Massachusetts.

George Eldon Keith was born in Brockton in 1850 and started as a shoe worker. He built the George E. Keith Company into a major player with over 3,000 workers. The company, benefiting from orders for the U.S. army, experienced tremendous growth during World War I.

The Fred F. Field Shoe Company opened its four-story factory in 1899. In 1910, the Field company began producing the world's first spike golf shoes. Nowadays, this same factory produces golf shoes and gloves under the Footjoy label. Footjoy of Brockton is part of the Acushnet Company of Fairhaven, Massachusetts, which is also the maker of Titleist, Cobra, and Pinnacle products.

The shoe industry to the south of Boston developed in other towns, including Rockland, Marlboro, Whitman, Weymouth, and Middleborough. Rockland was an important footwear provider for the Union army. They specialized in fur-lined boots. These south-shore towns were later linked by railroad and trolley, and workers and materials could readily move from one community to the other.

RUBBER SHOES AND ATHLETIC SNEAKERS

Crude rubber coming from the jungles of Brazil (called Para Rubber) was imported in Salem and Boston as early as the 1820s. Rubber factories were set

up in Boston, Chelsea, and Framingham, among other towns. The material proved difficult to work with until two men, then working in Roxbury, Massachusetts, found a method to keep rubber flexible and tough in both hot and very cold weather.

William Goodyear (born in New Haven, Connecticut in 1800) was working with Nathaniel Hayward at the Roxbury India Rubber Company. Hayward discovered that when rubber is treated with sulfur it is no longer sticky. By accident, Goodyear dropped some sulfur-treated rubber on a hot stove and discovered that it became more durable and more elastic. This chemical discovery, called "vulcanization," opened rubber to many commercial uses, such as making belts, raincoats, and tires. The shoe industry in the Greater Boston area started making heels, soles, and shoes out of vulcanized rubber. Soon, rubber footwear plants were set up in Cambridge, Watertown, New Bedford, Stoughton, and Taunton.

The Converse family name can be traced back to the very beginning of the English settlements in the Massachusetts Bay Colony. Edward Converse settled in Charlestown in 1630. Over the generations, many of the Converses remained in New England. One branch of the family that settled in Needham, Massachusetts, early in the nineteenth century is closely tied to the shoe industry. The oldest son, James W. Converse (born 1808), moved to Boston at age thirteen to become an apprentice to his uncles in their shoe and boot business located on the corner of Milk and Broad Streets. After making his money in shoes, James became a director and later president of the Mechanics Bank of Boston. He settled into a large house in Jamaica Plain. His brother Elisha Slade Converse (born 1820) left Needham, also at age thirteen, to work for James in Boston. Later, Elisha opened his own wholesale shoe and leather business at 36 North Market Street in Boston.

Elisha decided to try his hand at banking and found work at a bank in Malden, Massachusetts, a few miles north of Boston. At age thirty-six he was named president of the bank. Elisha became a prominent citizen in Malden and was elected mayor of the town in 1882.

The Converse brothers kept their interest in the shoe business. They used vulcanized rubber to make waterproof rubber shoes and rubber overshoes. In 1853 the Boston Rubber Shoe Company was established in Malden with James W. Converse as the president and Elisha S. Converse as the treasurer and general manager. The head office and warehouse of the company were at 245 Causeway Street in Boston. The first factory opened in Malden in 1853. When it was destroyed by fire in 1875, a larger plant was built in the same town. This factory employed 1,500 workers, producing 20,000 pairs of rubber shoes a day. Even so, the company could not keep up with demand. In 1881, the company opened a second factory in nearby Melrose, with over

1,000 workers and a production capacity of an additional 12,000 pairs of shoes a day.

The rubber was imported from the Far East through the port of Boston. The Boston Rubber Shoe Company was famed for its advertisements showing a proper Bostonian walking near the Boston Public Library on a rainy day; he was well-protected by his rubber shoes. Another advertisement shows a charming young woman sitting by a stream with her rubberized shoes dipping into the water. The company even has a connection with the development of the telephone. On January 31, 1877, Alexander Graham Bell made a call from the home of Elisha Converse in Malden to the company head office in Boston. Now, the bosses could give their orders from home!

Elisha Converse was a great philanthropist. He built the Malden Free Library in memory of his son, who was killed in a robbery at the family bank. Converse also donated the land for the Malden Hospital. The Boston Rubber Shoe Factory was sold to the U.S. Rubber Company in the 1930s and production left Malden.

The Converse name continued in flexible footwear throughout the twentieth century. In 1908, Marquis Mills Converse started his own company in Malden to manufacture winterized footwear for women, men, and children.[4] This was a separate entity from the Boston Rubber Shoe Company. The Converse Rubber Shoe Company was soon making over 4,000 pairs of shoes a day. The great success of the Converse company came with the introduction of sports shoes. The company started to produce canvas tennis shoes and then spread to shoes for other sports, including the famed Converse All Star basketball sneakers (1917) and the Chuck Taylor All Star line. Converse shoes were endorsed by sports icons and became wildly popular throughout the world. In 2001 production of the sneakers in America ceased and was transferred to Asia. In 2003, Converse was sold to Nike.

SHOE MACHINERY

In 1858 Lyman R. Blake from Whitman, Massachusetts (born 1835), tried out one of the Singer sewing machines that revolutionized the garment industry. The experience set him experimenting to see whether the same technology could be used in sewing leather soles to uppers—a task then done by hand. Blake developed a crude machine, which came to the notice of Gordan McKay, who saw its great potential and quickly bought the rights to it. McKay had trained as an engineer and had formerly managed a machine shop in

[4]Marquis Mills Converse was born in 1842 in Lyme, New Hampshire, the son of Peter Mills and Sarah Converse. He used both of his parents' last names, but was known as a Converse. He withdrew from the company in 1924 and moved to his farm in Andover, Massachusetts. He does not appear to be directly related to the Converses of the Boston Rubber Shoe Company. He died at age eighty-nine.

Lowell. He refined the leather sewing machine and had it ready in time to meet the great demand for footwear during the Civil War. By 1870 thousands of McKay machines were in use and had dramatically changed shoe production. These machines could sew soles to uppers at ten times the speed of a skilled worker using hand tools. The McKay Shoe Machine Company prevailed despite years of litigation.

Two other companies dominated the shoe-machinery business. These were the Goodyear Machinery Company and Consolidated Hand Lasting Machine Company. In 1871 Charles Goodyear Jr. (son of Charles Goodyear) patented a stitching machine to make high-quality welt shoes. The Consolidated Hand Lasting Machine Company grew out of the inventiveness of a humble immigrant and shoe worker by the name of Jan Ernest Matzelinger. This gentleman did not conform to the usual pattern of the young Yankee inventor born in Maine, Vermont, or New Hampshire. Matzelinger was born in 1852 in Dutch Guiana, the son of a Dutch engineer and a Surinamese mother. He came to Lynn, Massachusetts at age twenty-one and found work in a shoe factory. In those days, steel or wooden molds of foot sizes, called "lasts," were used to fashion the uppers of the shoes. Then came the skillful task of attaching by hand the top part of the shoe to the sole. After years of effort, Metzelinger perfected and patented his machine that held the shoe on the last, pulled the leather down around the heel, drove in the nails, and then released the completed shoe. His machine could do the work of ten skilled last workers. The demand for his lasting machine was overwhelming, but Melzelinger did not live long enough to enjoy his success. He died of tuberculosis at age thirty-seven.

Sidney W. Winslow Jr. was the guiding force to bring these three shoe machinery companies together to form the United Shoe Machinery Corporation into the largest shoe machinery company in the world. Winslow (1854–1917) was born on Cape Cod in the village of Brewster. His family could trace its roots to the first settlement in Plymouth. His father moved the family from Brewster to Salem to start a shoe factory in that town. His son joined the company and rose to the position of supervisor of the stitching room. Winslow Jr. learnt all aspects of the shoe trade and showed great organizational skills. He reckoned that the three major shoe machinery companies would become more efficient and profitable if they were merged into a single enterprise. He remained president of the United Shoe for many years. "The Shoe," as it was affectionately known, built its factory (from 1903 to 1906) in Beverly, Massachusetts. This enormous plant housed 4,500 workers by 1910, many of them new immigrants, coming to this quiet corner of Essex County for the well-paying jobs offered by the company. They worked fifty hours a week and enjoyed the sports facilities, housing, and health care provided by the company.

Before the formation of the United Shoe, there were many other companies making shoe machinery. Boston-based factories included Fortuna Skiving, Peerless Machinery, Markem Machine, and the Union Lock Stitch Company, among others. All these were swept aside by the power of the United Shoe Machinery Corporation. The Shoe patented thousands of inventions and came out with many new machines for every aspect of the shoe industry. It had a virtual monopoly on the shoe machinery industry. The United States Shoe Machinery Corporation was one of the first international companies and, by 1905, had branches in many countries. The company leased (rather than sold) its equipment. It had an army of technicians available to repair the machines at any location and at short notice. The Shoe received royalties on every pair of shoes made on its machines. In 1930 the company built Boston's first skyscraper to house its head offices. The company stock was described as "one of the bluest of the blue-chip investments" and provided a steady flow of dividends.

The corporation's size and leasing practices lead to anti-trust battles beginning as early as 1911. The case of the *United States* v. *United Shoe Machinery Co.* reached the Supreme Court. In 1918, Justice McKenna delivered the court's opinion that

> it is impossible to believe, and the court below refuses to find, that the great business of the United Shoe Machinery Co. has been built up by the coercion of its customers and that its machinery has been installed . . . by exercise of power, even that of patents.

The success of the corporation, stated the Supreme Court, was the result of "no other incentive than the excellence of its machines and the advantage of their use" (*U.S. v. United Shoe Machinery Co.*, 247 U.S. 32, 1918).

The battle against the corporation continued for many more years. In 1968, the Supreme Court—with seven justices forming the majority, one dissenting, and one not participating—interpreted the Sherman Act to show that the United Shoe Machinery Corporation was indeed in violation of the law. The majority opinion was that the United Shoe "had monopolized the shoe machinery industry" and should pay damages to the injured parties (*Hanover Shoe, Inc.* v. *United Shoe Machinery Corporation* [1968]).

This decision effectively ended the corporation's monopolistic practices. It tried to diversify with dozens of acquisitions. Instead of growth, it got itself into debt. Its value fell and it was taken over by the Emhart Corporation. The once-proud United Shoe Machinery Corporation closed its doors in 1987. The huge factory remained empty for a decade until it was renovated as the Cummings Center. The center, with over two million square feet of interior space, now holds some 400 different businesses in the area once occupied by a single company.

Shoes and Boots

The Boot and Shoe Towns

The footwear industry brought growth and prosperity to the towns that housed the factories. Lynn, Brockton, and the other shoe towns attracted immigrants hungry for jobs. The merchants of the towns provided ample opportunities for the workers to spend their money. The shops on the main streets offered foodstuffs and luxury items. The towns had live theaters and later movie-houses, as well as restaurants and hotels. Lynn and Brockton became regional shopping centers with large department stores. The chemist shops, tobacconists, dentists, and insurance companies had their offices downtown. The trolleys ran down the main streets, bringing well-dressed folks to shop, and to be seen and entertained. Saturday was an especially busy day downtown.

The region now known as Lynn was first settled in 1629 by people moving from Salem. It was named for Lynn Regis in England. Lynn started as a rugged agricultural community, but later developed a shoe industry with a specialty in ladies' shoes. At the beginning of the nineteenth century, the town's population was a few thousand. This grew to 14,000 in 1850. Thirty years later, the town's population had exceeded 38,000, of whom 11,000 worked in the shoe trade. In 1910 the population of Lynn was 89,336. Lynn was a workers' town with a small number of wealthy people. The Shoemaker School trained young people to enter the town's leading industry.

Lynn was served by the Boston & Maine Railroad. The shoe factories were built near the railway station. By the end of the nineteenth century, Lynn had electric streetcar connections south to Boston and north to Swampscott, Marblehead, and Salem. It was the hub of the Lynn & Boston Electric Railway Company, serving many communities to the north of Boston.

Lynn's downtown—with many stores, restaurants, and theaters—served much of the North Shore. Central Square and Market Street were lined with four- and five-story buildings with shops at street level. The imposing Italian Renaissance–style city hall was opened in 1867. In their free time, people enjoyed walking through the gardens on Lynn Common and along the many trails of Lynn Woods. Not everyone in Lynn could find work. The town supported an almshouse with beds for seventy people. In 1885 the town gave assistance to 519 local families and to 5,457 "tramps," passing through the town (Hurd, 1888).

By 1910 the population of **Brockton** topped 56,000. The town continued to grow well into the twentieth century and, by 1970, its population was close to 90,000. Four out of five industrial workers in Brockton were in the shoe factories. The smoke-belching factory chimneys dominated the

landscape. Brockton was linked to Boston by the Old Colony Railroad. Brockton became known as "The Shoe City" and rivaled Lynn as the dominant shoe town in America. In a manner similar to Lynn, the shoe factories and the shopping area developed near the railway station. Brockton's prosperous Main Street was also lined with four- and five-story buildings with shops offering necessities and luxury goods. The electric trolley lines helped the town to grow and brought in shoppers from the suburbs and the surrounding towns.

Dozens of other towns in eastern Massachusetts supported footwear factories. One such town is **Natick**, which lies to the west of Boston and started as an agricultural community. Some of the farmers built small workshops alongside their homes and took up shoemaking as a wintertime occupation. In 1836 the Boston & Albany Railroad came to Natick Center and a shoe industry developed, specializing in work shoes. The Chas. W. Dean Shoe Factory employed 2,200 workers. Shoe factories were built by William Pfeiffer, Riley Pebbles, and John Walcott, among others. By 1880, the town had twenty-three shoe factories. Leonard Morse made his money from shoes. He and his wife left their money to establish the Leonard Morse Hospital in the town.

MIGRATION OF SHOE AND BOOT INDUSTRY TO OTHER STATES

In the year 1850 there were some 110,000 shoe and boot workers in the United States, of which number almost 80 percent were in New England. At the peak of the industry, the Massachusetts shoe factories alone were producing half of all shoes manufactured in the United States. In 1860, the footwear industry in Massachusetts employed over 60,000 people. This was more than 28 percent of the Commonwealth's entire industrial labor force. Along with footwear, the state developed into a major center for the manufacture of machinery used in the shoe factories. Men from Massachusetts were moving westwards and setting up shoe stores and distribution centers in other states. They maintained links with the manufactures in Lynn, Haverhill, and Brockton, and provided new markets for Massachusetts-made footwear (Hoover, 1937).

Boston and the surrounding towns maintained a dominant position in the nation's leather and shoe business up to the Great Depression. In 1929, Boston accounted for 43 percent of the nation's leather wholesale business (Hoover, 1937). Rising labor costs and distance from major markets began to erode Boston's once-dominant position. The industry that had given employment to generations of shoe workers in Lynn, Brockton, Haverhill, and other towns gradually slipped away, leaving behind empty factories and large-scale unemployment.

When America began to develop to the west of the Atlantic seaboard, shoe men from New England began to seek opportunities in other parts of the country. Among them were Horace Lester and his brother George from East Haddam, Connecticut who set up a shoe factory in Binghamton, New York. The shoe factory was successful for a number of years, but was close to collapse by 1890. The business was saved by an injection of capital from Henry B. Endicott of Boston. Endicott ran the financial side of the business from his Boston office with George Johnson in charge of the daily management. In 1899 the two men formed an equal partnership. The following year, Johnson persuaded Endicott to buy 200 acres of land to the west of Binghamton to build a new factory. In the tradition of Francis Cabot Lowell and Abbot Lawrence, the new community was named for its founder; it was incorporated as the town of **Endicott**, New York. Here they built the Endicott-Johnson Shoe Company, known locally as "E.J." The factory grew to employ over 20,000 shoe workers.

The Endicotts hailed from Devonshire in England and were among the earliest settlers of Massachusetts Bay. There were Endicotts living in Salem in the 1660s. Henry Endicott owned the Commonwealth Shoe Company in Massachusetts before spreading his holdings into New York. His son Wendell Endicott was not inclined to continue running a shoe factory and instead devoted himself to his private investments and cultural interests. Wendell bought a large property in Dedham, Massachusetts near the Charles River. On this land he built the family mansion in the style of a French manor. Workmen were brought from Italy to paint the ceilings. The fireplaces were brought over from Europe. After Wendell's death, his children donated the house and the land to the Massachusetts Institute of Technology. It is now known as the Endicott House and is used by MIT as a conference center.

Another member of the illustrious Endicotts from Salem, Massachusetts was William Crowninshield Endicott (1826–1900), who served as secretary of war from 1885 to 1889 under President Grover Cleveland. Endicott married Ellen Peabody, whose family made its fortune in the Salem China trade. William Endicott graduated from Harvard College and was involved in Massachusetts politics before moving his family to Washington. In 1887 his twenty-three-year-old daughter Mary met the English politician Joseph Chamberlain, who was on a visit to the United States. The fifty-one-year-old Chamberlain was already famous as an industrialist in Birmingham, England, and as a statesman. He had lost his two previous wives in childbirth, but was so taken by Mary that he married her. The wedding ceremony in Washington was attended by President Cleveland and by members of the Cabinet and the United States Supreme Court. Joseph Chamberlain served in the Liberal and Conservative governments in Britain

and headed the Colonial Office at the time of the Anglo-Boer War. His sons from his first marriage formed part of the political dynasty that greatly influenced British history during the first half of the twentieth century. Joseph Arthur Chamberlain (1863–1937) was a leader of the Conservative Party and Foreign Secretary.

Joseph's brother Arthur Neville (1856–1940) served as the British Prime Minister before World War II. His appeasement of Hitler did not bring "Peace for our time," but merely fed the Nazi appetite for easy conquests. Their American stepmother, Mary Crowninshield Endicott Chamberlain, was widowed young. She lived in England, but regularly visited her family in Massachusetts until her death at age ninety-three.

THE WORKERS

Early in the nineteenth century Boston and its environs experienced a flow of Yankee folks coming off the farms of New England to seek their fortunes in the towns and cities. The rate of flow was increased by the development of the textile industry in Lowell, Lawrence, and later Fall River and New Bedford. Similarly, the footwear industry led to the rapid growth of Lynn, Haverhill, Beverly, and Brockton. It was the immigration from abroad that vastly increased the population of the cities. First came the Irish, driven out by the Great Potato Famine of the 1840s. Then came French-speaking Canadians and later Germans, Portuguese, Italians, Jews, and members of many other groups. Emigration was encouraged by the rapid population growth in Europe during the nineteenth century, which led to excess labor, low wages, and famine, together with political and religious friction. Trans-Atlantic shipping lines offered steerage-class passage to millions, who were lured to the New World by dreams of fortune. These ships left from the ports of Hamburg, Liverpool, and Genoa. Instead of weeks of perilous travel during the era of sail, immigrants who came on the steamboats now reached Boston or New York after a journey of only ten to twelve days. Over thirty million immigrants arrived in the United States between 1850 and 1910.

For the twenty-five-year period from 1820 to 1845, only 60,000 people entered Boston Harbor from foreign countries. From 1846 to 1866, over 320,000 entered Boston by way of the sea. This twenty-year period was the time of the great flow of people who left Ireland. That country lost half of its population with over 1.5 million Irishmen coming to the United States, of whom 160,000 came to Boston. In addition, there were many Irish immigrants who went first to Canadian ports before finding their way by land to Boston. The only other sizeable immigrant group entering Boston Harbor between 1846 and 1866 came from Great Britain and numbered some 60,000 people. During that period, almost as many people left Germany to settle in America, but fewer of them came to Boston (Ransom, 1989).

Immigration to Boston from France, Italy, and Holland remained small before 1866. Italians and Jews and others from southern and eastern Europe arrived in large numbers during the 1880s and 1890s. The North End was the point of entry for the Italians, but they soon spread to other Boston

neighborhoods. The Jews congregated in the South and North Ends, but by 1910 most had gravitated to the West End, which they shared with the Italian community. Other Jews built a replica of their eastern European villages across the harbor from Boston in the town of Chelsea.

In the Boston of the 1850s, it was still the native-born who occupied the top rungs of society. Almost all the physicians were America-born, as were the government workers, police, teachers, financiers, merchants, clerks, manufacturers, wholesalers, and retailers. The Irish found work in the building trades, but many were domestic servants or day laborers. In 1880, over 17,000 people in Boston were in domestic service and some 16,000 were laborers; most of these were Irish born.

Few Boston factories even approached the size of the large textile and shoe mills in the hinterland. In the town of Lawrence alone, the Washington, Wood, Arlington, and Pacific mills *each* had well over 3,000 workers. Many of the jobs in Boston were related to the import of raw materials into Boston Harbor and the flow of finished goods out of the harbor. New immigrants dug the ditches, built the roads and the transit system, took care of the horses that pulled the trolleys, and worked as laborers on the building sites. Some found work at the docks cutting fish, or off-loading raw wool, cotton, and hides.

Many of the Irish women worked as domestic workers in the grand homes on Beacon Hill and the Back Bay. Others of these women found work in the hotels near the train terminals along Tremont Street and in the Back Bay (O'Connor, 2002). The Irish men found work with the telephone, gas, and electric utility companies. Some became grocers, funeral directors, and bartenders or saw their opportunity in politics.

The Italians worked in the shoe industry, opened barbershops and restaurants, and worked in the fruit stores. Italian men found jobs in the building trades and at the docks, and Italian women worked in the garment trade. Many of the Jews were tailors in the Old Country and readily found work alongside the Italian immigrants in Boston's garment industry. By the time Italians, Poles, and Jews were arriving in large numbers, the Irish had already solidified their hold on Boston politics and the municipal jobs that went with that power.

Boston also had a small African-American population. By 1705 the town of Boston had over 400 African slaves. After the American Revolution, the legal status of blacks changed. The freed community began to settle on the North Slope of Beacon Hill toward Cambridge Street. By the end of the nineteenth century, the black community moved from Beacon Hill to Roxbury and the South End. By 1900, there were an estimated 11,500 African Americans in the city of Boston and sizeable

black communities in the surrounding towns. John Daniels described the occupation status of black men living in Boston in 1900. Three-quarters of those of working age were employed, mainly as waiters, janitors, laborers, and porters. There were also black barbers, clerks, carpenters, masons, painters, and tailors. Some blacks had their own businesses (as merchants, boardinghouse keepers, and shoemakers). There were twenty-nine black actors, ten dentists, thirty-one musicians and music teachers, thirteen clergymen, twelve lawyers, and twelve physicians and surgeons. African-American women found employment in domestic service and laundry work. Twenty-seven black women worked as nurses.

THE TEXTILE WORKERS

During its early years, the labor force of Lowell was made up mostly of healthy young women coming off the farms of New England. These women lived in company-owned boardinghouses. The typical boardinghouse offered accommodations for twenty-four women, living four to six to a room. Usually two or more women came together from the same community and their lives were carefully regimented. They worked twelve hours a day for six days a week, making a seventy-hour workweek the norm. For the rest of the time they remained in the boardinghouse where they ate their meals, wrote letters, washed their clothes, and read their books (Dublin, 1991). Most of the women remained at the mills for no more than four years, during which time they would had saved some money to marry or help their families. By 1840 there were 6,430 female—but only 2,047 male—textile workers in Lowell.

In the early 1820s Irish immigrants were brought from Boston to work on the expansion of the canals along the Merrimack River. Irish families began to arrive in greater numbers during the Potato Famine of 1844–1849. By 1860, one-half of Lowell's 40,000 residents were Irish. Competition for jobs increased after 1860 with the arrival of thousands of French Canadians, whose large families could no longer be supported by agriculture. The new immigrants—many of whom spoke little English—came with their families. Often, both the parents and their children over ten years of age sought employment in the mills. Even with their combined incomes, these families still lived near the poverty level.

The mushrooming of the textile industry led to overproduction and falling prices. Workers' salaries were reduced and the hours of work increased, while conditions deteriorated. The textile towns grew and absorbed many thousands of new immigrants. Each group of immigrants settled in its own neighborhood where Yiddish, French, Polish, Portuguese, and other languages were heard. These neighborhoods

supported their own churches, food stores, and social clubs. Workers' wages, meager though they were, also supported the shops and theaters in the downtown. People lived near the mills and walked to the stores or traveled downtown on the trolley.

The factory sirens sounded off at 5:30 in the morning. Apart from a half-hour break for breakfast and lunch, the workers labored flat out for up to thirteen hours a day in vast rooms filled with deafening machinery. Weekly salaries for the earlier immigrant groups—from England, Ireland, and Germany—rose to $11 for men and $9 for women. Newer immigrants from Italy, Russia, and Lithuania were given less skilled jobs with weekly wages of only $7 to $9 per hour for males and $6 to $8 per hour for the female workers. These low salaries forced more than one member of the family to work just to provide enough money for food and shelter (Juravich, 1996). Half of the Lawrence factory workers were women or children younger than eighteen years of age.

The British government was well aware of the economic advantage of keeping their new textile machinery and skilled workers at home. The ban on the emigration of workers was finally lifted in 1825 by parliamentary legislation. This led to a sizeable movement of skilled workers from Lancashire to the New World. These workers were to play an important role in the growth of the textile industry in eastern Massachusetts (Blewett, 2000). Immigrants from the British Isles established themselves in most of the mills in Massachusetts and in the rest of New England. They brought not only their work skills, but also a feisty—if not confrontational—approach to management. These British workers were at the forefront of the movement for the ten-hour workday and for increases in wages.

The mill owners had accumulated enormous debts and were repeatedly adjusting output and wages to meet the prices of their competitors, both at home and abroad. Reduction in wages, increased rents, and the worsening of conditions of work led to frequent conflict between workers and the mill owners. Bankruptcies and mill closures were common events. The economic depression of 1873–1879 hastened the financial collapse of the Borden family, which owned some of the larger mills in Fall River. The Durfee, Chace, and Stickney families faced financial ruin, putting yet more of the Fall River mill workers out of work.

The movement to reduce the workday to ten hours began as early as 1834. The workers realized that increasing mechanization would reduce the number of hands needed. Only by limiting their hours of work could the workers maintain their jobs, while still having time for other activities. However, recurrent economic slow-downs, the push of new immigrants seeking work, and overproduction greatly limited the power of the workers. The workers had

to wait until 1912 before the Commonwealth of Massachusetts lowered the workweek from 56 to 54 hours.

In Lawrence, the company bosses responded by reducing pay by 22¢ a week. On January 11, 1912, the workers at the Everett Mill were outraged to find their wages cut. The cry of "Short Pay" was heard throughout the mill. Workers shut down their machines and went from mill to mill, urging other workers to join their strike. The bosses at first refused to meet with the workers and reckoned that the largely immigrant labor force would soon give in and return to their jobs. They did not appreciate the determination and anger of the workers, many of whom had labor union experience in their home countries. Helped by Joseph Ettor and Arturo Giovannitti of the Industrial Workers of the World, some 27,000 Lawrence workers struck their factories and remained out for sixty-three days. The workers demanded a 15-percent increase in their wages. The Polish, Irish, Italian, Greek, and Portuguese workers demonstrated in their own languages, with the French Canadians singing the "Marseillaise."

The solidarity of the workers was strong. They were accused of being socialists and anarchists, while the bosses were criticized for caring more about machinery and profits than the welfare of their workers. In this volatile atmosphere, the governor of Massachusetts called out the militia to confront the workers. During the scuffles, the workers were knocked down and clubbed. Two workers were killed and 500 arrested. The strike leaders were charged as accessories to these deaths, but the trial ended in their acquittal. The strike was a major event in the life of Lawrence. Some workers held up banners that read, "Give us Bread and Give us Roses." The strike was a fight for money and for dignity, and became known as the Bread and Roses Strike. When it ended on March 14, 1912, the workers had won increases between 5¢ to 25¢ a day. These wage increases spread to all the mills in New England. The strike also gave voice to the Polish, Lithuanian, Irish, Greek, Jewish, and Italian immigrants and made them American workers.

SHOE WORKERS

The shoe industry grew to maturity after the textile industry, but was plagued with similar problems. At first, the entrepreneurs hired Yankee farmers and fisherman. As the industry grew, immigrant labor from Ireland and French-speaking Canada was used. With overproduction, many factories began to fail. The owners reduced wages, which led to frequent strikes. During the last half of the nineteenth century, a shoe worker was paid between $3 to $5 a week, which was below subsistence wages. In 1880, shoe workers in Brockton were earning an average of $460 per year, with

few benefits, for a sixty-hour week. As a result, two or more members of the family had to go out to work. Even then, the typical working family could barely reach a level of economic comfort and could certainly not afford a home or save any money.

Making shoes and boots was heavy work and some 70 percent of the workers were men. The percentage of women working in the shoe factories began to increase with the introduction of machinery. At the peak, the Commonwealth of Massachusetts had over 62,000 boot and shoe workers, with major concentrations in Haverhill, Lynn, and Brockton. The new machinery for shoes greatly increased production, which led to over-capacity and a fall in the price of shoes. Workers' salaries were cut. The shoe workers of Lynn demanded better wages and better conditions. In 1860, they went out on strike. The strike failed and many workers lost their jobs. The Civil War reversed the decline and the shoe factories in Lynn, Brockton, and Haverhill were working full-time again to produce boots for the Union troops.

Brockton, Milford, and Haverhill were strong union towns. The union of male shoe workers—called the Knights of St. Crispin—was formed in Milford in 1864. It grew to 70,000 members by 1870. The union of female shoe workers—called the Daughters of St. Crispin—was formed in 1869 and spread to shoe factories around Massachusetts. In 1872, the employers confronted the Crispins head on by cutting wages and refusing to hire union workers. The Crispins did not survive beyond 1873 (Juravich, 1996). There were shoe-worker strikes in Haverhill in 1895 and in Marlboro in 1898. Brockton and Haverhill had socialist-controlled governments in 1887 and 1898 (Montgomery, 1987). In 1909, the Boot and Shoe Workers' Union strike closed the Douglas Shoe Company in Brockton. Attorney Louis D. Brandeis (the future Supreme Court Justice) represented Douglas Shoe in that dispute.

THE MASSACHUSETTS BUREAU OF STATISTICS OF LABOR

In response to concerns about the well-being of "the working classes," the legislature voted for money in 1869 to establish the Massachusetts Bureau of Statistics of Labor. The governor at the time was William Claflin, who came from one of the leading families in Milford, where his father owned a shoe factory. William was educated at Brown University and had been a director of the family business before entering politics. As the first director of the bureau, Governor Claflin selected Henry K. Oliver, who entered his new task with great enthusiasm (Bedford, 1995). Oliver's reports were critical of the poor conditions under which the workers of Massachusetts were made to labor. The

ruling classes agitated for his dismissal and, in 1873, Oliver was fired by Governor William Washburn, a Yale-educated, wealthy chair manufacturer from Greenfield, Massachusetts.

Carroll D. Wright was appointed as the next director of the Bureau of Statistics of Labor. Wright had served in the Massachusetts Senate and was more attuned to the attitudes of his colleagues. Wright adopted a "scientific" and less polemical approach to the interpretation of data. His annual reports nonetheless provide fascinating insights into the state of labor during the last part of the nineteenth century.

The annual reports of the bureau described how workers' skills, acquired over many years, were being swept aside by mechanization and standardization. Workers were quickly affected by factors out of their control, such as over-production and economic downturns. In slow periods, many workers were let go without any compensation and forced to wander the streets looking for any work at any pay. The bureau analyzed the economic status of workers in various trades. In 1875, for example, one shoe worker reported an income of $540. His thirteen-year-old daughter and his sons, aged fifteen and twelve, all worked to bring in enough money for the family to survive. The total family budget of $1,176 covered their rent ($218), food ($574), and fuel ($55), with very little left over for clothing and nothing for savings or small luxuries. An iron worker and his fifteen-year-old son earned $949 to support a family of five. Unskilled laborers were poorly paid. The bureau documented the life of a French Canadian family with four children. Their total annual earnings were only $572, reducing them to squalid living quarters and barely enough food.

The figures provided by the bureau showed that skilled workers in late nineteenth-century Massachusetts could not support their families on their wages alone and needed the wages of their children, often under sixteen years of age. Unskilled workers could barely survive, even with the wages of their young children. Workers generally did their best to provide for their families. The living conditions of the better-paid workers were significantly higher than what the poorly paid could afford. Furthermore, those paid more tried to save some of their earnings, while those who were not were unable to put any money aside.

In its eighteenth report, the Bureau of Statistics of Labor analyzed the state of labor in Massachusetts for the year 1880. In that year, 199,393 people were employed in the state, of whom 37,657 made boots and shoes; 59,684 produced cotton goods; 22,597 produced woolen goods; and 11,435 were garment workers. These trades represented 66 percent of all employed workers in the Commonwealth. The building trades, machinery, metals, printing, and all the other trades made up the remaining 34 percent of the

employed workforce. Although the most numerous, the cotton and wool workers were among the least well paid, indicative of the cruel competition in these industries.

In 1880, there were thousands who could not find work, often for months at a time. They were willing to accept lower salaries to find any work. This state of affairs severely reduced the bargaining power of all workers. The economic depression of the early 1890s was a particularly difficult time for workers, many of whom experienced long periods without gainful employment. The charities of the time could barely cope with the widespread need. In Boston and other cities, funds were collected for established work relief centers. Men and women were put to work separately doing tasks for low wages. The resources were so meager that only two weeks of paid work were offered out of the month. In those times, poverty and stealing were viewed as personal failings brought about by a lack of skills and by alcohol abuse.

Francis Cabot Lowell and his associates, who built the textile mills in Waltham early in the nineteenth century, showed concern for the well-being of their workers. The young women who left their family farms were housed in well-supervised boardinghouses close to their place of work. These "mill girls" were well-dressed and well fed. They were encouraged to save some of their earnings to give to their families back on the farm. This benevolence did not last long. The bosses of the huge mills in Lowell, Lawrence, Fall River, and New Bedford, as well as in the shoe factories, saw the flow of immigrant families as an endless source of cheap labor. Machinery and immigrant labor led to over-supply of goods and workers and led to fierce competition.

Economic downturns and deflationary cycles occurred at least once in each decade from 1820 into the early part of the twentieth century, leading to plant closings and periods of unemployment (Keyssar, 1986). The period of the Civil War saw a great expansion of the labor force, but wages and benefits remained low. At the end of the war, demand for goods, especially boots and shoes, again slumped. Prolonged industrial depressions occurred from 1873 to 1879, during the early 1890s, and again in 1907. According to Keyssar, two years out of every five between 1870 and 1920 were periods of recession or depression. These periods of depression affected the factories, workers, local stores, and town banks.

When the weavers in Lawrence went out on strike in 1890, they were easily replaced by the ranks of the unemployed. In Fall River that same year, the weavers who protested a cut in their wages were fired. Workers' wages in 1911 were no higher than the wages paid twenty years before (Montgomery, 1987).

The Workers

Based on the data from the Massachusetts Bureau of Statistics of Labor, Alexander Keyssar assessed the effects on the workers of these frequent disruptions of the business cycle. The "mill girls" who worked in the Waltham and Lowell textile mills from 1814 to 1840 stayed only a few years, after which they married or returned to the family farm. The so-called Waltham System encouraged short work contracts and provided the workers with other opportunities when they left the mills. As the factory system developed after 1840, the workers became tethered to urban and industrial life and could no longer return to the farm. This was especially true for the immigrants from Europe coming with their families. These newcomers, who were mostly unskilled or somewhat skilled workers with little English, were especially vulnerable to loss of work.

Good times and improved machinery encouraged entrepreneurs to build new factories and hire more workers. The flow of immigrants kept wages low. This situation inevitably led to over-production and a fall in demand. When faced with a paucity of orders, the mill owners responded by cutting the hours of work, reducing wages, or abruptly letting workers go. The workers were held hostage to the fluctuations in the business cycle. The rate of unemployment (the percentage of workers out of work at any one time) in Massachusetts during 1885 and in 1895 was between 8 and 10 percent. However, the frequency of unemployment (the percentage of the workforce out of work at some time during the year) was much higher, at close to 30 percent.

Very few of these workers were able to save money and few had any savings to cope with hard times; however, few of them starved or became homeless. Many of the men in the labor force depended on their wives and children to work in order to keep the family going. If one member lost his job, the others would try to hold on to theirs. The unemployed would seek out day work and would take advantage of snowy weather to dig out the train and trolley lines and shovel the sidewalks for pay. Boston and other towns had welfare and work programs to help the needy. The unemployed were helped by their relatives and they took advantage of the soup kitchens. The woman of the house would do washing, cleaning, and babysitting for those who were better off. Sometimes, the family would take in boarders to earn extra money. Without a state and federal welfare system, the poor would help each other or turn to helping-hand societies set up by their fellow countrymen. If need be, the unemployed would move to cheaper accommodations or move on to seek better luck in another part of the country.

The workers formed unions to advance their cause for better salaries, shorter hours, and better conditions. These efforts were undermined by friction between the skilled and unskilled workers, male and female workers,

and workers with differing trades and skills who came from different countries. The Boston Central Labor Union was formed in the 1890s to represent all of organized labor in the city. The American Federation of Labor (AFL) opened a branch in Massachusetts with the intention of organizing the shoe, textile, building-trade, and other craft unions into a single federation representing all workers. With larger numbers and greater power, the unions fought for improved health and safety laws and a shorter workday. The nineteenth century was a harsh time for the workers of Massachusetts. The goal of good pay together with job security, workman's compensation, health benefits, vacation time, and other advantages would have to wait until well into the twentieth century.

THE DECLINE OF MANUFACTURING

The industrial boom during the nineteenth century transformed eastern Massachusetts from a largely farming-based economy to a highly urbanized factory-based economy. Hundreds of shoe and boot factories were built and a huge wool and cotton textile industry was developed. Industry was by no means restricted to the manufacture of footwear and textiles. Boston had many wool, leather, and cotton brokers who imported the raw materials and sent them off to the mills. Near the mills were allied industries, including machinery manufacturers and repair shops, tanneries, glove makers, and glue factories. The finished goods were usually sent back to Boston where the wholesalers and commission houses were located. From Boston, markets for these goods were found at home and abroad. Many of the companies maintained their head offices in Boston.

Historic villages became factory cities and new industrial towns, like Lowell and Lawrence, sprung up alongside the riverbanks. Farming and fishing gave way to power machinery. These machines were driven by water power, then by steam, and later by electric power. Almost every village and town participated in this transformation. Small-town youngsters began tinkering with machinery and later became captains of industry. The Yankees of New England were but one step behind their English relatives in creating the Industrial Revolution. These new businesses were established by ambitious men from New England with the use of local money. Many of these enterprises grew from the invention of a new technology. Often, two minds were involved—the one attuned to invention and the other geared toward implementation. These entrepreneurs had limited formal education, but they had the determination and vision to create great companies within their lifetimes.

By the beginning of the twentieth century, a vast industrial complex had developed, joining Boston closely with its adjacent towns. Boston Harbor was one of the busiest ports in the country. Into it flowed raw cotton, wool, leather, and coal. The leather, cotton, and wool brokers had their offices and warehouses nearby and arranged for the shipment of goods to the factories. Wholesale merchants, in turn, purchased and sold the finished textiles, shoes, boots, shovels, and countless other goods produced by the local factories.

THE GREAT WORKSHOP

Massachusetts—especially the Boston Metropolitan area—had become the country's largest manufacturer of leather and rubber footwear, as well as woolen and cotton textiles. The wool and fish trades out of Boston were the largest in America. The Ames Shovel Factory of Easton, the Bigelow Carpet Factory of Clinton, the textile machinery manufacturers in Whitinsville and Hopedale, and the shoe machinery company in Beverly were the largest in the world. Boston was a major banking center. Many of the private investment houses had their start in the city. Houghton Mifflin, Little Brown, and other book publishers, with head offices in Boston and factories in Cambridge, were the largest in the nation. Greater Boston was a major producer of chocolates and candies. Boston was a major producer of rum, using molasses imported from the Caribbean. Last, but certainly not least, the Quincy Shipyard developed by Thomas Watson (former assistant to the inventor of the telephone, Alexander Graham Bell) was among the largest in the country. Taunton was a major producer of kitchen ranges. Fellows like George S. Parker of Parker Brothers in Salem invented games that still amuse. These industries and the demand for their goods attracted thousands of immigrants and led to the growth of Boston and the cities within its orbit.

Well over 500 separate textile and footwear factories were opened in eastern Massachusetts during the second half of the nineteenth century. Some of the mills in Lowell, Lawrence, and Fall River each employed over 3,000 workers. The textile machinery towns of Hopedale and Whitinsville employed 5,000 workers apiece. By 1880 there were nearly 100,000 textile workers and 65,000 shoe workers in Massachusetts.

Major industrial towns such as Brockton, Lynn, New Bedford, Taunton, and Fall River developed busy downtown shopping and entertainment centers with many churches, schools, and businesses. The coming of the trains and the later street trolleys hastened development and brought prosperity. Townsfolk lived near their places of work. Each morning, they walked or took trolleys to their jobs. They shopped in the local stores and attended the local churches, and their children went to the local schools. With more money came new services. The towns soon boasted specialty shops and theaters. People needed insurance, legal and health care, barbershops, tobacconists, furniture stores, and restaurants. Photographs from the early twentieth century of Massachusetts towns show the busyness of daily life. The downtown streets were filled with well-dressed people going about their daily business.

The early success of eastern Massachusetts was its own undoing. Men from Massachusetts began to invest in the expansion of the rest of the country. The Union Pacific Railroad, among others, was financed with

The Decline of Manufacturing

Boston money. Textile manufacturers shifted their industry to the South to be closer to the raw material and cheaper labor. Shoe manufacturers moved west to be closer to the new areas of growth. The factories in Hopedale, Whitinsville, and in the shoe and textile towns became obsolete and were not adapted to new techniques. The Boston-based investment houses moved to New York. The Ames, Bigelow, Draper, and Millis families built major industries. The family businesses seemed to lose their dynamism after the founding fathers had died. The factories were closed or bought by competitors and moved elsewhere.

Textiles in Massachusetts began to fail early in the twentieth century. The Bigelow Carpet Company left Lowell in 1914 and the Middlesex Mills stopped production in 1918. In the 1920s, the Hamilton Company went bankrupt and was soon followed by the Suffolk and Tremont Mills. Between the years 1926 and 1928, over 80,000 workers in Massachusetts lost their jobs. The trade unions were under great pressure and could not stand up for the rights of the workers. Competition from southern mills and factories abroad flooded the market for shoes and textiles, causing local factories to close and lay off more workers. Wage cuts provoked strikes in New Bedford and other communities, but these proved ineffective against the fundamental economic changes that were taking place.

The stock market crash of October 1929 heralded in the Great Depression and accelerated the process of plant closings. The huge waterfront mills closed one after the other and the shopping centers went into decline. The flight of industry left the great industrial towns of Massachusetts without their major sources of livelihood. Members of the large, skilled labor force were unemployed for long periods and could find only a day's labor here and there. Job losses in Massachusetts were not limited to shoes and textiles, but spread to the building trades, the machine shops, and to all branches of the economy. Bewildered workers went from factory to factory looking for work. Instead of lining up in their work clothes in front of the factory gates at 5:30 in the morning, the former workers now stood in their best clothes, hats on heads, in the long unemployment lines. Rents could not be paid and purchases beyond food could not be made. Town taxes were not paid. The city of Fall River declared bankruptcy. The street trolley cars were replaced by trackless trolleys. The railway lines merged to accommodate the change.

The private automobile replaced much of the public transit system. Cities started to tear down their grand Victorian buildings to make room for parking lots. The new highways drew people away from the old towns. Try as they might, New Bedford, Fall River, Brockton, Lynn, Lawrence, Lowell, and other one-industry towns could not recover from the loss of their

primary industry. They entered a period of severe decline. Their schools and city services faltered and depended increasingly on support from state and federal funds. Instead of a weekly wage, more and more people were left unemployed and dependent on welfare. The new roads and highways bypassed the town centers, further diminishing their vitality as places for shopping and entertainment.

The disabled and the unemployed remained in the old downtowns. Those who still had jobs no longer needed to live close to where they worked or shopped. Many followed the roads and moved to the new suburbs further and further from the old towns. Inner-city Lowell, Lawrence, Lynn, Brockton, New Bedford, and Fall River are today but a sad contrast when compared with their vitality of one hundred years ago. The old drugstores, the Five and Dimes, the theaters and movie houses, the furniture stores, and the elegant clothing shops are mostly gone. The sidewalks are no longer filled with shoppers and the streets no longer carry the clanging of the trolleys. Immigrants—mostly non-English speaking—have moved into these towns as the sons and daughters of the mill workers have moved elsewhere. Despite significant state and federal aid, large pockets of unemployment and poverty have stubbornly remained.

The profound changes in the nation's social contract have clearly cushioned the effects of unemployment and disability. Before the Great Depression, people who became ill or were unemployed had only their families to assist them. The New Deal, implemented by President Franklin D. Roosevelt, provided hope. The effects of the Great Depression also encouraged the passage of the Social Security Act, which was signed into law on August 14, 1935. Social Security began as a program to pay benefits to retired workers aged sixty-five and older. The act was later amended to include benefits for the spouse and the minor children, and to pay benefits to family members in the event of the early death of the wage earner. In 1954 the act was again amended to provide payments to workers who became severely disabled before the age of retirement. Supplemental Security Income (SSI) was added in 1950 to assist needy disabled persons.

What began in 1935 to provide a small benefit to relatively few people has ballooned into an enormous trust fund taking in money from those now working and paying money to the disabled and the retired. In 2001, nearly forty-six million people were receiving social security benefits worth over $430 billion. In addition, nearly seven million needy people were receiving SSI at a cost of over $32 billion. One in six Americans now get benefits from Social Security (Social Security Administration: Publication No. 21-059, August 2000).

The Decline of Manufacturing

In addition to Social Security programs, the residents of the poorer towns in Massachusetts and elsewhere have benefited from public welfare, food stamp programs, subsidized housing, fuel assistance programs, meal services, home care, and publicly-funded health services. These towns have public shelters, food pantries, and residential programs for the disabled. In recent years, inner-city Boston and the old mill towns have attracted large numbers of new immigrants. Many have not found the factory jobs that were available a century before. Instead, they have become dependent on government assistance. In fact, health and social services have replaced manufacturing as the major industries in the old mill towns.

The revolution that transformed Massachusetts from a rural into an urban, industrial state was cruel to its workers. The mainly immigrant workforce labored long hours for little pay and few benefits. During the twentieth century, American labor fought for and won a far better deal. In our times, a well-educated workforce is protected by labor laws, vacation and sick benefits, health insurance, company-sponsored retirement schemes, a relatively early retirement age, decent salaries, disability insurance, and other benefits. Many of these benefits—including Social Security, Medicare, and Medicaid—are guaranteed by payments from the federal government.

When Social Security was first started, relatively few retirees lived long after age sixty-five. The social planners who implemented these programs hardly considered the effects of better health care, which has produced a growing population of the aged, many of whom will continue to receive benefits for more years than they spent in the workforce. The costs of healthcare, supporting an aging population, and paying out ever greater amounts of Social Security benefits will soon exceed revenues. Unless taxes are raised or benefits scaled back, it is doubtful that these benefits can be kept up long into the twenty-first century.

By 1900, the 2,805,346 people of Massachusetts comprised 3.7 percent of the total population of the United States. One hundred years later, the population of Massachusetts had grown to 6,379,097, which is only 2.2 percent of the U.S. total. In 1900 the city of Boston had a population of 560,000. During the first half of the twentieth century, Boston continued to grow, but at a slower rate. In 1950 over 800,000 lived in the city. After that date, the population began to decline. Today the city of Boston has about as many people as it had one hundred years ago. Most of the mill towns of Massachusetts have also stopped growing or have shed population.

The very considerable population growth *around* the old cities and towns has ensured that Metropolitan Boston continues to grow. Commuter suburbs now extend to the north, west, and south of the center of Boston for more than thirty miles. Shopping malls and business parks have sprung up along the

major highways. This process has hastened the decline of the old mill towns and has weakened the magnetic pull of Boston itself. In 2000 Metropolitan Boston had a combined population of nearly six million people. This is much less than Greater New York's twenty million, Los Angeles's sixteen million, and Chicago's nine million. Metropolitan Boston is only slightly less populated than Washington, Baltimore, San Francisco, and Philadelphia, and ranks overall as the seventh-largest metropolitan area in the country.

Massachusetts Bay is the place of one of the earliest European settlements in North America. Plymouth is the first English town and Gloucester is the oldest fishing port in America. The struggle for Independence began here. The "shot heard 'round the world" was fired in Massachusetts. America's industrial revolution began in Massachusetts. The first telephone call was made in Boston. America's first subway was built in Boston. The shipyards of Quincy were the second largest in the United States. The city of Boston still maintains the charm of its old neighborhoods of Beacon Hill and Back Bay. Boston still has a flourishing cultural life with live music and live theater. It is a great college town. Greater Boston has many attractions. The forests, hills, lakes, rugged coastline, distinct seasons, diverse cultural offerings, heritage, and rich academic life make it a distinctive place in which to live. The city has capitalized on its history to become a major tourist center. Metropolitan Boston has developed a vast service economy based on medical care, education, money management, computers, insurance, and tourism.

Much in Boston has changed. The elevated railway is gone and the harbor has many more pleasure boats than trading vessels. The warehouses that stored cotton, wool, molasses, and leather have been converted to apartments. Downtown is no longer a premier shopping area. Ready-made clothes are no longer locally produced and very few major American companies have their headquarters in the city. Boston is no longer a center for book publishing and the city no longer has seven daily newspapers. Revere Beach, Norumbega, and the other amusement parks are gone.

Automobiles did not clutter the streets until after the 1920s. There were still large areas of woods and farmland separating the towns from each other and from Boston. To accommodate the fast-growing number of cars, it was necessary to transform the landscape. New highways were built to suburbs further and further from the old city center. Shopping malls were built along the major roads. The old industrial towns are trying to find new uses for the empty factories and to harness their history as a means of attracting tourists. The American Textile Museum in Lowell, the Peabody Essex Museum in Salem, the Plimoth Plantation in Plymouth, and the Whaling Museum in New Bedford offer a nostalgic view into the past. Many of the mills have been torn down. Others have been recycled into office space or apartments. Some of

these great mills still stand empty as haunting memorials to the Industrial Age of Massachusetts.

Since its settlement at the start of the seventeenth century, Massachusetts Bay has witnessed the rise and fall of agriculture, fishing, shoes, and textiles. Machinery is no longer powered by water. Barges no longer travel the rivers and canals. Ships no longer carry large quantities of goods and passengers to and from foreign ports. At the start of the twenty-first century, healthcare, computer services, entertainment, insurance, legal services, education, and tourism are the leading industries. It remains to be seen whether these industries can provide Boston with the independence and wealth of its Industrial Age. Change needs to be anticipated and embraced. The inventiveness of the people of Massachusetts will be needed to create the new industries necessary for future prosperity.

BIBLIOGRAPHY

Abbott, E. *Women in Industry: A Study of American Economic History.* New York: Appleton & Company, 1909.

Adams, R. King Gillette. *The Man and his Wonderful Shaving Device.* Boston: Little-Brown, 1978.

Bacon, E.M. *Book of Boston—Fifty Years Reminiscences.* Boston: The Book of Boston Company, 1916.

Bedford, H.F. *Their Lives and Numbers: The Condition of Working People in Massachusetts, 1870–1900.* Ithaca, NY: Cornell University Press, 1995.

Bither, B. *Charlestown Navy Yard.* Charleston, SC: Arcadia Publishing, 1999.

Blewett, M.H. *Constant Turmoil—The Politics of Industrial Life in Nineteenth-Century New England.* Amherst, MA: University of Massachusetts Press, 2000.

Brooks, C. *History of the Town of Medford.* Boston: Rand, Avery & Company, 1886.

Brown, R.D. and J. Trager. *Massachusetts: A Concise History.* Amherst, MA: University of Massachusetts Press, 2000.

Carossa, V.P. *More than a Century of Investment Banking: The Kidder, Peabody & Co. Story.* New York: McGraw-Hill, 1979.

Chase, G.W. *The History of Haverhill, Massachusetts, 1861.*

Cheney, F. and A.M. Sammarco. *Trolleys Under the Hub.* Charleston, SC: Arcadia Publishing, 1997.

———. *When Boston Rode the El.* Charleston, SC: Arcadia Publishing, 2000.

Clarke, G.K. *The History of Needham, Massachusetts, 1711–1911.* The University Press, 1912. Reprint: Bowie, MD: Heritage Books, 2000.

Crowther, B. *Hollywood Rajah: The Life and Times of Louis B. Mayer.* New York: Dell, 1961.

Dalzell, R.F. *Enterprising Elite: The Boston Associates and the World they Made.* Cambridge, MA: Harvard University Press, 1987.

Daniels, J. "Industrial Conditions among Negro Men in Boston." *Charities.* Vol. 15: (October 7, 1905).

Dawley, A. *Class and Community: The Industrial Revolution in Lynn.* Cambridge, MA: Harvard University Press, 1976.

Derderian, T. "Boston Marathon: The First Century of the World's Premier Running Event." *Human Kinetics:* (1996).

Dickens, Charles. *American Notes: A Journey.* (First published in 1842.) New York: Fromm International Publishing Corporation, 1985.

Dorgan, M.B. *History of Lawrence, Mass.* Published by author, 1924.

Earl, H.H. *The Centennial History of Fall River, Mass.* New York: Atlantic Publishing and Engraving Company, 1877.

Ferguson, N. *Empire: The Rise and Demise of the British World Order and the Lessons for Global Power*. New York: Basic Books, 2002.

Flibbert, J., K.D. Goss, J. McAllister, B.F. Tolles, and R.B. Trask. *Salem— Cornerstone of a Historic City*. Beverly, MA: Commonwealth Editions, 1999.

Gertner, J. "The History of American Capitalism in a Single Industrial Complex." *New York Times Magazine*: (June 8, 2003).

Gross, L.F. *The Course of Industrial Decline: The Boott Cotton Mills of Lowell, Massachusetts, 1835–1955*. Baltimore: Johns Hopkins University Press, 1993.

Handlin, O. *Boston's Immigrants: A Study of Acculturation*. New York: Atheneum, 1972.

Hoover, E.M. Jr. *Location Theory and the Shoe and Leather Industries*. Cambridge, MA: Harvard University Press, 1937.

Hurd, D.H. *History of Essex County*. Volume 1. Philadelphia: J.W. Lewis & Company, 1888.

Isaacson, W. *Benjamin Franklin—An American Life*. New York: Simon & Schuster, 2003.

Juravich, T., W.F. Hartford, and J.R. Green. *Commonwealth of Toil: Chapters in the History of Massachusetts Workers and their Unions*. Amherst, MA: University of Massachusetts Press, 1996.

Keyssar, A. *Out of Work: The First Century of Unemployment in Massachusetts*. Cambridge: Cambridge University Press, 1986.

Lewis, A. *History of Lynn*. Boston: Shorey Publisher, 1865.

Lowell National Historic Park & Tsongas Industrial History Center. www.nps.gov/lowe/.

Map of the Electric Railways of the State of Massachusetts. Report of the Railroad Commissioners, Library of Congress, 1899.

"Massachusetts Bay Tercentenary, 1630–1930." *Official Chronicle and Tribute Book*. Boston: George G. Hall Company, 1930.

Massachusetts Bay Transportation Authority. "History of the Boston Transit System." www.mbta.com.

McDermott, C.H. *A History of the Shoe and Leather Industries of the United States*. Boston: John W. Denehy & Company, 1918.

Montgomery, D. *The Fall of the House of Labor—The Workplace, the State, and American Labor Activism, 1865–1925*. Cambridge: Cambridge University Press, 1987.

Morison, S.E. *The Maritime History of Massachusetts*. Boston: Houghton Mifflin, 1961.

O'Connor, T.H. *The Hub: Boston Past and Present*. Boston: Northeastern University Press, 2002.

Quincy, J. Jr. *Quincy Market*. Boston: Northeastern University Press, 2003.

Ransom, R.L. *Conflict and Compromise: The Political Economy of Slavery, Emancipation, and the American Civil War*. Cambridge: Cambridge University Press, 1989.

Rivard, P.E. *A New Order of Things: How the Textile Industry Transformed New England*. Hanover, NH: University Press of New England, 2002.

Russell H.S. *A Long, Deep Furrow: Three centuries of farming in New England*. Hanover, NH: University Press of New England, 1982.

Bibliography

Sarna J.D. and E. Smith (eds). *The Jews of Boston*. Boston: Northeastern University Press, 1995.

Shand-Tucci, D. Built in Boston—City and Suburb, 1800–1950. Amherst, MA: University of Massachusetts Press, 1988.

Stone, O.L. *The History of Massachusetts Industries: Their Inception, Growth and Success*. Boston: S.J. Charles Publishing, 1930.

Sweetser, M.F. *New England—A Guide for Travellers*. Boston: Houghton, Mifflin & Company, 1890.

"Taunton Tercentenary (1639–1939)." Issued by the Taunton Tercentenary Committee, 1939.

Van Dulken, S. *Inventing the Nineteenth Century: The Great Age of Victorian Inventions*. London: The British Library, 2001.

Warner, S.B. Jr. *Streetcar Suburbs*. Second Edition. Cambridge, MA: Harvard University Press, 1978.

Weible, R. ed. *The Continuing Revolution—A History of Lowell, Massachusetts*. Lowell, MA: Lowell Historical Society, 1991.

Whitehill, W.M and L.W. Kennedy. *Boston: A Topographical History*. Third Edition. Cambridge, MA: Belknap Press, 2000.

Whitman, N.A. *Window Back: Photography in a Whaling Port*. New Bedford: Spinner Publications, 1997.

Williams, A.W. *A Social History of the Greater Boston Clubs*. Barre, MA: Barre Publishers, 1970.

INDEX

Index

Index